BEACH HOUSES

Also by Michael Webb

Architecture in Britain Today

Magic of Neon

Hollywood: Legend and Reality

Happy Birthday, Hollywood!

The City Square

LA Access Guide

Architects House Themselves: Breaking New Ground

New Stage for a City: Designing the New Jersey
Performing Arts Center

Volume Geometry Color: House Design
by Regina Pizzinini and Leon Luxemburg

Free Expression: House Design by Edward Niles

Themes and Variations: House Design by Ray Kappe

Living with Nature: House Design by Javier Barba

Through the Windows of Paris

Architecture + Design LA

It's a Great Wall!

Modernism Reborn: Mid-Century American Houses

Richard Sapper: Out of the Black Box

Also by Roberto Schezen

Ancient Temples of Italy

Churches and Cathedrals of Italy

Adolf Loos: Architecture 1903–1932

Places and Memories

Newport Houses

Visions of Ancient America

Italian Splendor: Palaces, Castles, and Villas

The Splendor of France: Châteaux, Mansions,
and Country Houses

Palm Beach Houses

Spanish Splendor: Places, Castles, and Country Houses

Joze Plecnik: Architect

Genova

Vienna 1850–1930: Architecture

Adolf Loos: Theory and Works

Miami: Trends and Traditions

New York: Trends and Traditions

Palaces of Rome

Great Villas of the Riviera

Roman Gardens: Villas of the City

Roman Gardens: Villas of the Countryside

Private Architecture: Masterpieces
of the Twentieth Century

The Palladian Ideal

The Villa: From Ancient to Modern

Louis Kahn: Architect

Le Corbusier: Architect

BEACH

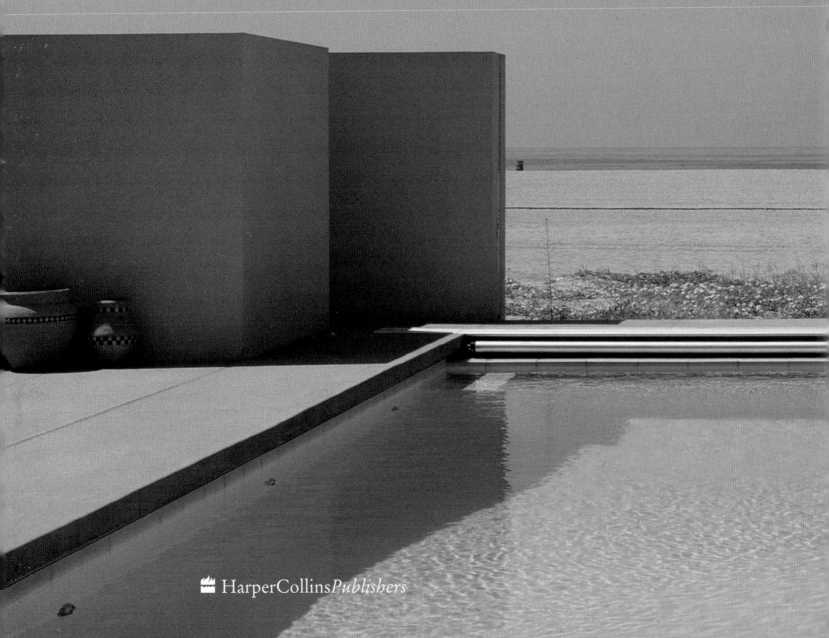

HarperCollins*Publishers*

HOUSES

Photographs by Roberto Schezen

Text by Michael Webb

HarperCollins books may be purchased for educational, business, or sales promotional use. For information, please write: Special Markets Department, HarperCollins Publishers Inc., 10 East 53rd Street, New York, NY 10022.

FIRST EDITION

Designed by Joel Avirom and Jason Snyder
Design Assistant: Meghan Day Healey

Library of Congress Cataloging-in-Publication Data

Schezen, Roberto.
 Beach houses / photographs by Roberto Schezen ; text by Michael Webb.—1 st ed.
 p. cm.

ISBN 0-06-019773-0

 1. Sea side architecture—United States. 2. Architecture, Domestic—United States.
 I. Webb, Michael. II. Title.

NA7575 .S34 2002
728'.37'097309146—dc21

 2001016936

02 03 04 05 06 10 9 8 7 6 5 4 3 2 1

To Chessi Rainer

Acknowledgments *xi*

Introduction *xiii*

FLORIDA

PALM BEACH: House on Lake Worth (Richard Meier & Partners, 1977–79; 1995) *6*

PALM BEACH: La Ronda (Pierre Delbé & John Volk, 1969–74) *16*

GOLDEN BEACH: Landes house (Carlos Zapata Design Studio, 1991–93) *26*

MIAMI BEACH: Burke house (Mike Burke, 1995–) *36*

THE NORTHEAST

QUOGUE: Scaladd house (1910) *48*

SOUTHAMPTON: Ertegun house (Cooper, Robertson & Partners, 1990–92) *56*

SOUTHAMPTON: Holzer house (Francis Fleetwood, 1999–2000) *64*

SAGAPONACK: The Barns (Carlos Brillembourg Architects, 1983–97) *72*

SAGAPONACK: Villa Amore (Agrest & Gandelsonas Architects, 1989–90) *80*

MONTAUK: Eothen (Rolf Bauhon, 1931) *86*

BLOCK ISLAND: Cox-Hayden house and studio (Venturi, Rauch
　　　　　　　　and Scott Brown, Architects, 1980–81) *94*

Contents

THE NORTHWEST

GIG HARBOR: Dafoe house (Kirk Wallace McKinley, 1962) *104*

BELLEVUE: Pleasure Point house (Olson Sundberg Architects, 1997–99) *110*

CASPAR: The Wave (Bart Prince, Architect, 1996) *118*

SEA RANCH: Yudell-Beebe house (Buzz Yudell & Tina Beebe, 1998–2000) *126*

STEWARTS POINT: Beach house (Joan Hallberg, 1992) *132*

SOUTHERN CALIFORNIA

SOUTHERN CALIFORNIA: Oceanfront house (Andy Neumann, Architect, and Carlson Chase Associates 1995) *144*

SANTA MONICA: Lewin house (Richard Neutra, 1938; extended by Steven Ehrlich Architects, 1998) *154*

CAPISTRANO BEACH: Glass house (Rob Wellington Quigley, Architect, 1989–93) *162*

MALIBU: Morton house (Kanner Architects, 1992–96) *174*

MALIBU: Oceanfront residence (Gwathmey Siegel & Associates, 1988–93) *182*

Acknowledgments

Our thanks to Joseph Montebello, Jane Holzer, Parker Ladd, Vanessa Stich, Susan Friedland, and Joel Avirom for their active involvement in making this project possible.

To the many people who opened their homes to us: Nicholas and Catalina Echavarria de Landes, Mike Burke, Arnold Scaasi, Ahmet and Mica Ertegun, Atilio and Marie-Blanch Brillembourg, Richard and Eileen Eckstract, Paul Morrissey, Welde Cox, William and Margaret Dafoe, Boyd and Mary-Kay Hight, Buzz Yudell and Tina Beebe, and Donald and Lorraine Morton, as well as those home-owners who chose to remain anonymous.

And to the architects who created these beach houses: Richard Meier and Partners; Pierre Delbé and John Volk; Carlos Zapata Design Studio; Copper, Robertson and Partners; Francis Fleetwood; Carlos Brillembourg Architects; Agrest and Gandelsonas Architects; Rolf Bauhon; Venturi, Rauch and Scott Brown; Kirk Wallace McKinley; Olson Sundberg Architects; Bart Prince; Joan Hallberg; Andy Neumann; Richard Neutra; Steven Ehrlich; Rob Wellington Quigley; Kanner Architects; and Gwathmey Siegel and Associates.

Introduction

Everyone, even in Kansas, has a secret fantasy of living by the ocean. Partly it's the thrill of sharing space with something wild and beautiful that can easily turn destructive, of enjoying a view that constantly changes but can never be spoiled. And partly it's the city dweller's fantasy of living close to nature, stripping off his clothes, and going as nearly naked as local custom allows.

Over a century ago, a desk-slave-turned-sailor wrote about that impulse. Herman Melville believed that almost every boy dreams of running away to sea, in quest of adventure and to elude the responsibilities of living ashore. In the opening paragraphs of *Moby-Dick,* he describes the Sunday crowds in New York who are drawn unthinkingly to the water's edge, just to gaze over the ocean or admire the ships in harbor. The city has changed in every way since that novel was written, but the South Street Seaport is still thronged on the weekends, and so are many other historic havens.

The houses that today line the shores of America offer comforts a nineteenth-century mariner could never have imagined. And yet the same compulsion that drove Melville to exchange the security of teaching school for the perils of life aboard a whaler is shared by everyone who builds at the water's edge. Our distant biological ancestors crawled out of the surf; we feel impelled to plunge back into it.

The beach marks the shifting frontier of continent and ocean, between the world in which we live and one we can only contemplate or tentatively explore. We have tamed and fenced the land, and built over it; the ocean defies our will to master nature. A compendium of moods, it becomes angry, agitated, or still with every shift of wind and weather, the seasons and the time of day. Unpredictable and seemingly

infinite, it is home to gulls and great whales, and offers the ultimate challenge to sailor and surfer. Its tides build and destroy, pulverizing rocks and shells to create the finest sand, smoothing pebbles, and smashing through the barriers of nature and man.

America's beaches are as varied as the nation itself, extending from San Diego to Seattle, from Eastport, Maine, to Key West, and around the Gulf of Mexico to Brownsville, Texas. Every bay and island, cliff and rocky outcrop interacts with the ocean as it changes from turquoise to slate gray on its voyage north. Travel agents and swimsuit makers, *Baywatch* and the Beach Boys have implanted a hedonistic image of sunbathing and sand, bronzed lifeguards and picnic coolers. Romantics prefer a deserted beach at sunset, strolling barefoot at the water's edge with a dog racing ahead, scattering the birds. For kids, it's the excitement of collecting driftwood, wading through tidal pools, digging for clams, and building sand castles. The beach even has a metaphorical dimension. As the seventeenth-century British scientist Isaac Newton wrote: "I seem to have been only a boy playing on the seashore, and diverting myself, now and then finding a smoother pebble or a prettier shell than ordinary, whilst the great ocean of truth lay all undiscovered before me."

Residents pay dearly for a front-row seat that guarantees maximum exposure to the ocean's many wonders, to storms as well as shore, but the price includes much more than firm ground and shelter. The water is a constant presence, whether obscured by fog or sparkling in sunlight of extraordinary clarity. Its murmur instills a deep calm in those who live beside it, and it freshens the air, sending in cooling breezes. Despite its ceaseless motion, it mirrors lightning and sunsets, the cold glitter of the moon and the sweep of a distant beacon. At night, even an offshore oil rig can be transformed, by reflection, into a magical apparition. In fine weather, the shore is a parade ground for humans and wildlife. After a storm it becomes a repository for the detritus of nature and civilization; a scatter of glass floats and bleached logs, nets and shells, with an occasional treasure to reward the patient searcher.

The struggle between public access and private property rights has grown ever fiercer, but happily most American beaches remain accessible. We should cherish their beauty and be concerned about their vulnerability. A recent report from the Federal Emergency Management Agency warned that a quarter of the houses within five hundred feet of the ocean and Great Lakes may succumb to the waves in the next

sixty years. Global warming could raise the level of oceans around the world, inundating entire communities. Palm Beach and East Hampton might become as watery and legendary as Atlantis, with fish gliding through windowless salons and octopi nestling in the marble tubs.

Undeterred by these grim prospects, people clamor to build beside the ocean, though few seem to respect the object of their affections. Houses that take best advantage of their setting are always rare, and waterfront sites demand more than most architects can offer. Today, the typical beachfront lot is long and narrow, walled in by neighbors to either side and backing onto a busy coast highway, with the beach as a communal front yard. To give every room an unobstructed view and balanced natural lighting while maintaining privacy, security, and protection from storms is a challenge that's rarely met. Weathered fishermen's shelters, so appealing to the imagination, have been replaced by fortified shacks that stick sharp elbows into their neighbors' ribs and block views like a pumped-up SUV on the highway. Some have no character; others are designed to reflect the owner's fantasy of living in a Cape Cod, an Andalusian farmhouse, or the Grand Trianon, however inappropriate that may be to context and climate. And most are designed with little thought of the corrosive salt air and prove expensive to maintain.

The twenty-one houses shown here respond to nature and the spirit of place as well as to the ambitions of their owners. Modest or grand, traditional or modern, each is a good fit for the site, client, and fortunate guests. They are grouped by region, progressing up the Atlantic coast and down the Pacific, though many are located on inlets and inland waterways, or at a safe distance from the water. In the south of Florida, two contrasting mansions in Palm Beach and a sea captain's folly in Miami Beach face west over sheltered water, while the fourth house confronts the ocean. In the Northeast, there is one house overlooking a saltwater pond on Block Island, and six at the eastern end of Long Island that run the gamut in size, style, and site. On the Northwest coast, three oceanfront houses are separated by rocks or cliffs from the pounding of the surf, and the two in Washington State are bordered by the still gray waters of Puget Sound and one of its many inlets. The five in Southern California are among the beachiest, opening directly onto the sand. Scattered between these dwellings are images of shorelines that have eluded the developers and may remain pristine to delight future generations.

The choice of properties was a personal one. Roberto Schezen has moved from Milan to Miami to New York, using his lens to celebrate the richly varied ways in which we put a roof over our heads. He selected the houses in Florida and Long Island, capturing the relationship of house to water, and the quality of the light. I made the West Coast selection, having moved from London to Los Angeles partly in response to an ocean that nearly carried me away on my first visit. The memory of the surf, tugging me out like a giant hand, is an enduring one. Although, like so many coast dwellers, I now take the ocean for granted, I feel refreshed whenever I step upon the sand, or contemplate (from a safe distance) the primal power of the waves. And so, this project has renewed a passion for my adopted country and the shining seas that bound it.

BEACH HOUSES

Florida

Palm Beach

A synonym for wealth and privilege, Palm Beach has become a community of surreal perfection, at least on the surface—like a fashion model who has been coiffed, made up, and dressed to seduce the camera. The inland waterway called Lake Worth serves as a moat to protect this manicured barrier island from the unplanned sprawl of West Palm Beach on the mainland, and we expect to be challenged at the bridges, as we are at the gates of less distinguished communities. Many of the finest houses, including the two shown here, are concealed behind tall, thick hedges, and pedestrians—unless jogging or exercising small dogs—stand out like aliens on the deserted sidewalks.

This skinny, sixteen-mile-long strip of sand was first developed a century ago as a stepping-stone in the southward progress of Henry Flagler. This visionary developer of railroads and real estate was the first to see the potential of swampy, mosquito-ridden Florida as a winter resort for rich Northerners. His first great resort hotel was located at the top of the state in the old Spanish settlement of St. Augustine. By 1894, he had reached Lake Worth, where he commissioned the Royal Ponciana Hotel before

continuing on to Miami Beach. That remained an isolated landmark until 1917, when Paris Singer, an heir to the Singer sewing machine fortune, and society architect Addison Mizner transformed Joe's Alligator Farm into the wildly eclectic Touchstone Convalescents Home. Originally intended for officers recovering from their injuries on the Western Front, it soon evolved into the exclusive Everglades Club. Membership was limited to three hundred families, and the club became the nucleus of a planned community of grandiose Mediterranean-style houses, and the chic stores and paseos along Worth Avenue.

5

The devastating hurricane of 1926 leveled trees, flooded estates, and put an end to the Florida land boom, three years before the stock-market crash wiped out many affluent winter residents. And yet, in contrast to Miami Beach, Palm Beach retained its cachet and much of its heritage of public and residential architecture. An idyllic mix of period-style buildings, lush vegetation, and gleaming ocean beaches complements the sheltered lakefront and the privacy of the long straight streets. It would be no surprise to spot Jay Gatsby, dashingly attired, speeding through in an open Duesenberg.

Palm Beach
House on Lake Worth
Richard Meier & Partners
1977–79; 1995

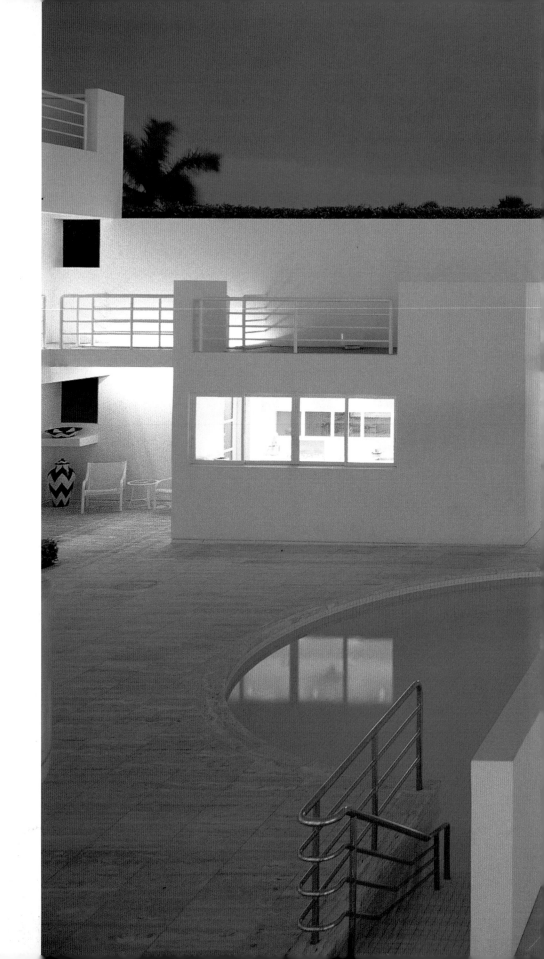

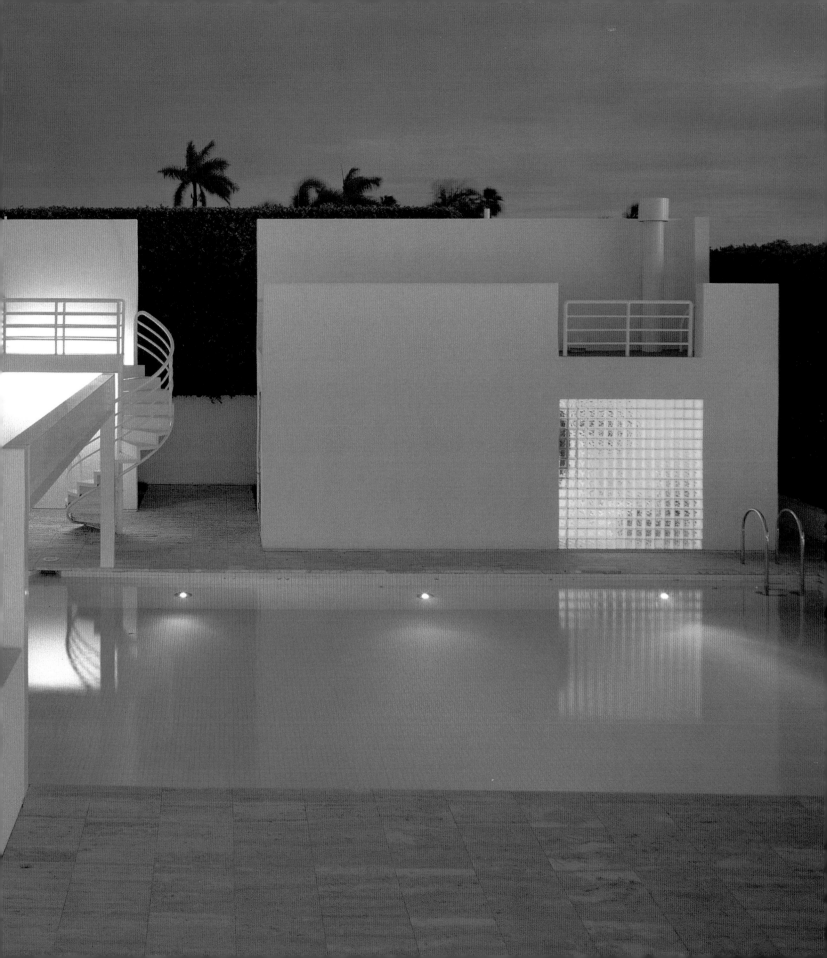

We live in a gilded age very similar to that of a century ago, when new wealth clamored for attention and commissioned houses of extravagant size and ornament, stuffed full of costly trophies. Today, as then, the results are often comical in their ostentatious vulgarity. American architect Richard Meier offers a radically different approach, stripping away everything that is inessential from his houses. As Paul Goldberger has noted, Meier is a poet of beauty who conceals the effort needed to achieve his effects. His houses are costly to build and maintain, for the luxury is implicit in the materials and details, and in the denial of conventional trappings.

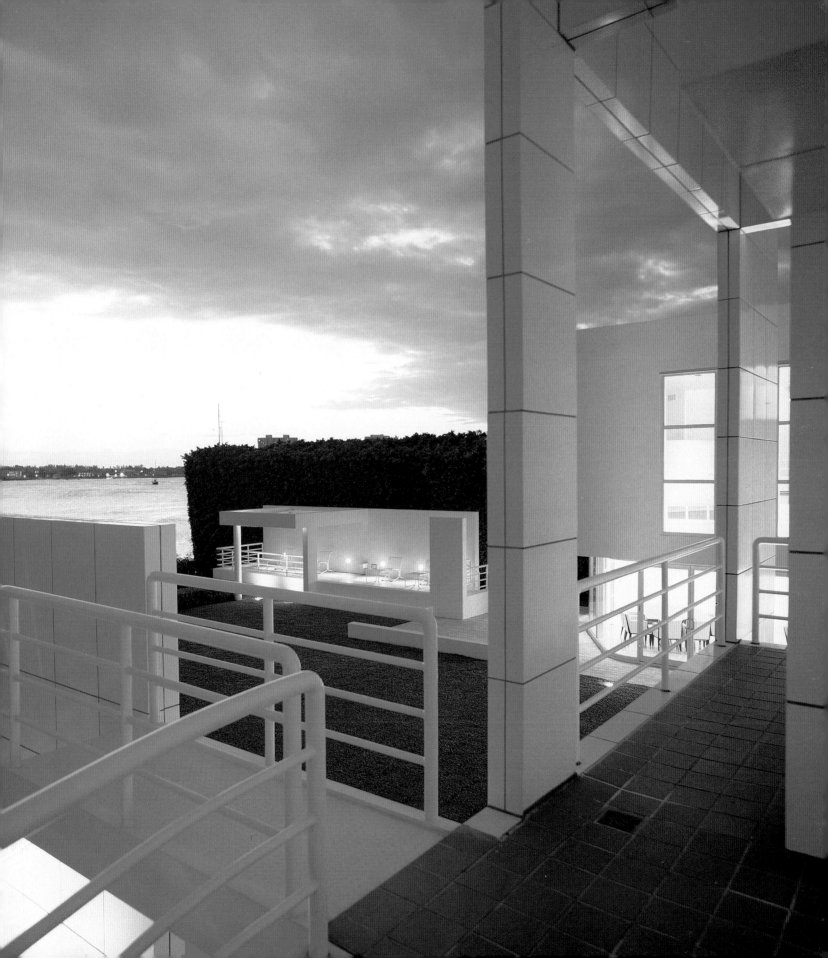

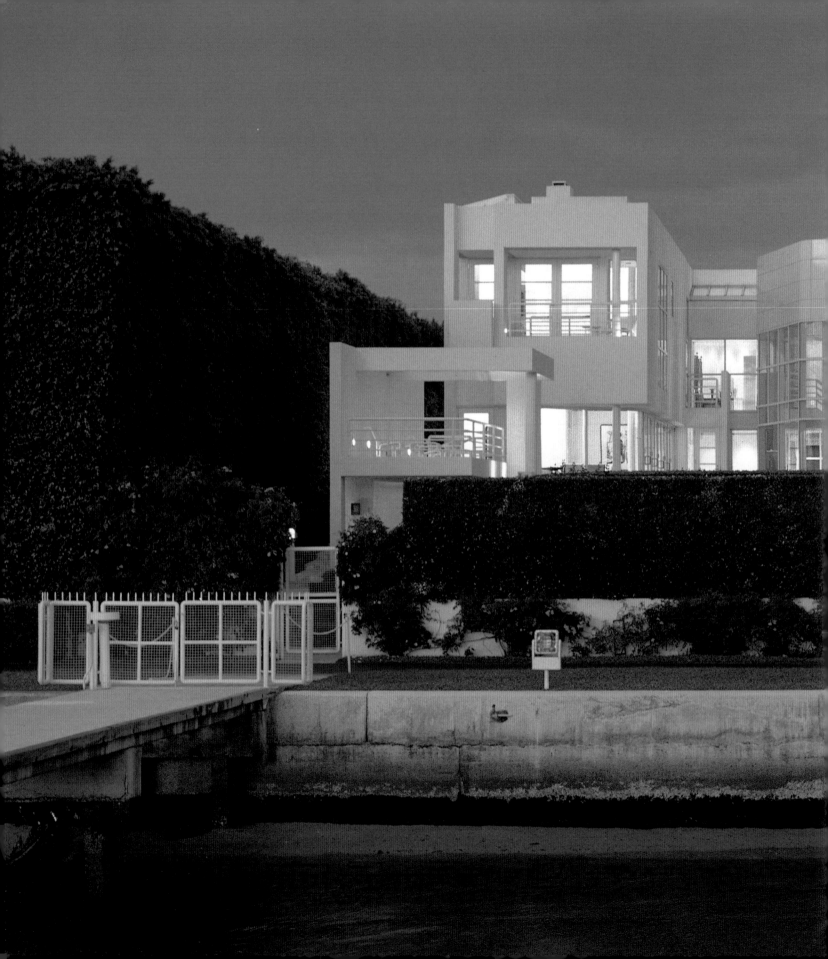

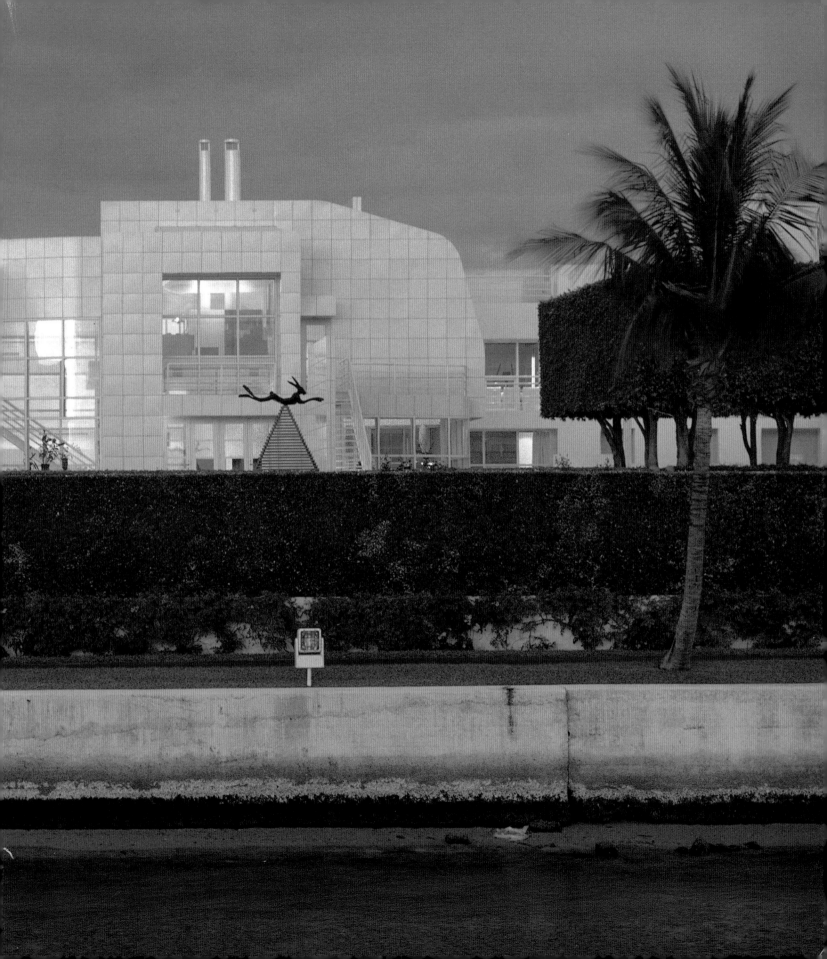

Refined, pristine, and sensual, they show how complex and subtle simplicity can be. He brings order and grandeur to his clients' lives, as the New York architectural firm of McKim Mead White did in the last gilded age.

Meier's crisp white geometry, with its echoes of cruise ships, has a natural affinity to water, and the Smith house in Darien, Connecticut, looking out over Long Island Sound, launched his career. Since then, commissions have streamed in for waterfront properties from Florida to East Hampton, Lake Michigan to Malibu. Each of these houses is shaped to the site and the specific needs of demanding clients, but they share several important characteristics: White walls serve as a canvas for constantly shifting tonalities and intensities of light, and the expanses of glass mirror the glittering surfaces and liquidity of water. Elemental in their purity, Meier's houses are stages for human activity and the drama of nature.

The Palm Beach house marked a decisive advance in Meier's work: in scale and complexity of plan, and in the introduction of surface grids of white-enameled metal panels. It's as grand as its traditional neighbors, but stands apart from them with the clarity of a Brancusi in a roomful of academic sculpture. The impassive entry wall of white stucco and glass brick, shielding the open compound and view from the street, has become a familiar device in Meier's houses, but this was the first in which the living pavilion is broken out as a separate structure, its organic form clad in a grid of white panels. Railed terraces and open staircases, buildings that frame the pool, and arches that frame the buildings look forward to the urban campus of the Getty Center in Los Angeles. Like the later Ackerberg house in Malibu, the house serves as a laboratory of ideas, and a demonstration of how outdoor and indoor spaces can be fused together when the climate is benign.

12

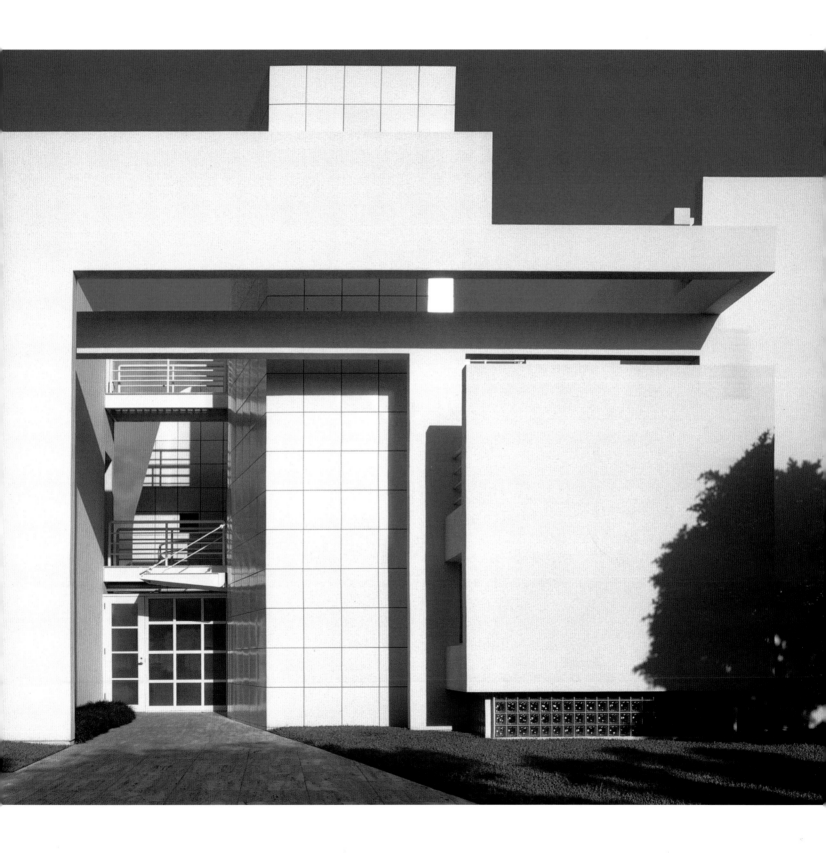

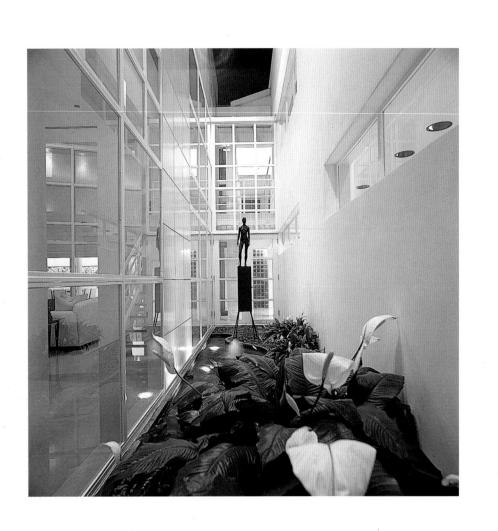

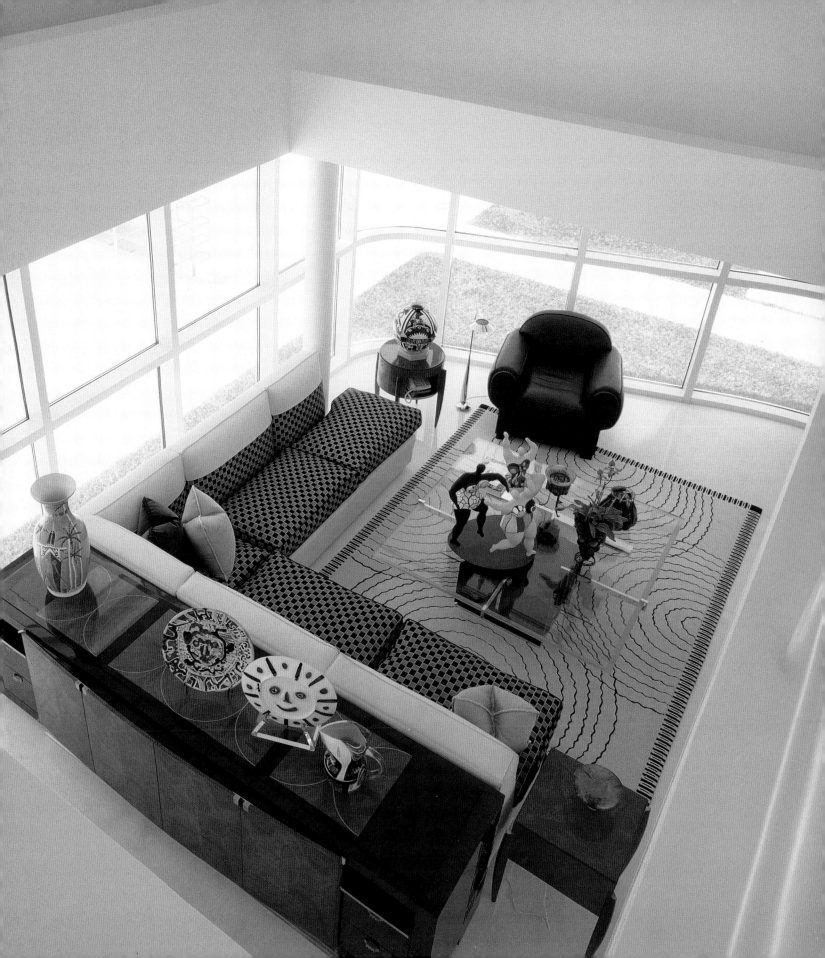

Palm Beach
La Ronda
Conceived by Pierre Delbé;
executive architect John Volk,
1969–74

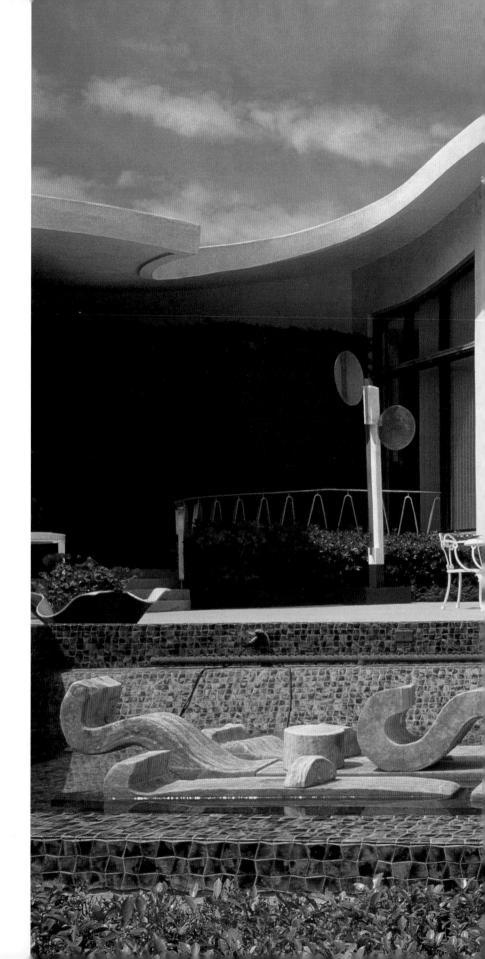

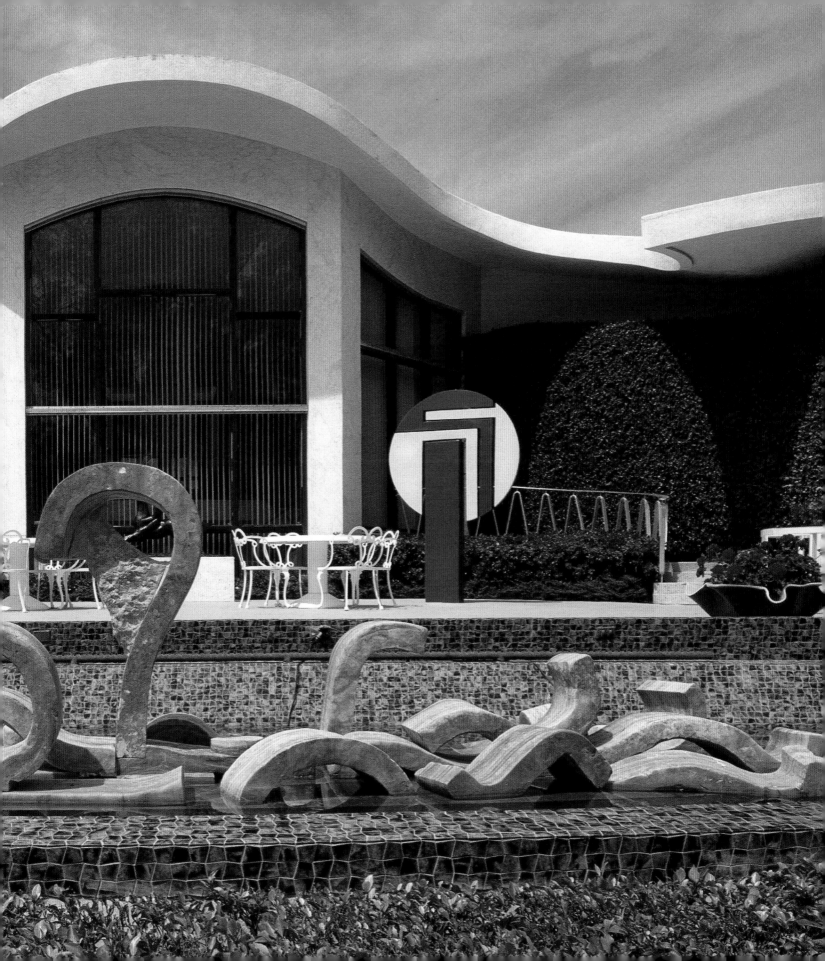

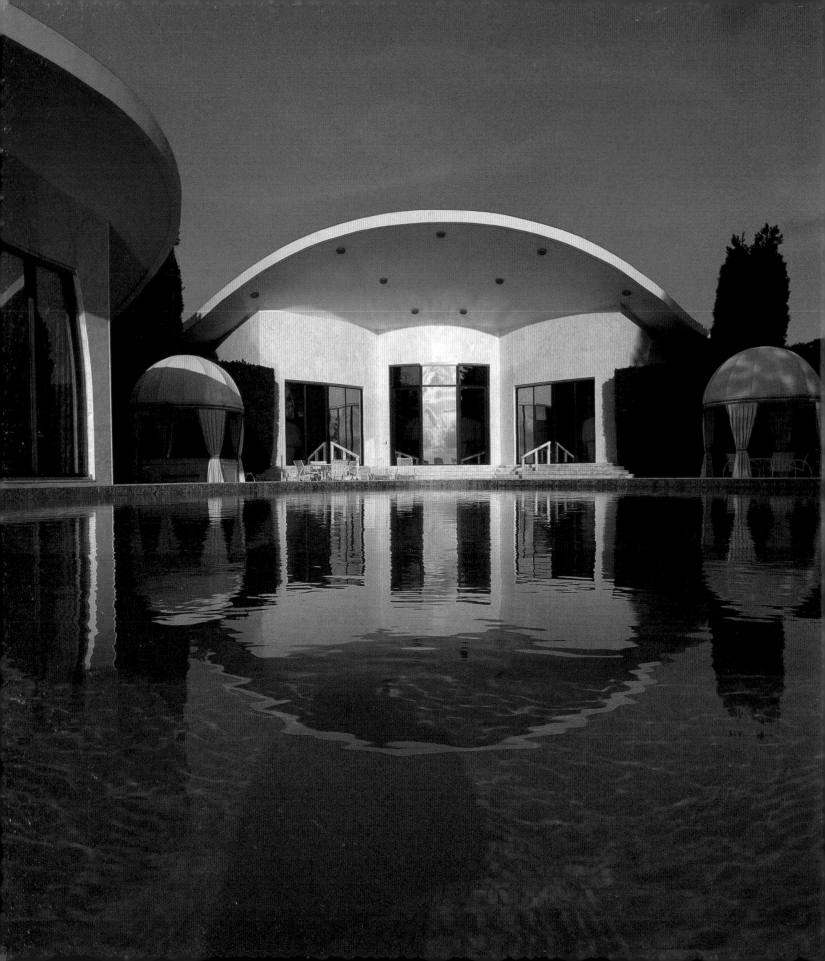

James J. Ackston, the publisher of *Arts* magazine, and his wife, Ziuta Gerstenzang, commissioned this showcase of art and architecture from Pierre Delbé, a Paris-based architect who created stately pleasure domes for the Shah of Iran. The house was initially designed for a location in Marbella on the rugged Costa del Sol of Spain, but the clients decided they preferred to live in Florida. Delbé refused to visit the new site. He remembered the fate of his brother, who suffered a fatal stroke while designing a Palm Beach mansion, reportedly as a result of his frustration in dealing with local authorities! Responsibility passed to Delbé's associate on the project, John Volk, a well-established Palm Springs architect who had arrived in 1926, on the eve of the hurricane.

In its refinement and the mannered elegance of its circular plan, La Ronda remains as quintessentially French as a 1938 Talbot-Lago automobile with teardrop coachwork by Figoni et Falaschi. Like that car, the house manifests a sensual abandon—in the undulating roof, the canopy that projects east and west as a sunscreen, and the white marble floors and facades. Behind the high hedge is a sculpture garden that separates the house from the street. A broad porte cochère, enclosed at either end to double as a garage, divides the ground-floor theater and four family and guest bedrooms from the entry pavilion.

Within this pavilion, a grand staircase leads up and back to a long axial living room with bowed, cove-lit walls that flow into an oval salon and out to the pool terrace. To the left is a circular library, a kitchen and dining room; to the right is the master suite. It's a lucid plan, which separates the public areas to one side, the private to the other, and gives both a westerly view over the water, while assuring privacy. The same play of curves animates the terrace. An oval pool with a sunburst pattern of yellow tiles flows under a shallow bridge and appears to merge into Lake Worth, before tumbling invisibly to a channel below. To the right is an arched white guest house that complements the projecting plane of the main house.

Art and fine craftsmanship were integral to the house from the start, and the bold lines of the architecture are matched by the riches it contains. There's an eclectic display of abstract canvases and sculpture by Picasso, Calder, Chagall, and Miró as well as emerging artists from Ms. Gerstenzang's Gallery 63 in New York and Rome. Sonia Delauney created a major tapestry, and the artist-designed rugs were custom-woven

by Aubusson. Fabric-covered walls in the living areas are overpainted with a delicate grid. Black-lacquered walls complement the onyx floor and basin of the powder room. All the furnishings were commissioned in Milan and have a wonderful period flavor. The intimately scaled dining room has swiveling high-backed chairs upholstered in a stylized zebra-print fabric arranged around a pedestal table. Stainless-steel and yellow metal cabinets accent the kitchen and pantry. The master suite is still more refined. Her bathroom has a stepped, freestanding oval tub of black marble echoed in the cove of the ceiling; his has a pearlized silver plastic tub and gray marble basin, with a boldly patterned brown and white wallpaper. Every detail—like the egg-shaped door handles—reaches out and invites you to touch.

Architect-historian Robert Stern compares La Ronda unfavorably with its traditional neighbors, calling it "a building with the cultural force and spatial freedom more typically associated with commercial roadside architecture than with gracious resort living." In fact, Volk won plaudits from people who assumed the design was his, and the house is far better suited to contemporary living than the sprawling Mediterranean palazzos of the 1920s that Stern so admires. Its fluid lines and nacreous surfaces unite the house, pool, and waterway in a single liquid composition.

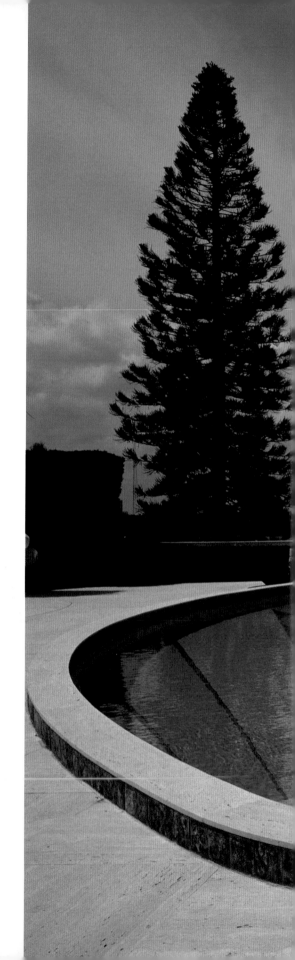

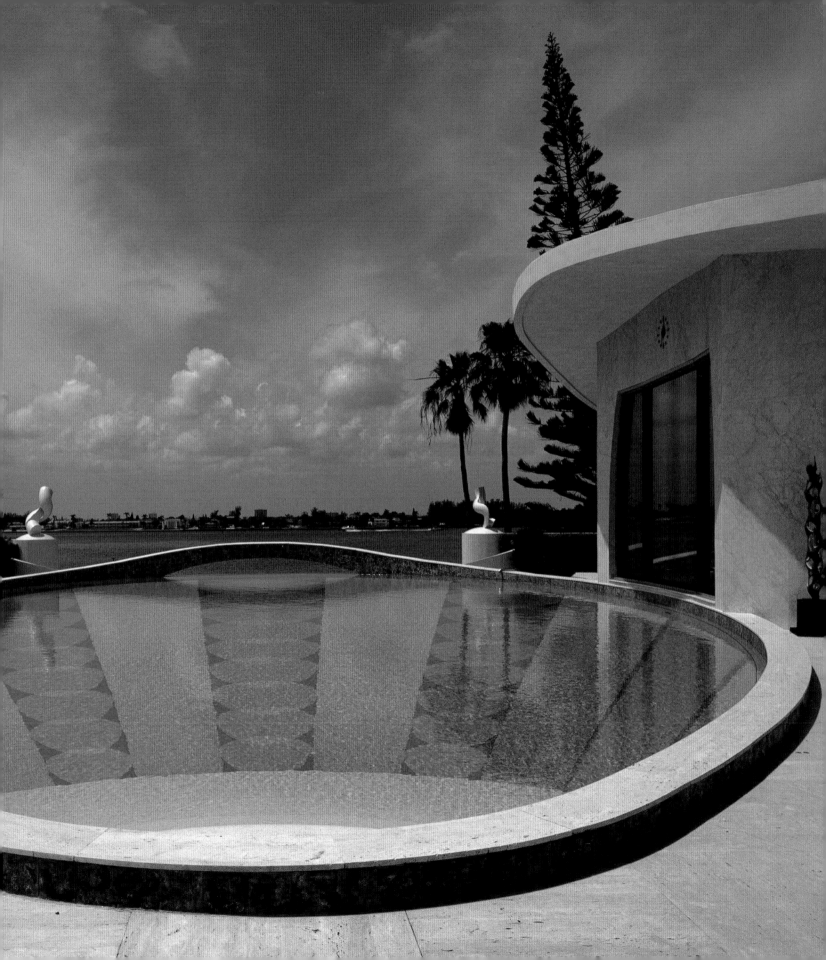

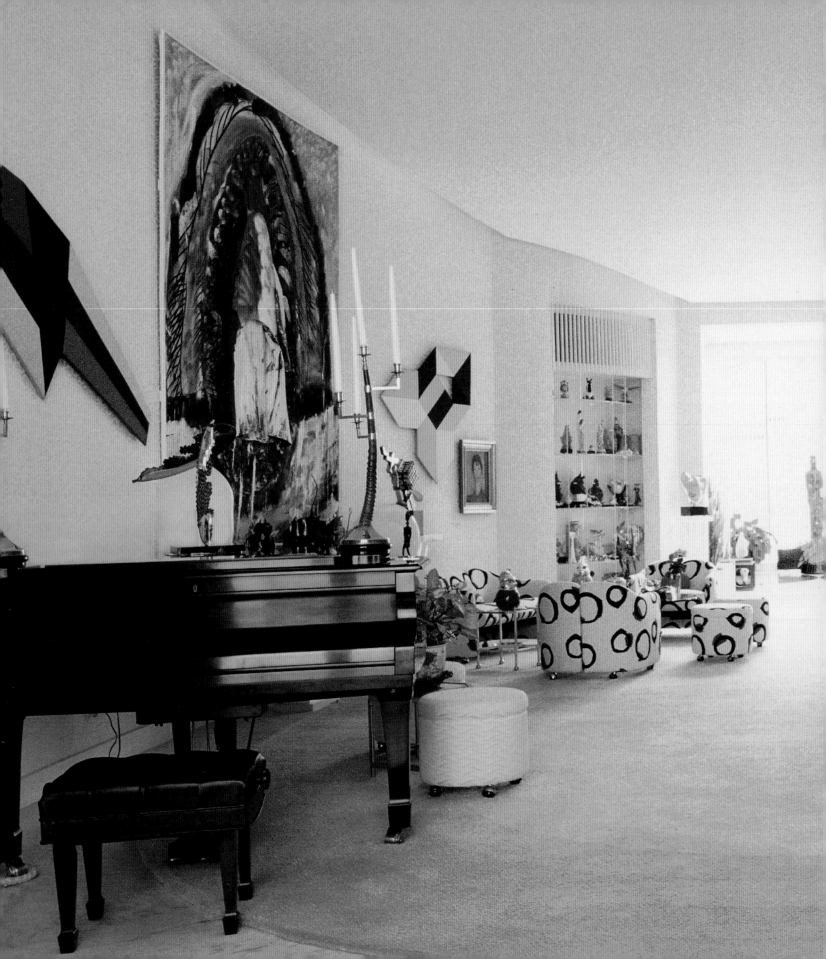

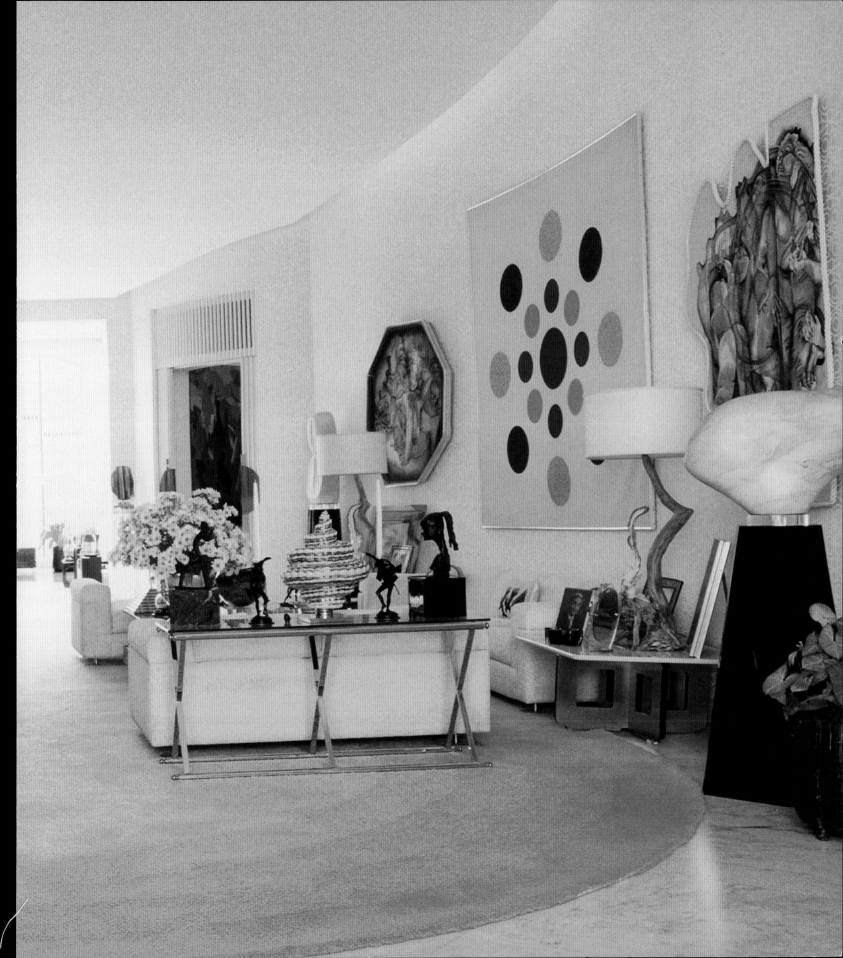

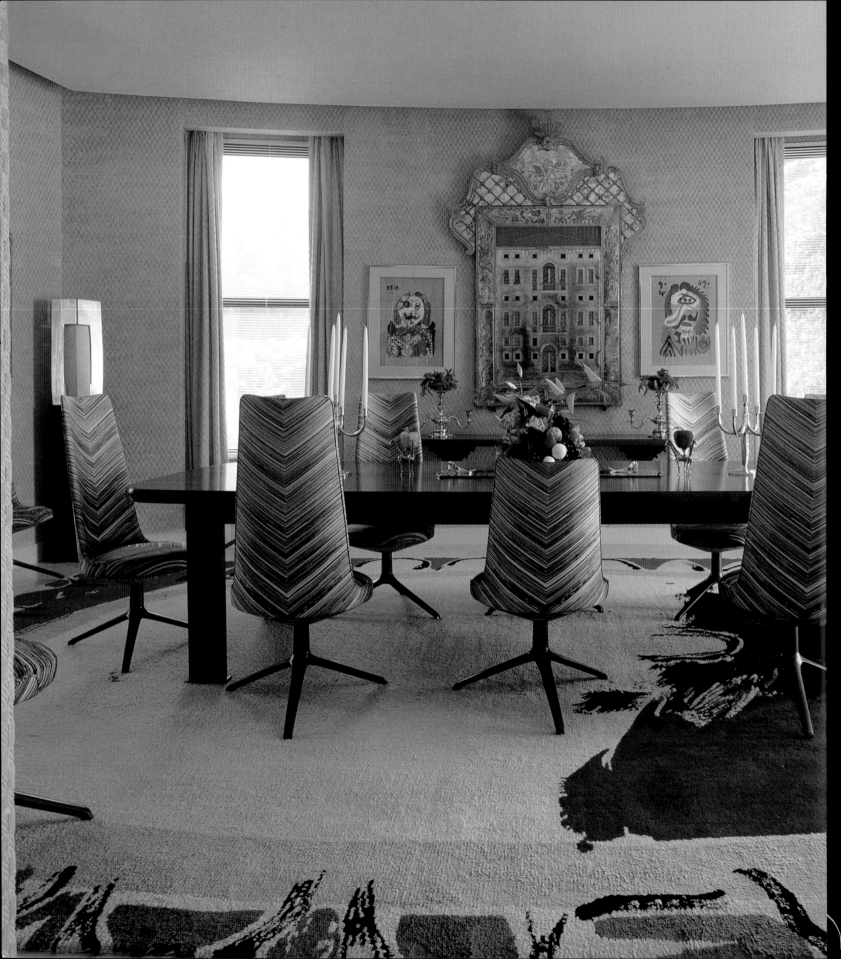

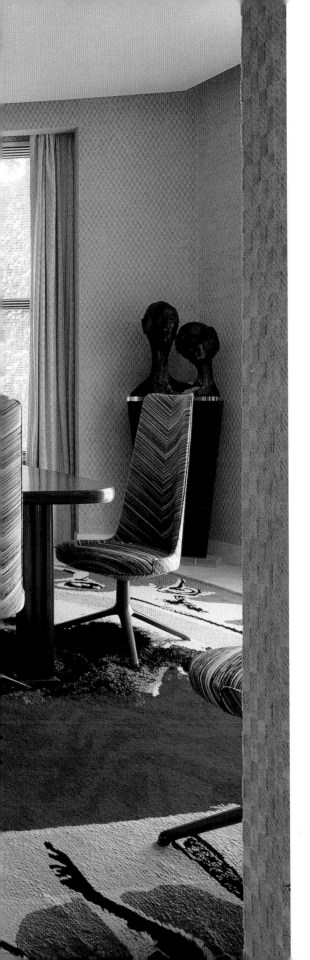

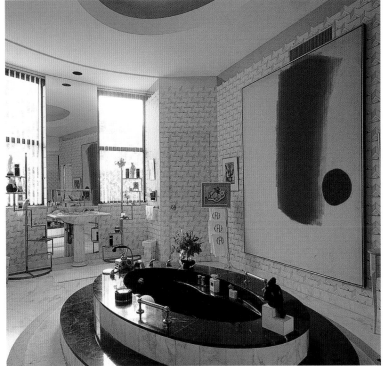

Golden Beach
Landes house
Carlos Zapata Design Studio,
1991–93

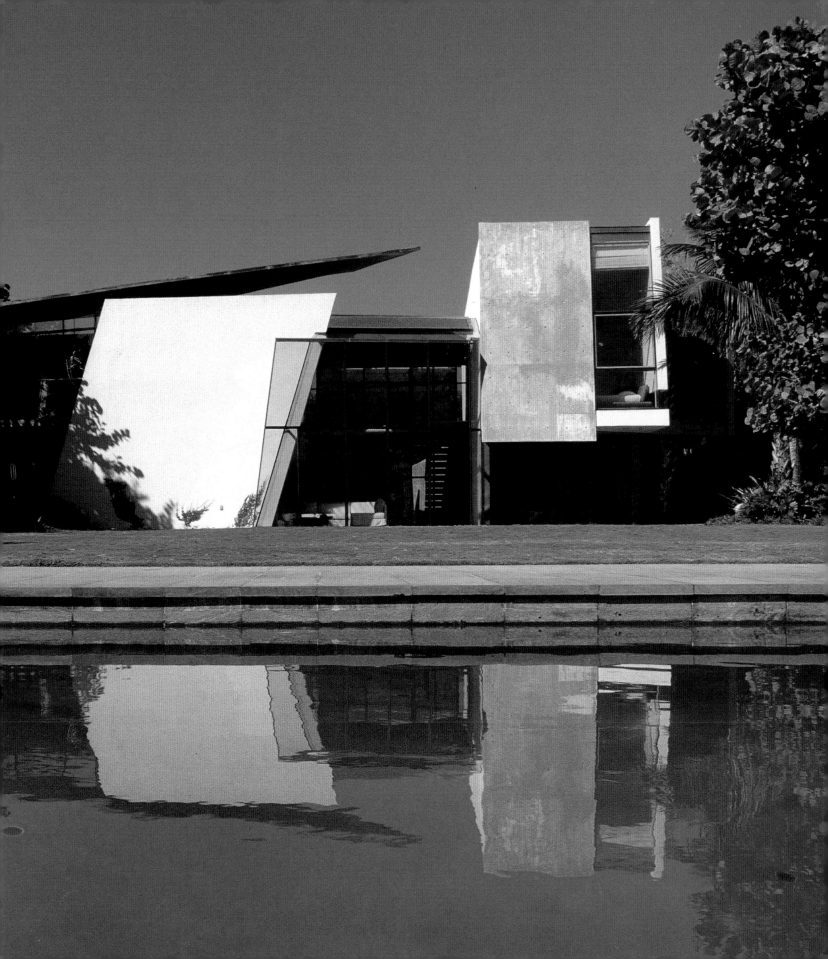

Miami is the first, and sometimes the final stop for recurring waves of Latin American exiles and visitors, a bilingual, semitropical bridge between two cultures. Infused with energy by the Cuban influx, it seemed an ideal place for Carlos Zapata, a Venezuela-born architect, to practice, and for Colombia-born interior designer Catalina Echavarria de Landes and her family to work and play. The Landeses bought a Spanish Colonial house on Golden Beach, just north of the city. President Roosevelt had wintered there, but the house was boxy, dark, and had nothing to recommend it but its site on the edge of the sand, facing out to the ocean. The new owners began tearing it apart, then realized they needed expert help and turned to Zapata, even though he had built nothing up to that point. However, his sketches showed brilliant promise, and he was a friend from the days when they were all growing up in Ecuador.

The house had to withstand the assault of Atlantic storms and be a comfortable fit for Catalina Echavarria, her banker husband, Nicolas, and their three children.

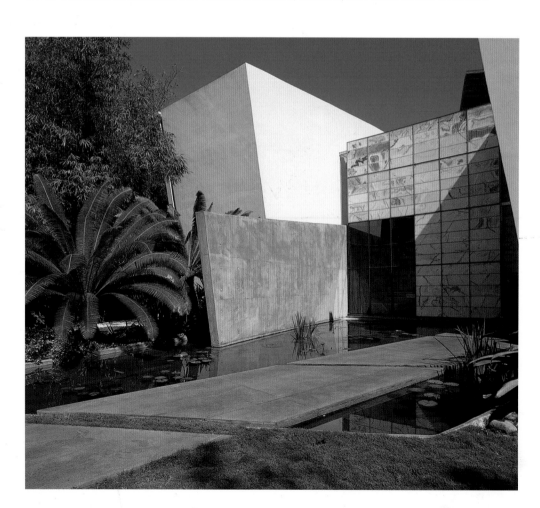

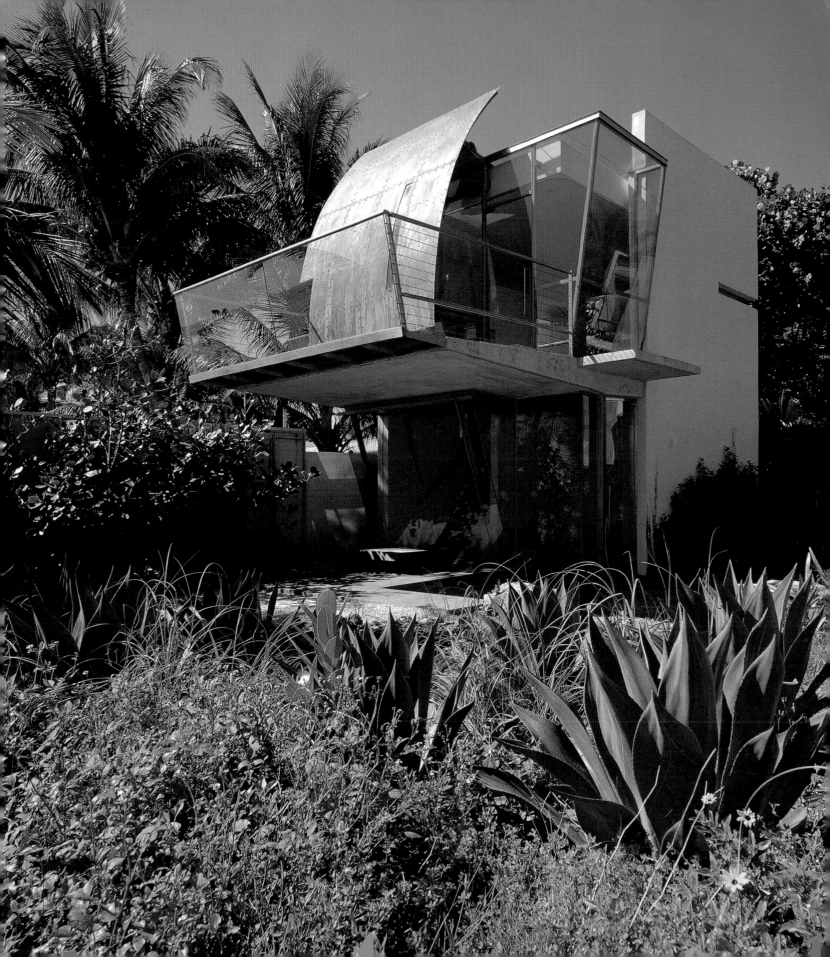

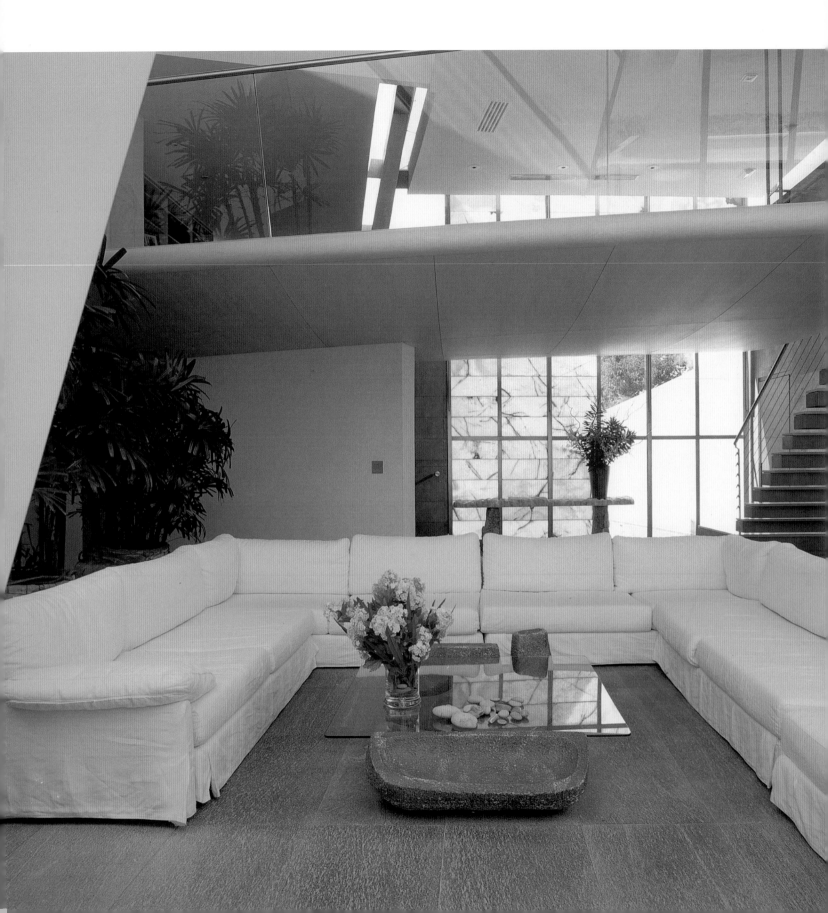

The architect satisfied those basic needs, and went far beyond, creating a dynamic composition of tilted planes and angled roofs that seems to be exploding in slow motion from within. Screens of onyx, patinaed copper, concrete, and stucco provide shade and privacy, but from some angles the structure appears to be a green-tinted glass house that you can look straight through. There is nothing remotely like it on this or any other beach, and another client might have been apprehensive about living within such a radical work of art and entrusting its completion to an inexperienced thirty-one-year-old.

Señora de Landes didn't hesitate. "She was very open-minded and it took her only thirty seconds to approve the model," says Zapata. "We had a true collaboration throughout the three years it took to refine and build the house." Architect and client discussed how much of each material to use and how far the curved copper shield over the guest house would open up. As Señora de Landes explains: "I'm best at interiors, not the exterior. I got him to be more minimalist, and he got me to be more sensitive to certain materials and to movement. I worked as an editor, took his lines, and distilled them." She was impatient to move in, and so construction began while the design was still being finalized.

That was one of the challenges. Another was the building permit, which mandated a remodel, not ground-up construction. A new steel frame would have been much easier and less expensive to achieve, but the local authorities demanded an inner structure of steel, wood, and concrete that mimicked the old, even though the two houses had nothing else in common. That complicated life for project engineer William Faschan, who made all the calculations and pared the steel down to a graceful minimum. At times it became a game. "We kept the old electrical meter on a four-by-five-foot section of an original wall," recalls Zapata. "The fragment had no function, and shared the same base as a new inclined wall, but as long as the meter was running, the inspector was happy."

The house is set well back from the street behind a high hedge, and the entry facade is impassive. A walkway crosses a lotus pond to the front door, and an onyx screen filters the glow of the setting sun and surrounds clear glass windows. Behind is a dramatic staircase with treads that are cantilevered from a concrete wall and wrapped in steel. Narrow slits pull light into the four bedrooms. The rear facade of the house, by contrast, is open and inviting, with expansive windows overlooking

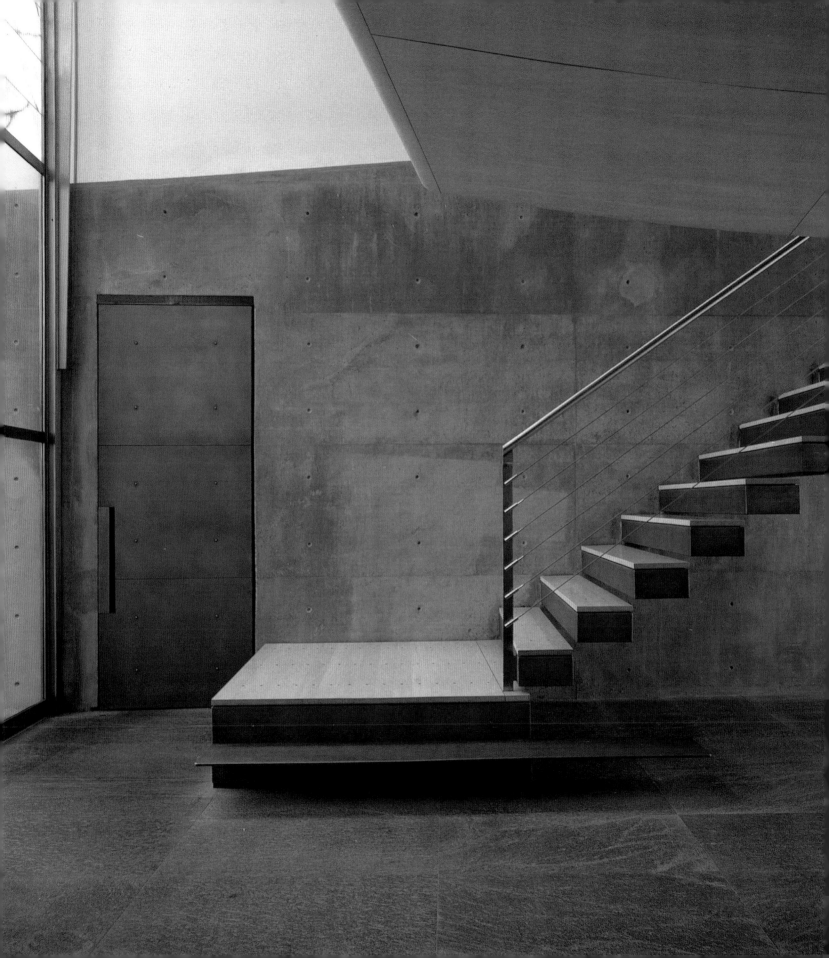

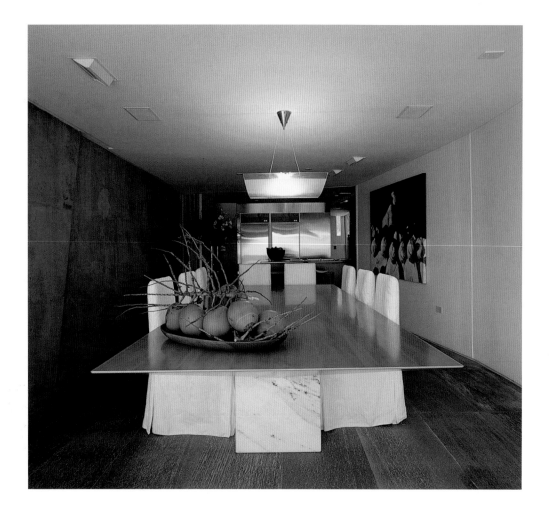

34

the pool, dense vegetation, and the beach. The two-story guest cottage plays variations on the angular geometry of the house.

A double-height living room with a green slate floor extending out to the terrace separates the upstairs master suite from the children's wing. These free-flowing spaces and intimate private areas are furnished with a pleasing mix of warm and cool materials that play off the exposed steel and concrete. Catalina Echavarria's company, Una Idea, designed the pearwood cabinetry and soft comfortable sofas, besides selecting the natural fibers and sisal carpets.

Though startlingly different from its neighbors, the house responds to the challenge that confronts every oceanfront house: protection from and openness to nature (Hurricane Andrew narrowly missed the site during construction), a vantage

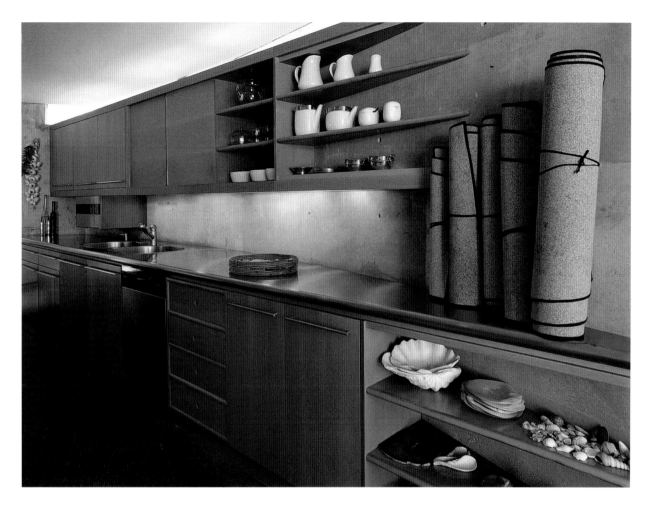

point, and a retreat from the glare of sun, sand, and sea. In all these ways, it's a house that's rooted in Florida, controlling the brilliance of the light and exploiting the heat.

Zapata has since moved his practice to Boston and has recently completed a far more subdued house at the eastern tip of Long Island. However, this first venture gave him a laboratory to test his ideas. "Tilting and distorting volumes gives a space character and personality," he explains. "With shifted and accidental fragments, you generate a lot of views that escape the volume. When you open and tilt spaces, you allow light in through the cracks, and spaces start to move." The Landeses embraced this novel experience for as long as they lived there, and Catalina Echavarria felt that the house "captured some of the magic of South America, with its unconventional excess of imagination."

Miami Beach
Burke house
Mike Burke, 1995–

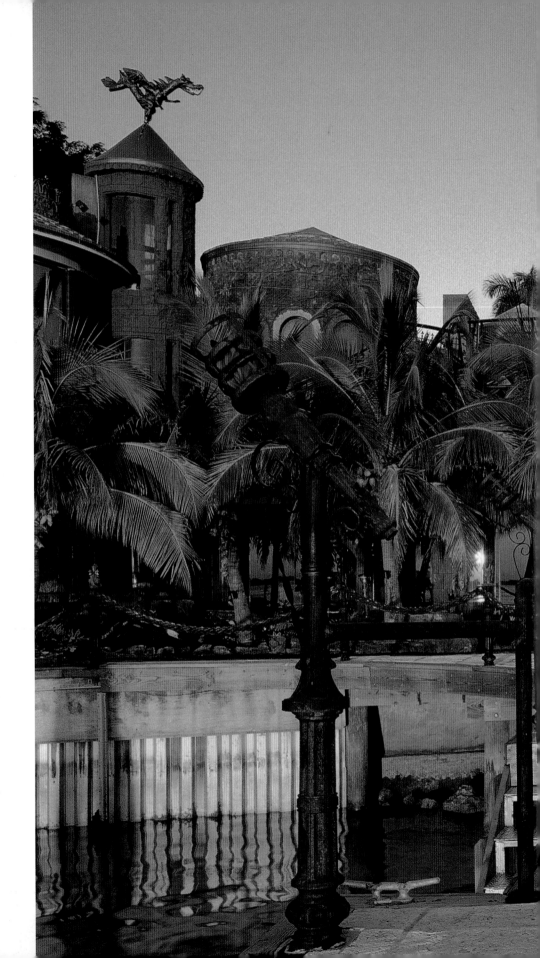

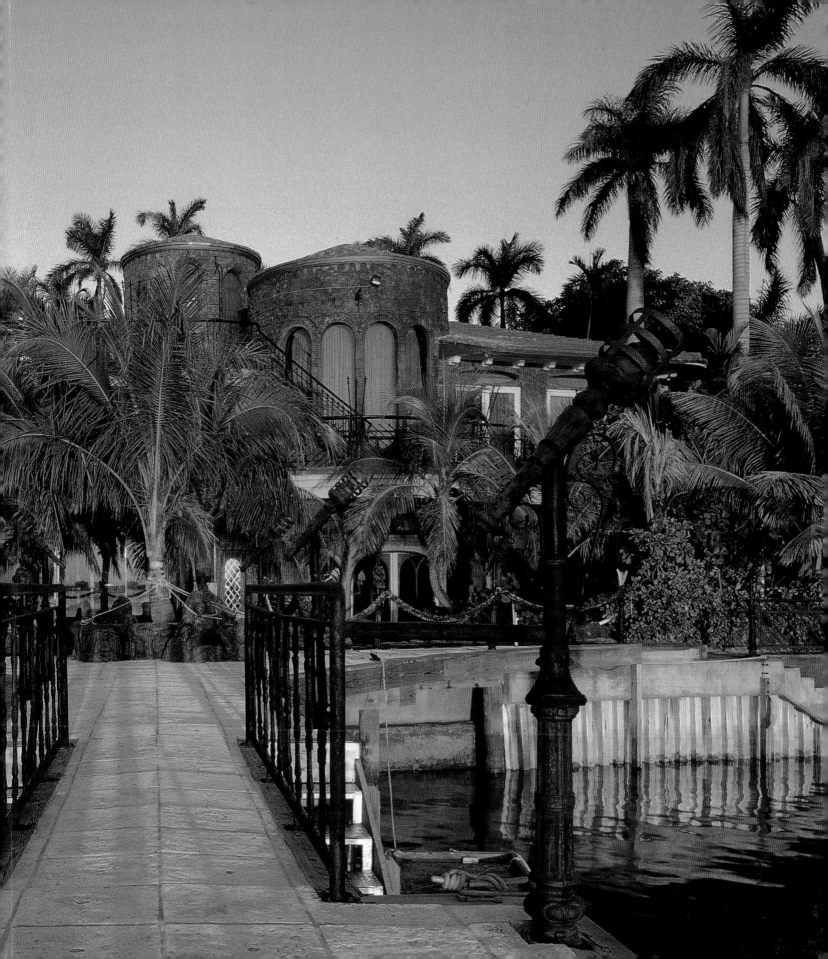

"Growing up in New Jersey during the Depression, I read everything I could find about King Arthur and imagined myself as one of his knights," says Mike Burke, the weathered captain of a fleet of windjammers. "Now I've dropped anchor and can relive those fantasies in a house I've been building for five years."

The Addams family mansion has nothing on Burke's fantastic castle of molded concrete—a startling neighbor to dignified Spanish-style estates on a quiet residential street. The Gothic gate tower and portcullis are flanked by walls that writhe with crocodiles and octopi, demons and djinns, armored knights and maidens fair. Palms and a banyan tree shade the forecourt. Massive chains line the footpaths around a pool where nine-foot sharks glide hungrily below the footbridges and a giant moray eel glides out furtively at night.

An arched entry leads into a great hall with a gallery, massive carved furniture, tapestries, and armor. A window wall slides open onto a free-form rock swimming pool with waterfalls, shaded by coconut palms. Footbridges lead to a torchlit terrace and jetty. This safe haven for a not-so-ancient mariner is located a few miles and a world away from the ocean beaches, glitzy hotels, and colorful Art Deco district of South Miami Beach. It faces out over the inland waterway to enjoy calm seas, spectacular sunsets, and a distant view of downtown towers.

Burke's whole life has been a maritime adventure. He learned to sail at age fifteen and spent the Second World War on submarines. To celebrate his release, he went on a drunken binge in Miami and awoke on board a nineteen-foot sloop, which he had bought unknowingly with his navy severance pay. Weekend sails with friends kindled a passion for the ocean. "It's the ultimate challenge to match yourself against the sea," he declares. "I've been in three hurricanes and never thought they could hurt me until I lost a three-hundred-foot schooner and thirty of my friends. The ocean can also be beautiful and caress you. Like a fish, I feel more comfortable in water than ashore." For Burke, sailing began as a hobby and became a full-time business. As the head of Windjammer Barefoot Cruises, he claims to own the world's largest fleet of tall-masted sailing ships—a dozen in all—which carry other adventurers around the Caribbean.

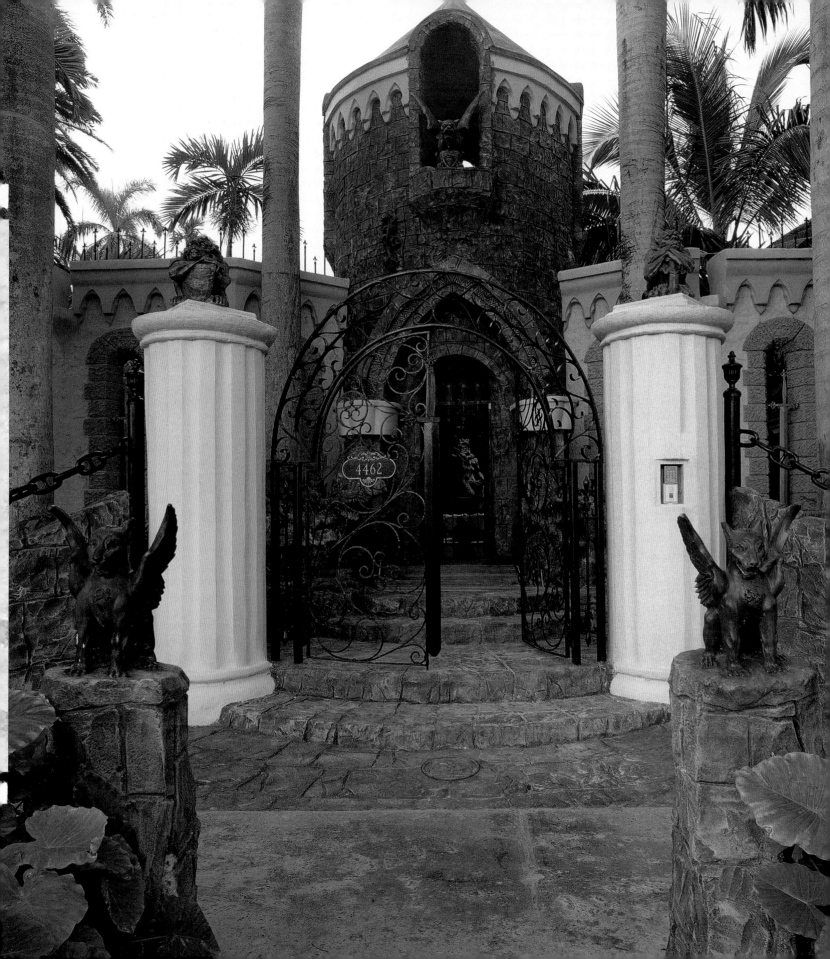

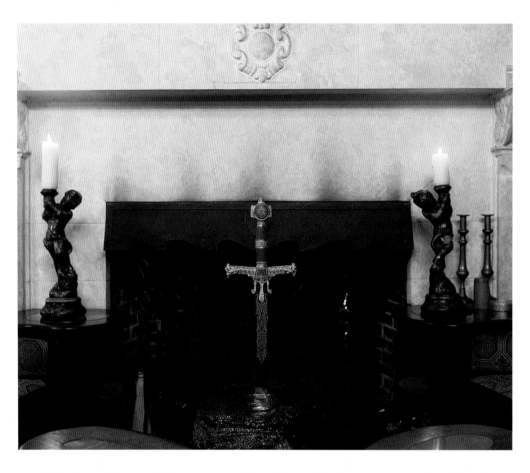

The house is a work in progress and a self-portrait. In contrast to the refined, architect-designed residences that fill these pages, Burke designed his by intuition, making it up as he went along, and drawing on the native skills of the West Indians who build his ships in Trinidad. Like a ship it's constructed to withstand storms, and there is enough steel reinforcement in the poured concrete to support ten stories. The concrete was shaped and carved, and impressed while wet with keystone to give it the look of an old Caribbean sugar mill.

The interior is even more eclectic: half castle, half galleon, constructed of oak, teak, cedar, and pine. Palms in planters rise to the pitched vault of the great hall, with its oxblood walls and carved wood chandelier. An inglenook embraces the soaring hearth, where one could roast a whole ox on a spit, and the place of honor in front of the fire is occupied by Excalibur, a sword set in a stone. It's a favorite treat for Burke's eighteen grandchildren to try to pull it out as Lancelot did at the court of King Arthur.

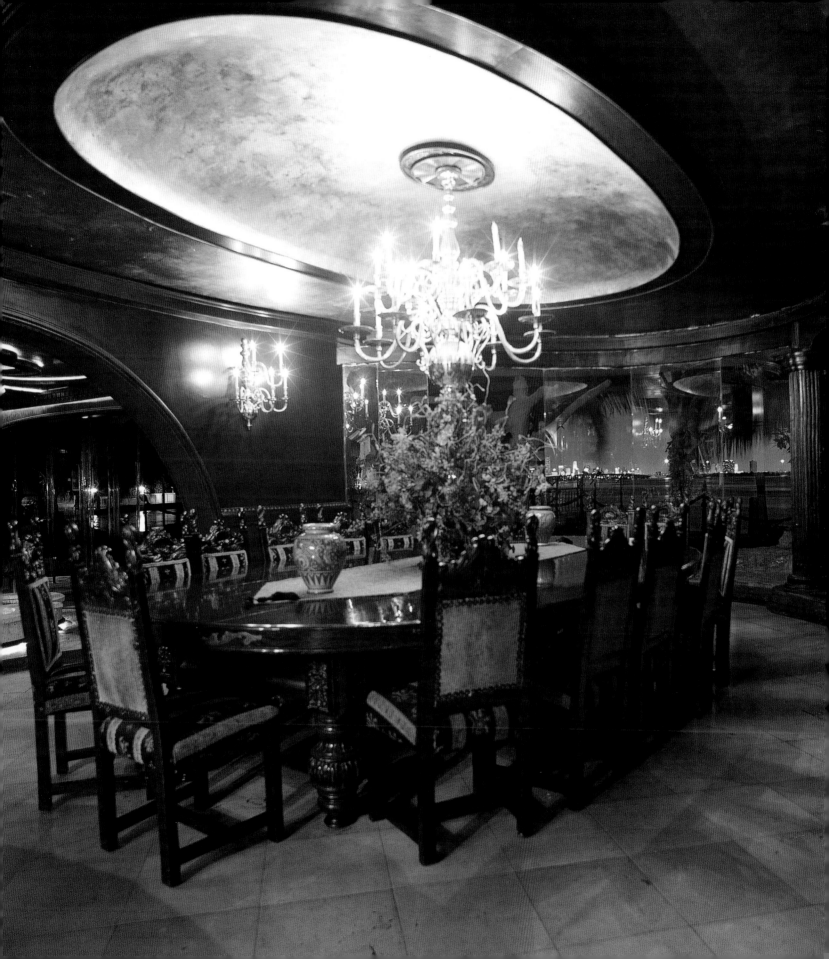

Burke tells them to pray to Merlin for strength—then quietly releases the electro-magnetic clip that secures the sword.

Arches lead to a billiards room and to the formal dining room with its richly carved Jacobean glass-fronted china closet, brought over from England. Armchairs are grouped around a Renaissance-style quatrefoil fountain, with a concrete floor, simulating stone, ornamented with the impressions of starfish and other marine creatures. Upstairs are the captain's quarters: a circular bed in a skylit rotunda backed by a carved satyr pursuing a nymph, and a circular glass bathroom with concentric circles inlaid in the floor as though a pebble were sending ripples across a pond. There's also an octagonal dining room in which every guest has a niche, and Gothic windows command a sweeping view of the bay. We are reminded that King Arthur was the product of Celtic legend, living near the edge of the known world with an ocean beyond, (and Burke occupies a land that was long regarded as mythical).

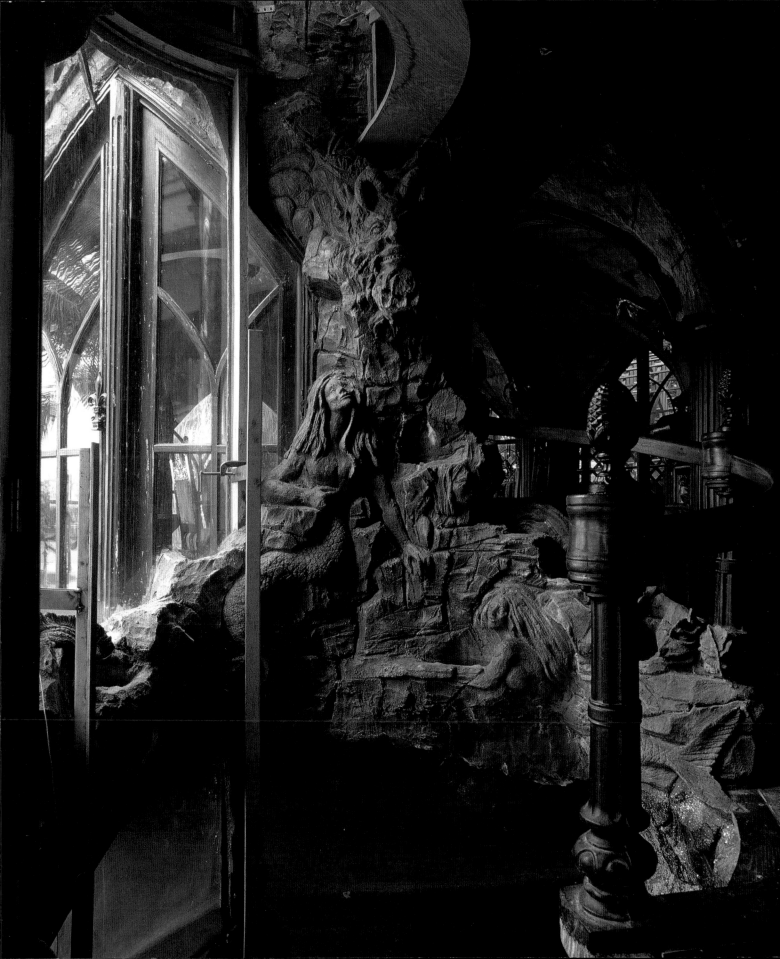

The Northeast

The Hamptons

Every era has its fashionable resorts. A century ago, the Eastern establishment summered in the Adirondacks and Newport, and wintered in Florida or Pasadena.

Now the smart set is more likely to be found skiing in the Rockies or Europe in winter and spending the dog days on Martha's Vineyard, Nantucket, or in the Hamptons—an elastic term, comprising a string of sprawling villages along the Atlantic shore. The Colonial British settlements of Westhampton, Southampton, Bridgehampton, and East Hampton alternate with Sagaponack, Amagansett, and Montauk—places that were formerly settled by the Montauk tribe of Native Americans.

In the 1920s, when the trip from Manhattan to the tip of Long Island was even more taxing (though less trafficked) than it is today, the Gold Coast was located on the near-north shore, a mere twenty miles from the city. In *The Great Gatsby,* F. Scott Fitzgerald placed Tom and Daisy Buchanan in fictional East Egg, a peninsula jutting into the Sound, where rich friends brought their yachts and stayed for weeks. Now New York's movers and shakers (plus those who merely vibrate in sympathy) are to be found every summer crawling along narrow roads in their own cars or the Hampton jitney, unless they have the means to fly, for frenzied weekends or an August rental.

This ordeal has a payoff. Getting to the Hamptons is hellish, and the expense ruinous, but the place can put you very close to heaven. Development is controlled, the sandy beaches are pristine, and the air is still pure. There's delicious local produce and cuisine, and a lively social scene. It's not for everyone. A recent *New Yorker* cover showed a beach with an unsmiling gatekeeper standing beside a velvet rope, clipboard in hand. Slim figures pose and prance on the sand; an overweight couple, she in orange, he in black socks, are about to be turned away. The reality is almost as daunting. You could be rail thin and wearing Armani yet still not be allowed to park at the shore without a resident's permit. Those who consider this undemocratic are welcome at Jones Beach, a mere thirty minutes from the city, where the sand and ocean are just as beautiful— if you can see them for the crowd.

What makes the Hamptons so desirable is their combination of remoteness and sophistication. You can be jammed into a bar that seems to have strayed in from TriBeCa or the Upper East Side, then step outside and stroll along a beach with nothing but curlews for company. And for every pretentious McMansion, there's a relic of the days when this was farming country, full of barns and windmills, with a few modestly scaled summer houses. Tranquil ponds and inlets alternate with ocean beaches and dunes that are protected from wind and waves by open fences and long grasses. The memory of these idyllic settings and the contrast they offer to urban life, as well as the clambakes, fresh strawberries, and luminous summer evenings give this stretch of shore an irresistible allure.

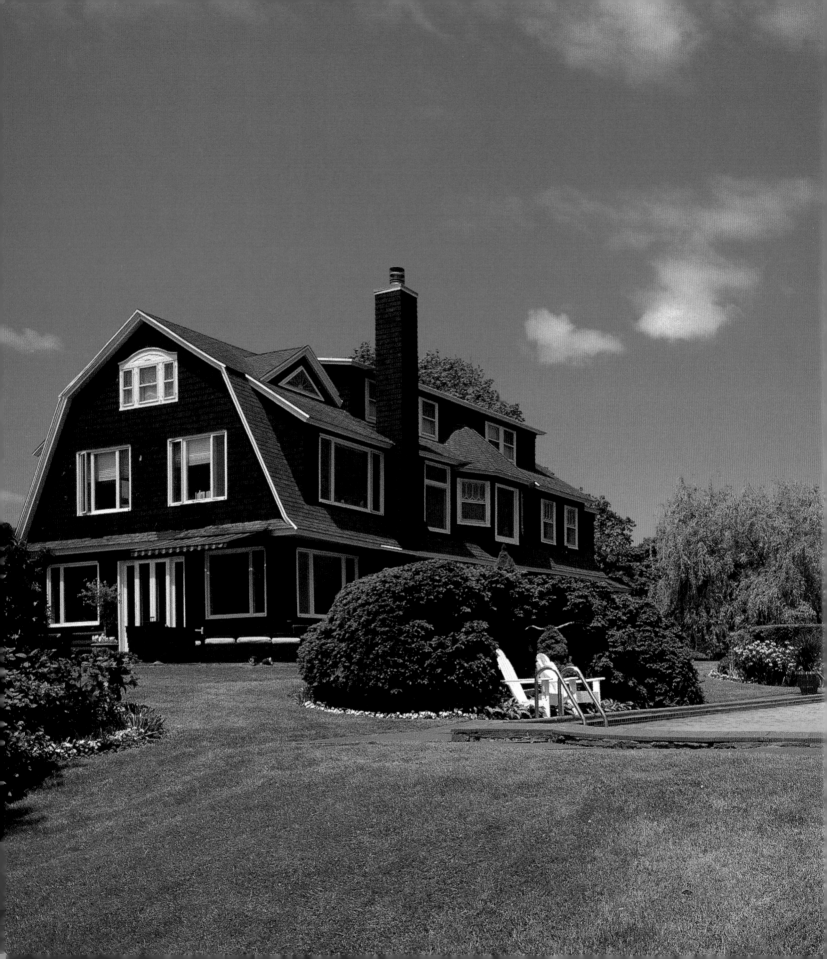

Quogue
Scaladd house
1910

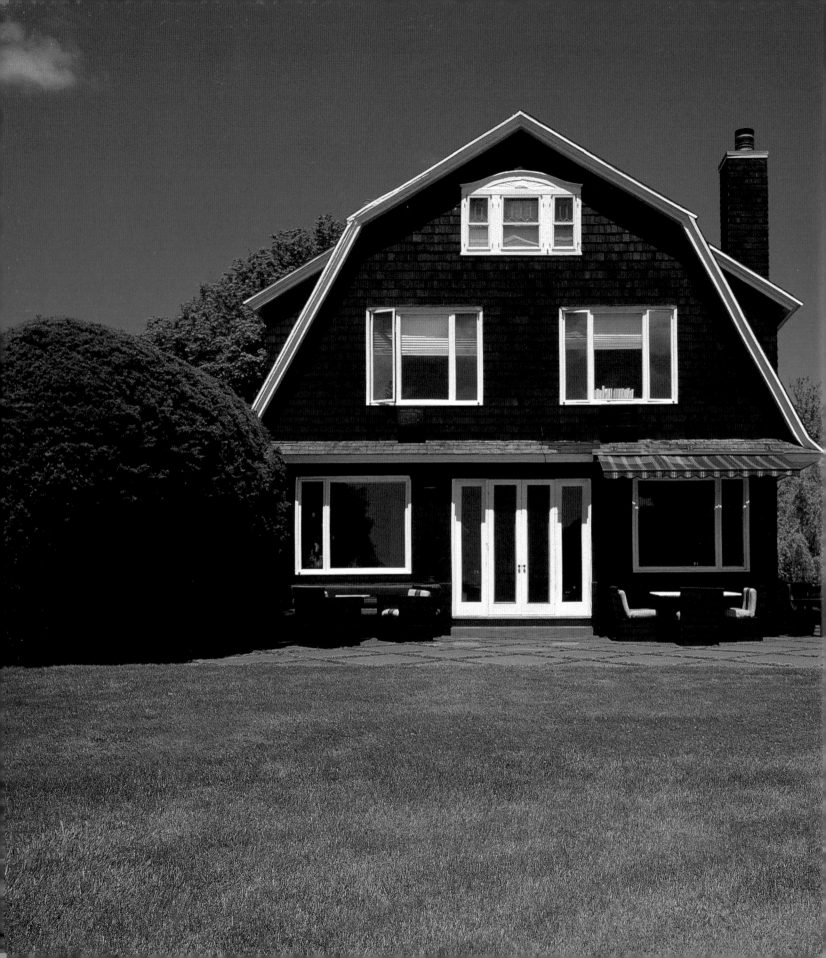

Fashion designer Arnold Scaasi and his partner, Parker Ladd, had been living in New York's West Village and looking for a place on the water within easy reach of the city when they spotted this shingled house from the far side of a narrow inlet that borders it on two sides and leads into Shinnecock Bay. (The inlet was originally a pond, but the destructive hurricane of 1938 breached the sandbar and the water has been salt ever since.) The house, with its gambrel roof studded with dormers and a tall chimney, was built in 1910 by the uncle of actor Robert Montgomery and evoked the farm it had replaced. It was tightly shuttered, and the realtor insisted that the owners would never sell.

"He showed us other houses, but we kept bringing him back here," recalls Scaasi. "Finally, in 1974, the owner died, we bought it at once, and finally got to see the interiors—cheap fake wood and pea-green paint. I was horrified." He rose to the challenge and friends proffered advice. Louise Nevelson suggested that the exterior be painted black—like her sculptures—with white trim. Scaasi added the black-shingled club chairs that look like a miniature of the house and roll around the patio on casters. He also sacrificed the tennis court to excavate a pool, which is bordered with red tiles. The late decorator Chessy Rayner proposed that the ugly Gothic fireplace be removed. That opened up the entry hall to the porch, which was enclosed to become one-half of an expansive living room.

Scaasi is known for the brilliant colors of his couture clothes, and he brought that same adventurous palette to the interior. Sizzling red upholstery sets off the white walls and columns of the living room. The large white-beamed dining room, which bustles with summer guests, has a Matisse-like blue and white paper on walls and ceiling to complement Thonet café chairs, and the black and gold papier-mâché

51

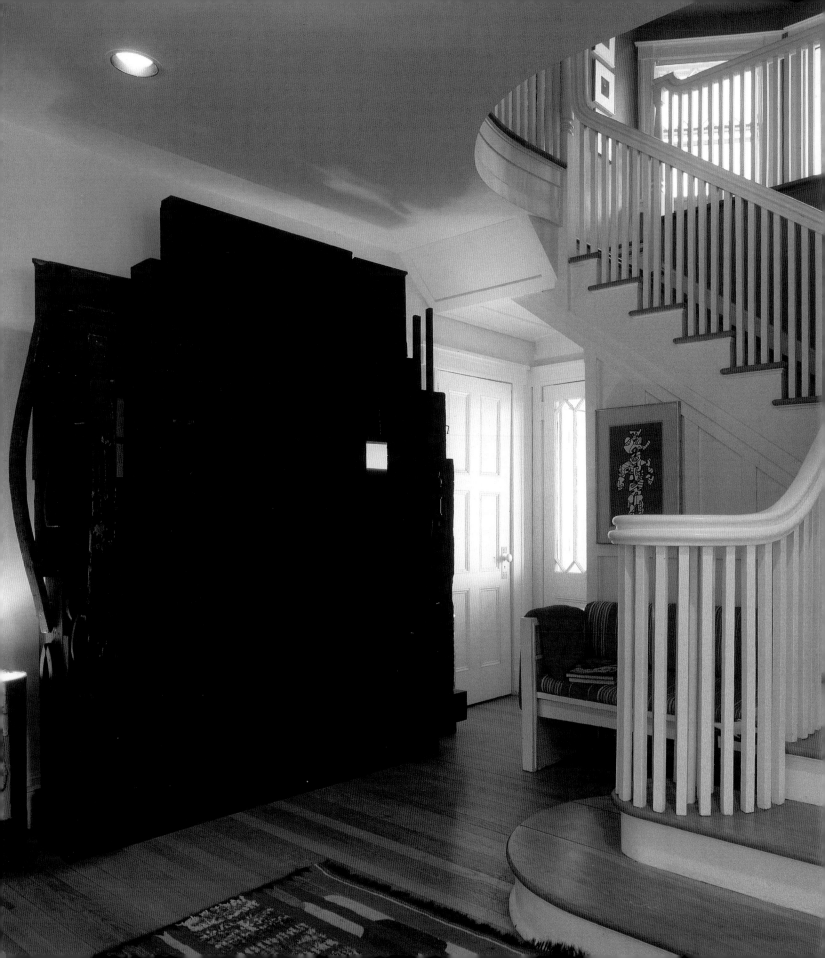

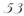

armchairs and sofa that represent an early-nineteenth-century English love of chinoiserie. Notable works by Warhol, Dubuffet, and Nevelson were collected before the art market soared.

Upstairs, the colors achieve psychedelic intensity. The stair hall is lacquered scarlet in contrast to the white of the elegant balustrade. Bedroom doors are chrome yellow; one room is all blue, another green. It's a brilliant strategy, for the colors provide a joyful lift on wakening, or drive you from bed to enjoy the vistas of garden and water that unroll so enticingly from every window. And their intensity throws everything into sharp relief—not least the facade of the house, which would have won approval from the Pilgrim fathers for its sobriety.

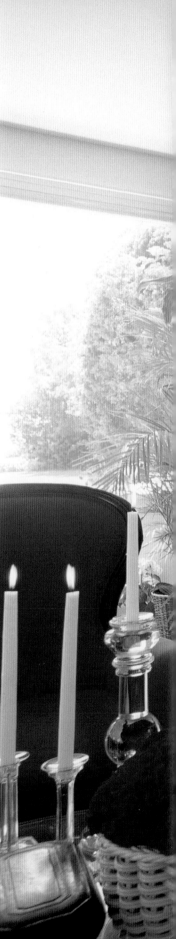

Southampton
Ertegun house
Cooper, Robertson & Partners,
1990–92

Ahmet Ertegun, the chairman of Atlantic Records, and his wife, Mica, who cofounded the interior design firm of Mac II, are at home everywhere in the world, but one of their favorite retreats in which to unwind and entertain their friends is this handsome waterfront house in Southampton. It is located on a meadow leading down to the reed-fringed shore of an inlet off Shinnecock Bay, and looks across to undeveloped wetlands. The melancholy beauty of the site reminded Mica Ertegun of the Russia of Chekhov and Pushkin, and of the lazy hours those writers spent communing with nature on their country estates. Her friend, the late Condé Nast art director Alexander Lieberman, was an heir to that tradition and loaned her a book on prerevolutionary Russian dachas. She shared the pictures with three architects, and selected Jaquelin T. Robertson, a native of Virginia, who once wrote, "For me, Jefferson lives, and I can say he is an ever-present mentor."

It was an ideal choice for, in the early nineteenth century, neoclassicism was the fashionable style for the newly independent United States as well as czarist Russia. Architects in both countries came up with fresh interpretations of Palladio's villas. These wood-framed houses, with their shady porticoes and elegant symmetry, have a timeless beauty and lend themselves to very different patterns of living. The style had an equally strong appeal to Ahmet Ertegun, who was born in Turkey, as to his wife, whose family came from Romania, a Russian neighbor.

Mica Ertegun had a clear idea of what she wanted and worked closely with Robertson over two years to achieve it. The H-shaped plan of the house and its extended service wing and pool court reach out into the flat landscape and reduce the bulk of its ten thousand square feet. It is raised on concrete stilts to protect it from freak high tides, and this accommodates a flight of broad steps leading up to the lofty great room in the crossbar of the "H," and the raised, covered deck to the rear. To provide overflow space for entertaining that doubles as an intimate enclave for the owners, a winter garden was added to the great room, separated from the principal volume by a screen of columns, and extending out over part of the terrace.

Two-story wings form the uprights of the "H." The roof is copper, and the wood siding is painted in yellow ocher, a color that is as Russian as borscht, set off by white columns and trim. Close-cropped pear and linden trees are combined with classical urns from Paris to create a formal garden behind the high hedge that shelters the

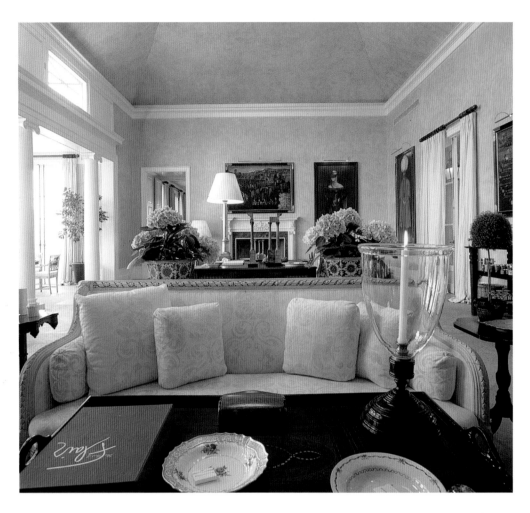

property from the street. The pool is treated as an outdoor room, with a raised wooden deck and a cabana that echoes the house. A boardwalk leads down to a landing stage at the water's edge. "I'm not fond of flowery borders," says Mica Ertegun. "The trees and pool require little maintenance and are nice to look out on, even in winter."

A broad columned hall links the wings to the right and left of the entry, increasing the drama of the double-cube great room with its pyramidal vault and roof lantern. Sandstone pavers are laid diagonally like a great crosshatched carpet, pulling everything together. To achieve the gold-brown glow of the walls and vault, a local craftsman mixed marble dust, pigment, and milk with wet plaster, then waxed and buffed the surface. French windows, shaded by white linen drapes, lead out to the terrace. An eighteenth-century English partners desk anchors the center of the room;

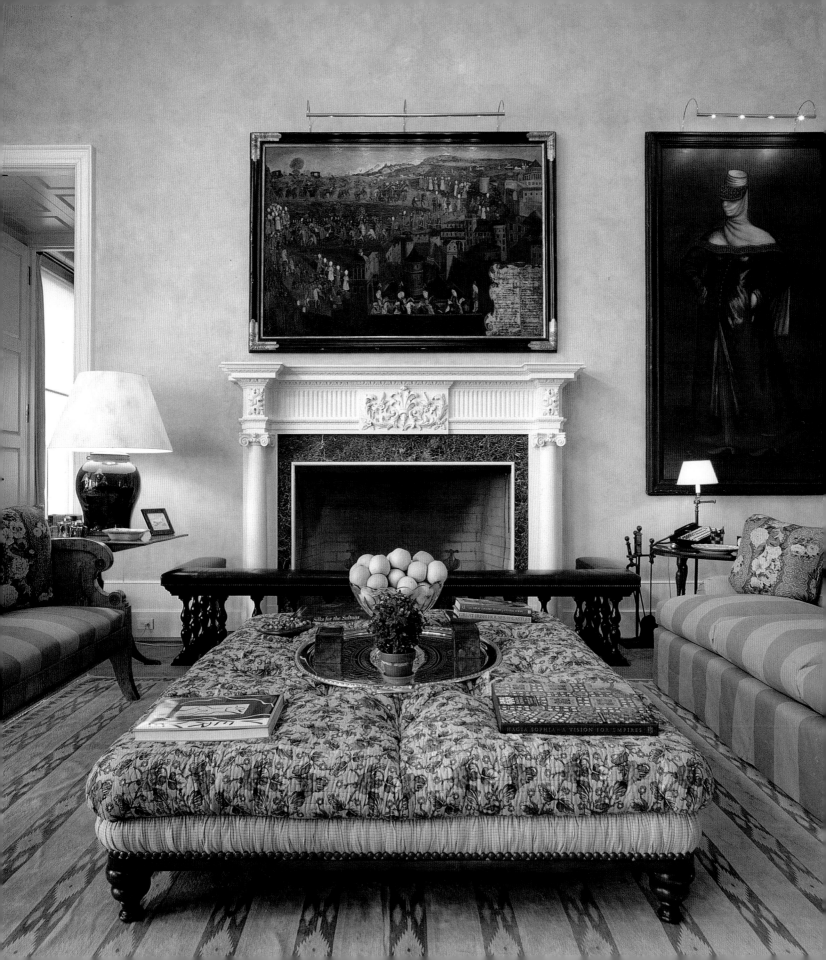

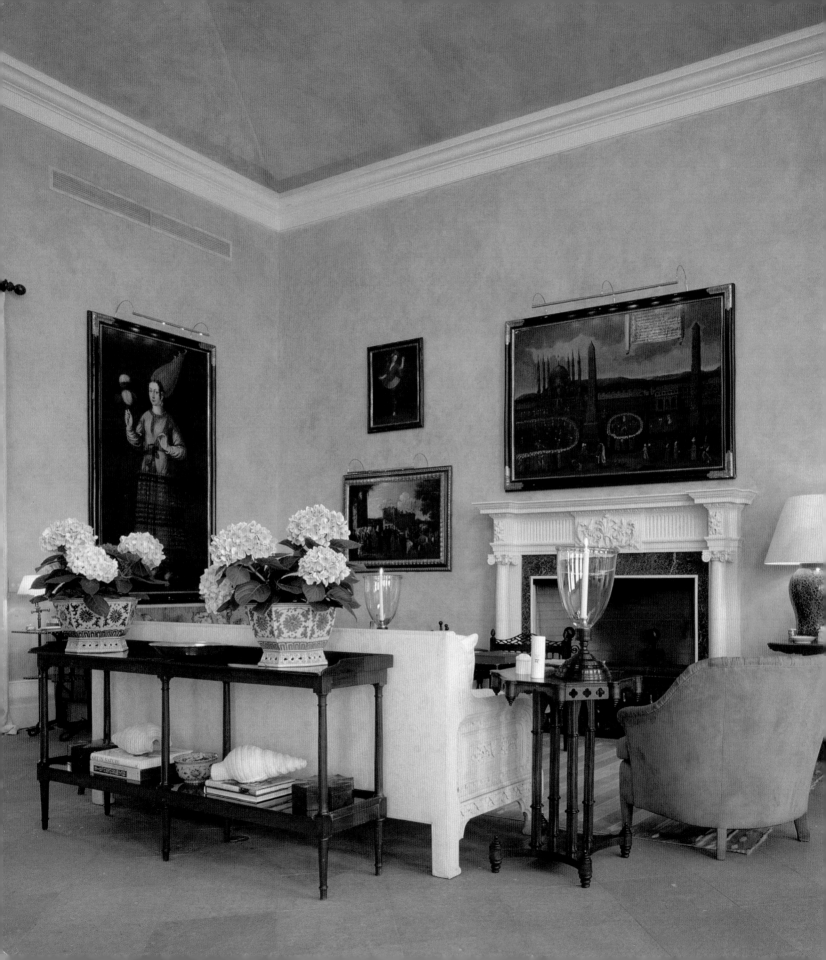

chairs and sofas are arranged around the fireplaces with carved pine mantels to either side. Ottoman portraits and three parade scenes, commissioned in 1620 by the Austrian envoy to the Sultan, remind Ahmet Ertegun of his boyhood at the Turkish embassy in Washington, D.C., where his father was ambassador.

While the great room is certainly the most dramatic, each of the other rooms is a distinctive work of art. Leading off to the north is the low-ceilinged dining room, with aqua walls that Mica Ertegun intended to evoke the patinaed copper of the roof. There's a pleasing mix of modern and traditional: a seagrass carpet on the dark polished wood floor, carved and lacquered furniture with twentieth-century abstract paintings that include a Mondrian. Beyond is an expansive and highly functional kitchen. To the south of the great room is the library, a sanctum that includes a desk inlaid with mother-of-pearl and marquetry, room-height bookcases, and shelves of bleached mahogany set between tall windows and doors. The master bedroom upstairs has a pitch-vaulted ceiling, and its yellow ocher stucco has a trim of dark red to evoke the piping on a campaign tent. Grand yet relaxing, a place to be alone or entertain a crowd, this is no conventional beach house. Yet it responds to the clear light and dappled reflections off the water, becoming a serene oasis in the frenzied lives of its owners.

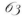

Southampton
Holzer house
Francis Fleetwood,
1999–2000

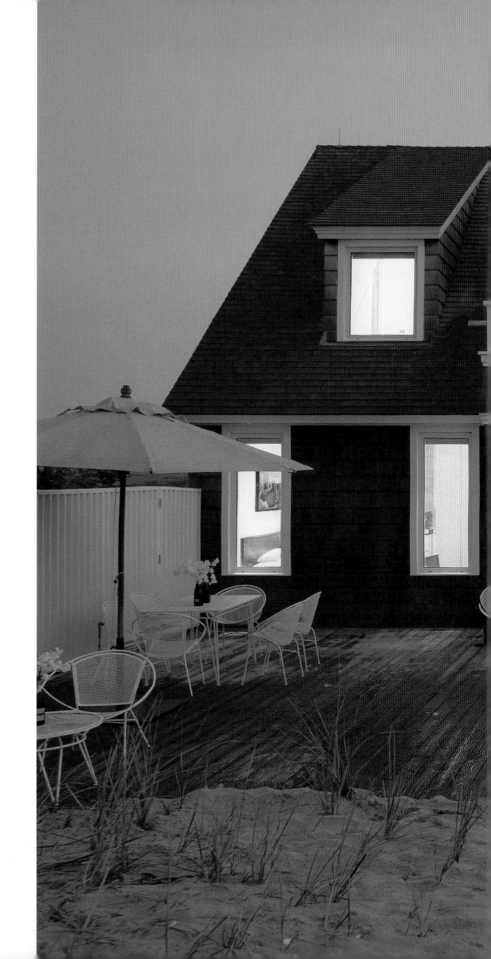

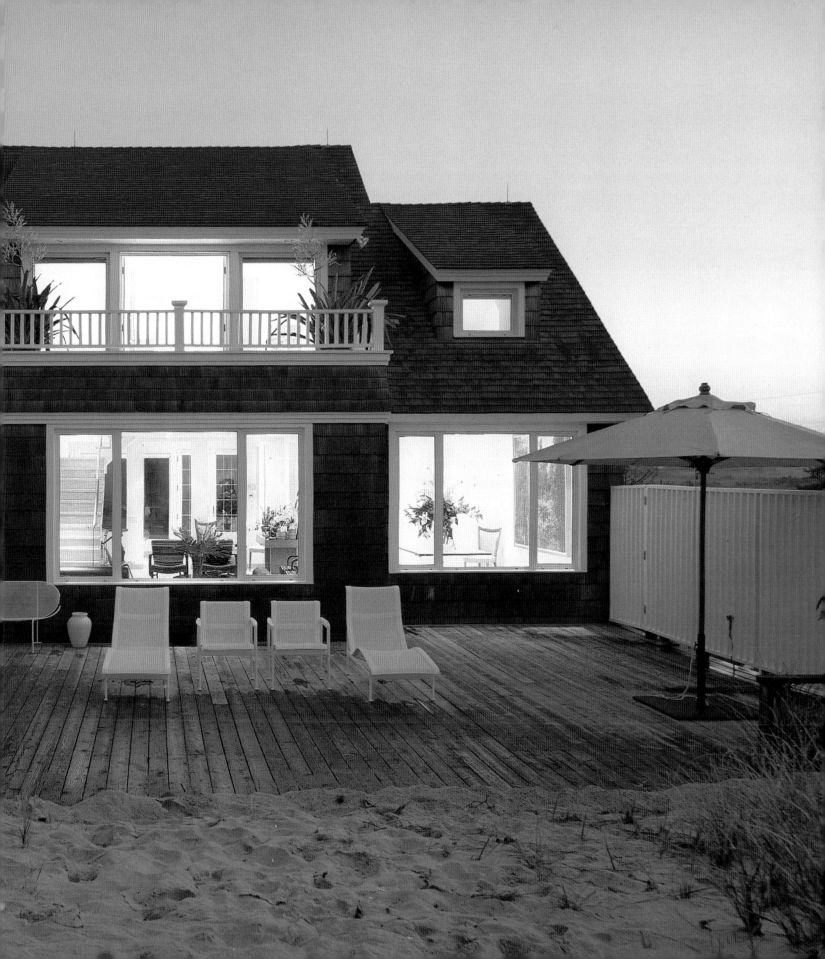

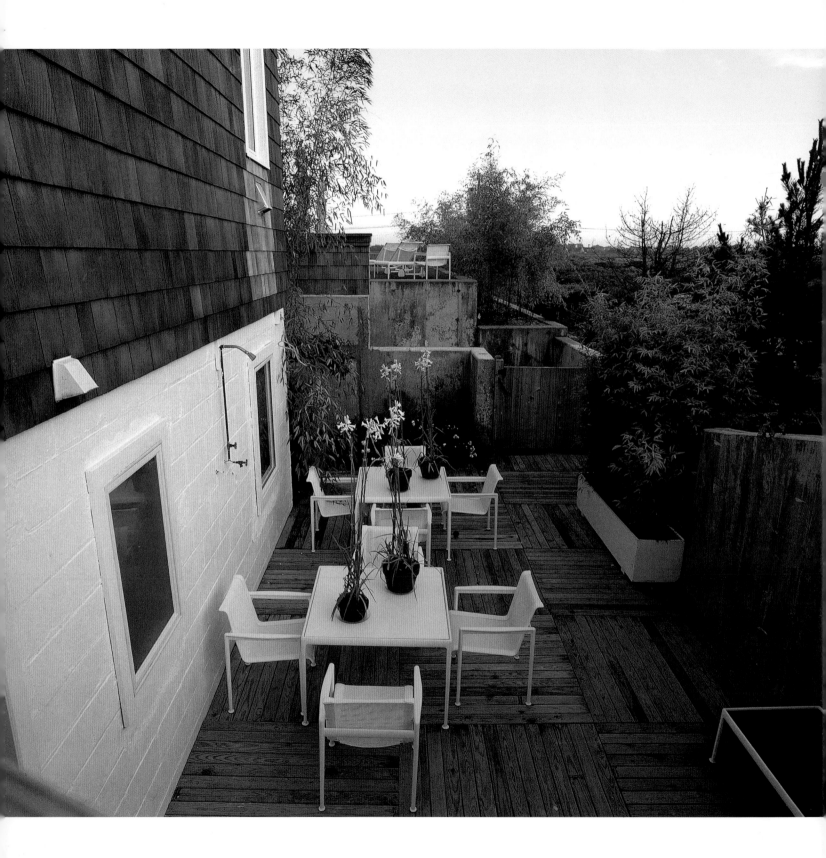

In contrast to the genteel residences we have just explored and the placid water they confront, this is a true sand-between-the-toes beach house, opening directly onto the dunes, a Frisbee throw from the breaking surf. During her marriage, Jane Holzer had lived rather grandly in the Hamptons; now she wanted an intimate, warm-weather retreat from her decorating practice in the city, where she could unwind and entertain friends.

She bought this exposed site with no guarantee that she would be able to install a pool (she did). Nor did she have a clear picture of the kind of house she wanted, leaving it to architect Francis Fleetwood to tear down most of the existing cottage and replace it with a traditional shingled house, with a gable roof, broad dormer, projecting bay, and expansive windows. The living room is similar to the old one, but the kitchen was widened (sacrificing a vintage pink oven), a bedroom was turned into a dining room, and an enclosed porch was added. A major addition is the upstairs master suite that extends to fill the generous volume of the pitched roof. Four guest rooms are located in the existing subbasement, looking out onto a sunken garden with a deck that is sheltered from the wind. A classic shingle-style mansion is her nearest neighbor, and the surroundings have a timeless quality, as though there had never been a building boom in the Hamptons.

"I waited to see what Francis did and then realized my vision within his house," says Holzer. "It was hell to get it built right, even though I was constantly driving out to supervise the contractor, and it took much longer than I had expected and often cost twice as much as it should have because things had to be done over." Her battle for tilt-turn windows, properly installed, became an epic saga. However, eighteen months of frustration led to a joyful fulfillment of the owner's dreams for the interiors. She tried twenty different whites before finding the right bluish tone. She incorporated finds from Palm Beach and Palm Springs, Minneapolis and New York, emphasizing the fifties, but salting her choices with later vintage modern pieces.

Holzer describes herself as "a crazy person who buys whatever she likes and squirrels it away." As a result, each room—including the downstairs guest rooms—expresses the personality of its owner. In the porch, two Samuel Marx sofas are set end to end in front of a unique seventeen-section Eames plywood screen, and "Invisible" Plexi armchairs by the Lavernes float over the polished white vinyl floor. Two Mies daybeds and a quartet of Paul Frankl armchairs flank a James Mount table—all scaled

67

to Andy Warhol's head shot of Botticelli's *Venus*. A nine-foot-long plate-glass table fills most of the dining room, but, like the Plexi chairs, seems to vanish into space. A hand-forged steel rail leads up to the master suite, which features Plexi hanging chairs from Finland, more Marx and Frankl, and a Murano glass chandelier. But the star of the show is a solid marble tub from a Roman settlement in Turkey: a piece of sybaritic excess that had to be brought in by crane and required that the floors be strengthened to prevent it crashing down to the basement.

At night, it's easy to imagine yourself in a Roman penthouse, waiting for Sophia Loren to make her entrance, loll onto a sofa, and light a cigarette in a long holder. By day, the living areas are quintessentially American, open to the salt breezes and filled with friends in shorts and T-shirts, exchanging the latest gossip and mixing long cool drinks. Few houses encompass such different lifestyles with such resounding success.

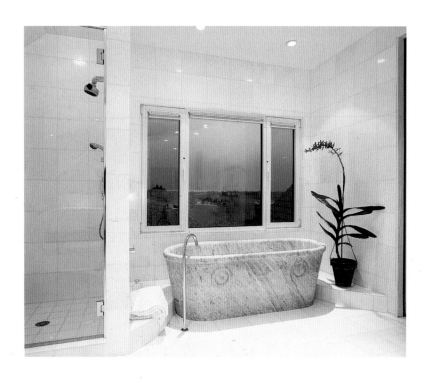

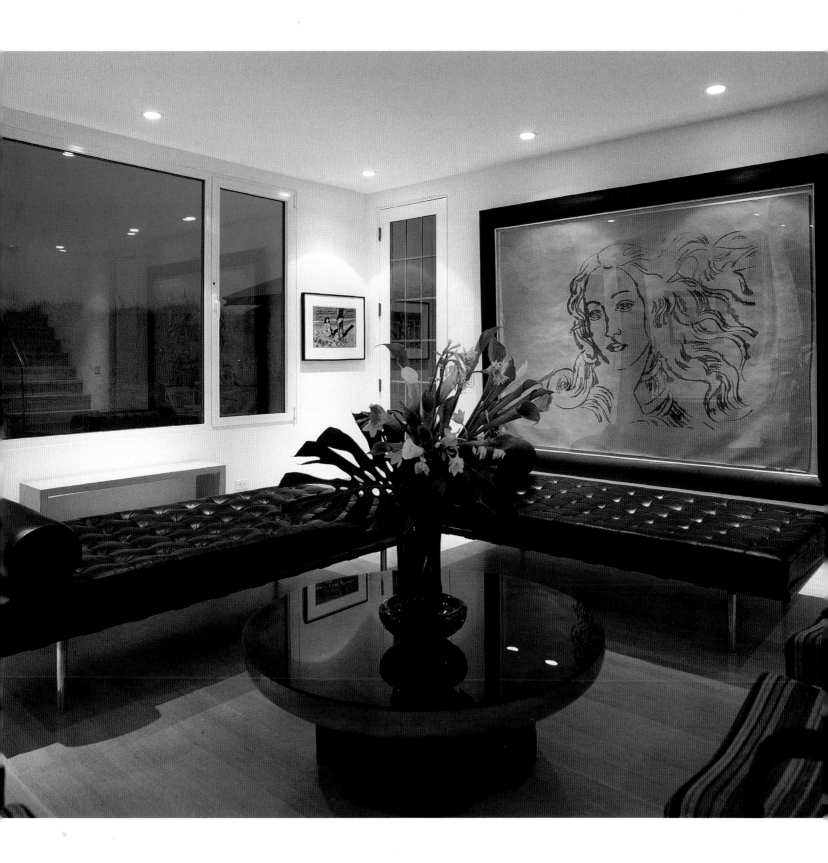

Sagaponack
The Barns
Carlos Brillembourg Architects,
1983–97

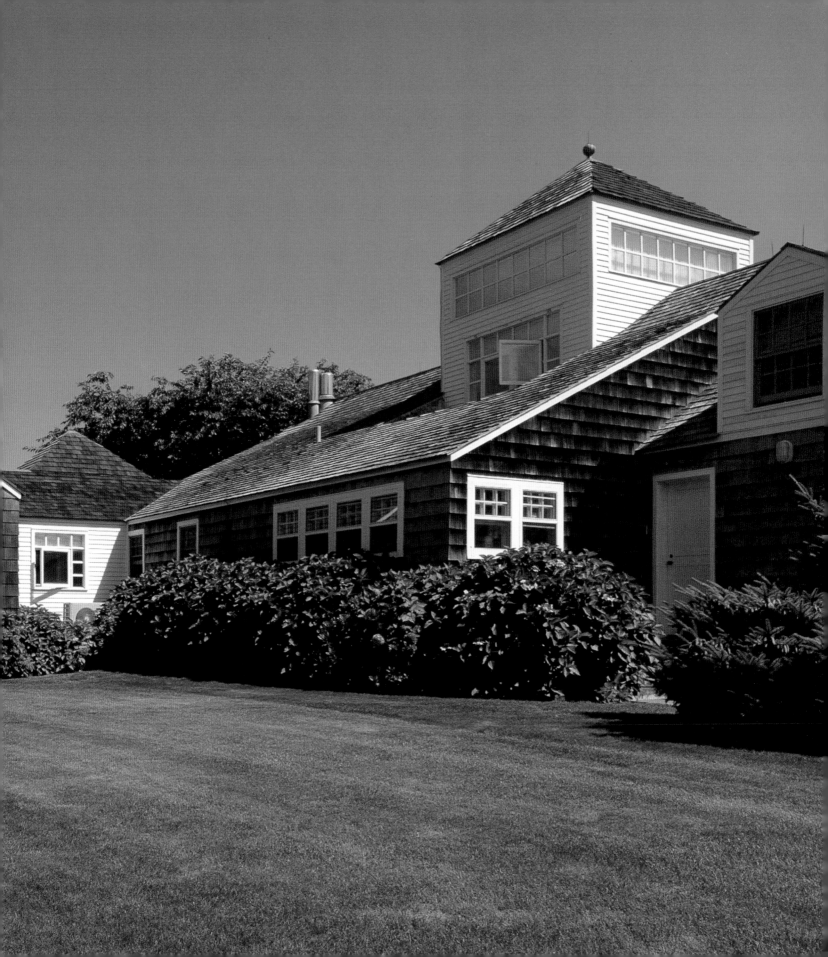

Twenty years ago, Atilio Brillembourg, a Venezuelan businessman living in Gstaad, Switzerland, fell in love with the openness and tranquillity of this rural area, sandwiched between the villages of Southampton and Bridgehampton. A friend had considered buying two old barns brought here from the North Fork of Long Island and set down end to end on a 1.6-acre plot. When the friend dropped out, Atilio called his cousin, who was beginning his architectural practice in the city. "I trust his taste, and wanted to know if Carlos could create a spacious second home within these barns without sacrificing their character," he recalls. The architect rose to the challenge, respecting the integrity of the old structure while subtly transforming it into something new.

The barns were reinforced, and their roofs were insulated and replaced. The larger of the two became a double-height living area, with an off-center porch and a belvedere rising directly behind to pull light down into the center of the house and offer views over the trees to the ocean. Two stories of family and guest bedrooms were shoehorned into the smaller barn, and dormers were inserted into the roof. A pool with a pair of shingled cabanas was set at an angle to the house. Atilio bought a neighboring field and planted the largest trees he could find around the perimeter as protection from whatever might be built beyond. Three years later, a new master bedroom was added to the far corner of the living room, and a pool house with guest rooms above was built at the near end of the pool. A few years ago came another addition: a garage extending from the rear of the house to display a vintage Porsche and other cars the owner had enjoyed racing.

All farms sprout additions as families and their business grow, but here the expansion was more like an artwork in progress. Carlos had a few simple ideas at the outset and stayed true to these. All the additions, except for the cabanas and garage, are painted white to set them off from the weathered cypress shingles of the barns. The white cube of the master bedroom complements that of the tower, and the white grid of the porch and windows is echoed in the open wooden frame that defines a skeletal dining room beneath the belvedere, separating the entry from the living area. Traditional double-hung windows frame the landscape like paintings while flooding the interior with light, and yet, in their purity and scale, they respect the character of the barn. Each of these grids reinforces an axial geometry: the invisible lines of force

that extend through the house and tie its parts together. The same sense of order is carried through the landscaping. A tall hedge conceals the house until you reach the end of the drive, and the angle of the pool defines a wedge of lawn on the far side of the hedge, creating a sense of forced perspective.

The elegant double staircase with its balustrade of tapered rods adds a flourish to an interior that feels entirely relaxed. "It was originally minimalist, but my wife, Marie-Blanche, turned it around," says Atilio. "Being here always makes me happy and gives me an incredible sense of peace. Even out of season, when it's cold, you can hear the ocean and smell it on the wind—this is the greatest outdoor spa in the world."

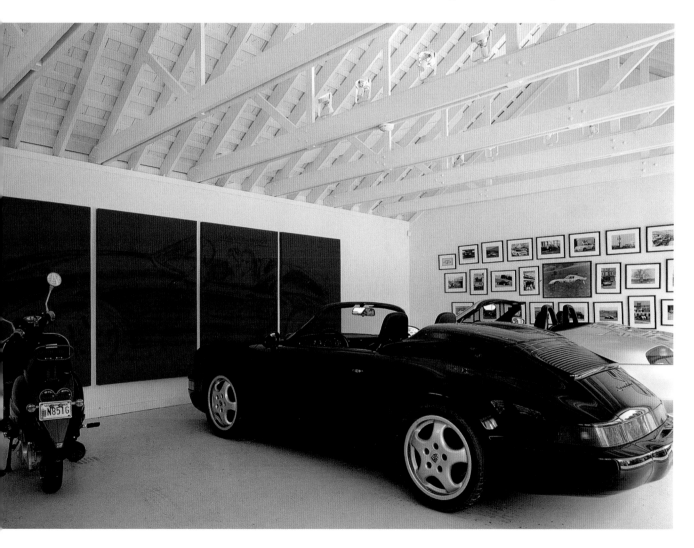

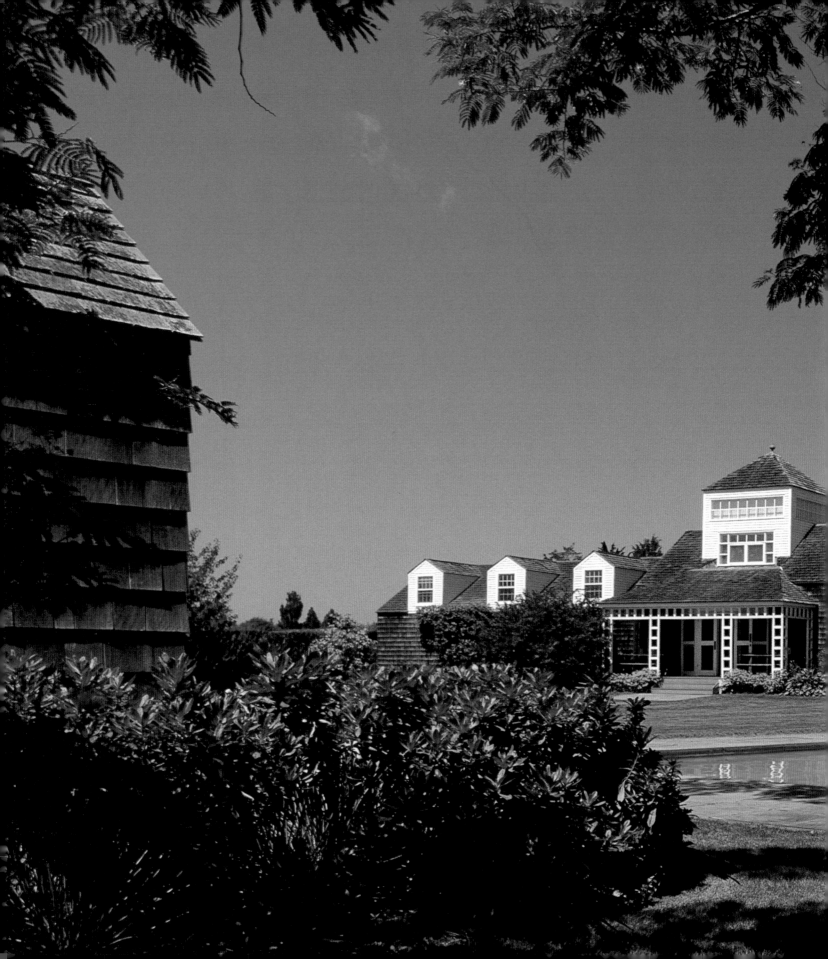

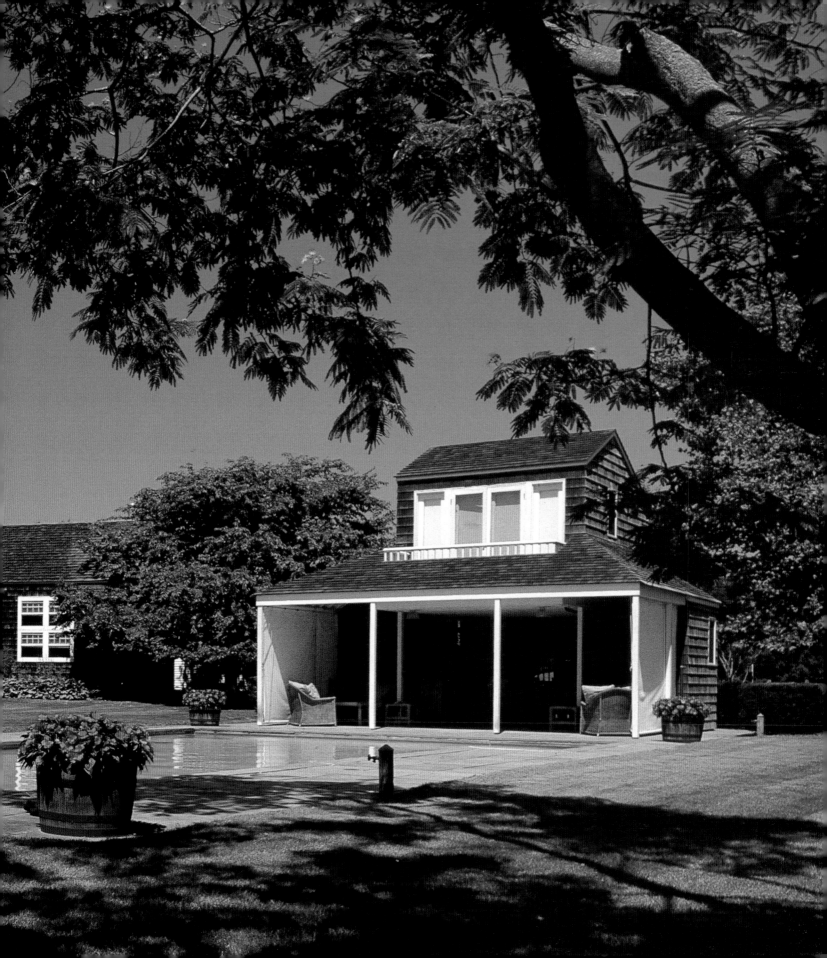

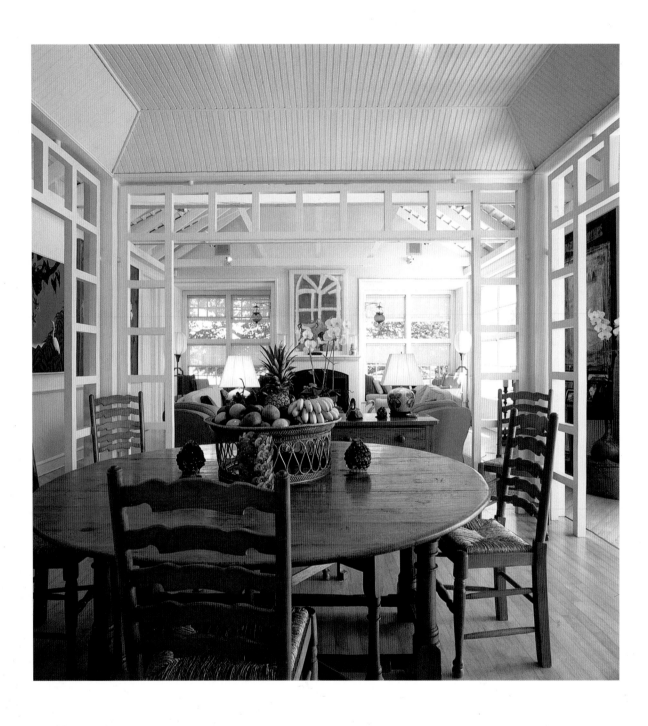

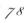

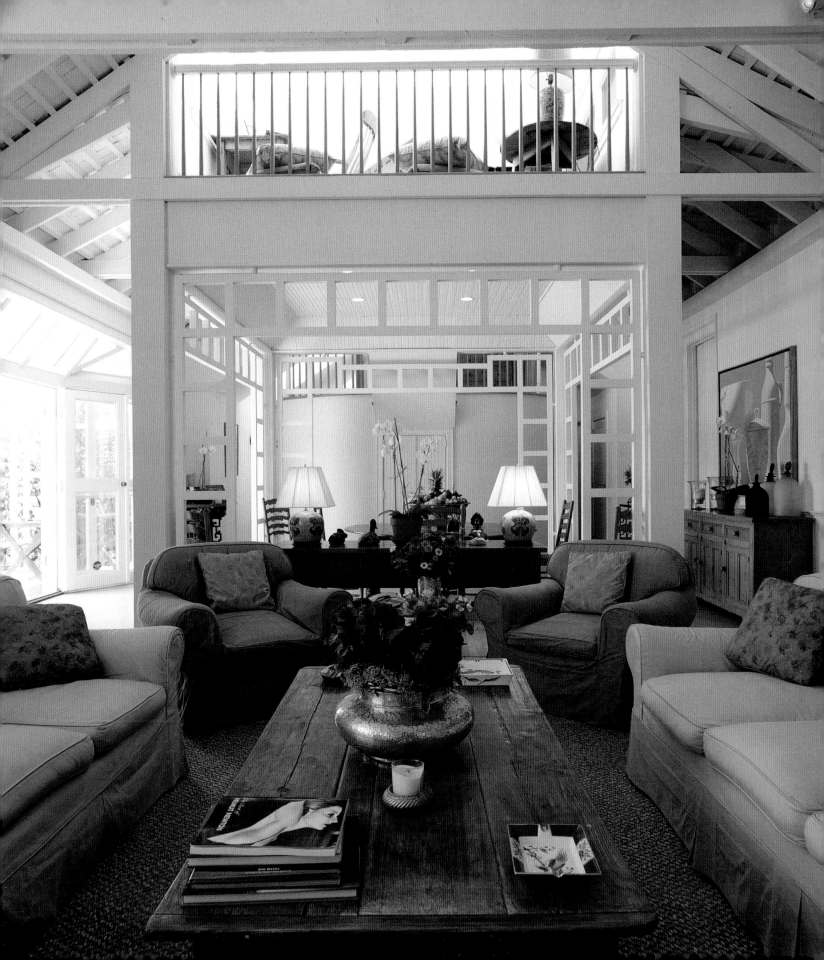

Sagaponack
Villa Amore
Agrest & Gandelsonas Architects,
1989–90

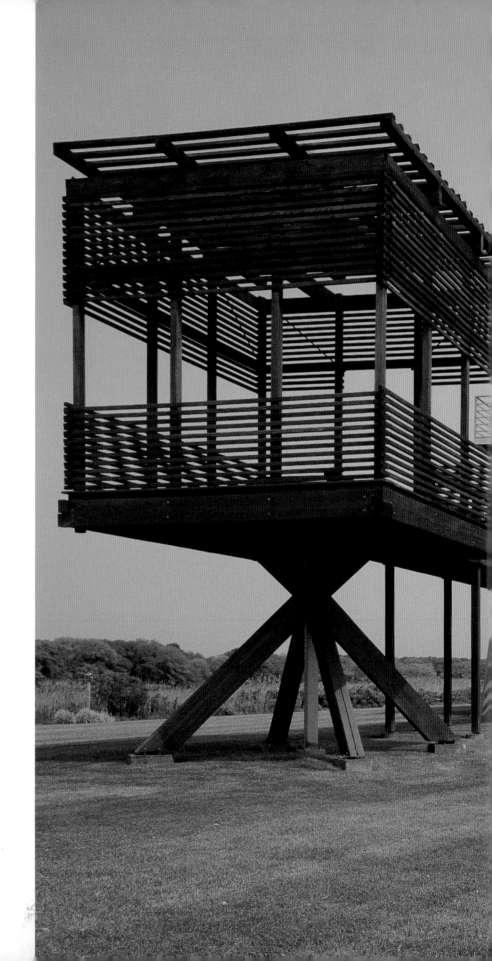

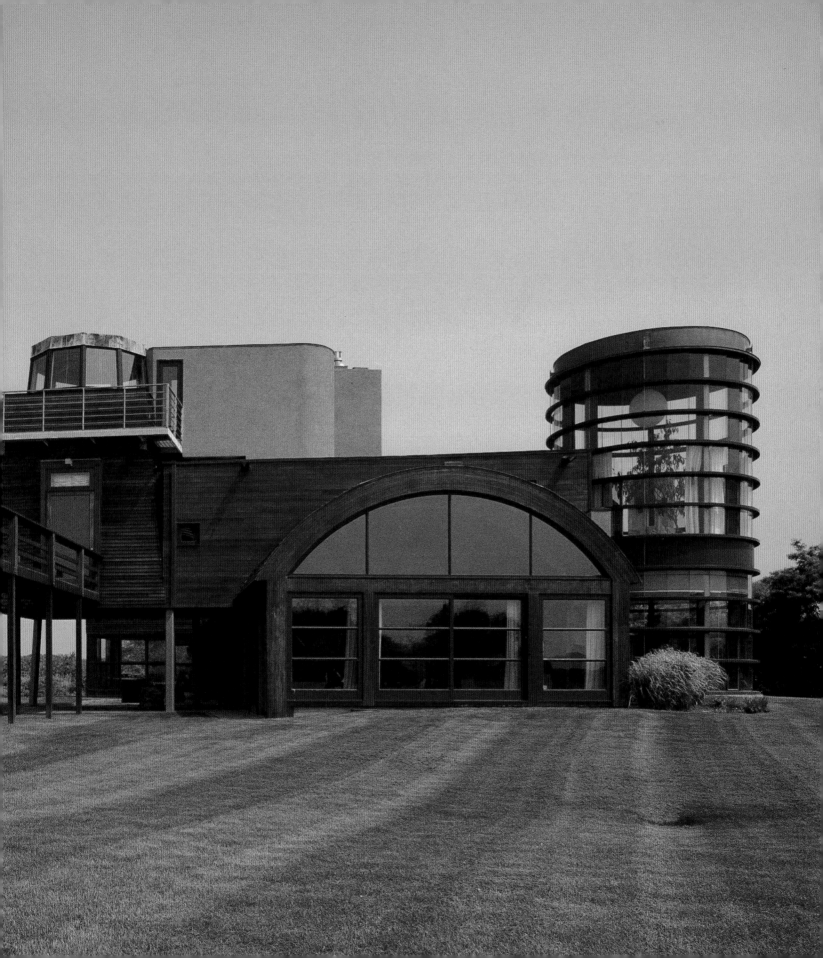

In contrast to The Barns, the Villa Amore is all new, but in spirit it is just as much a part of the rural-maritime vernacular. Richard and Eileen Ekstract asked for a traditional house and got a design that deploys traditional forms but gives them a fresh meaning. Barns and silos, jetties and lighthouses inspired the clustered, interlocking forms of this house, which is set back a mere hundred feet from Sag Pond behind an expanse of lawn and long grasses at the water's edge, with a distant view of the ocean. On this seven-acre site it is hard to believe you are only a few blocks away from heavy traffic, so serene and unspoiled is the vista. Salt and fresh water mingle in the pond, making it a magnet for local and migrating birds, as well as a mirror for the constant shifts of light, especially at sunset.

Poetry and practicality are combined in this unique creation, which is reinforced with steel to withstand winds of up to 130 mph. By fragmenting its 8,500 square feet of enclosed space, the adventurous New York–based architects Diana Agrest and Mario Gandelsonas reduced its mass and gave every room a separate identity and panoramic views. The cluster is much more than the sum of its parts, for each geometric form plays off those it adjoins or intersects, and the relationship of the separate elements changes as you move around them. Thus the second-floor guest wing and master suite cuts through the barrel vault of the spinal living area. Guest rooms at either end are

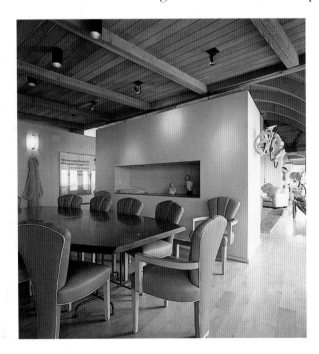

expressed as tiny saltboxes with opposed roofs. The gazebo is treated as an open crate of wood strips in counterpoint to the square tower of the maid's quarters. The transparency of the glass silo is set off by the expanses of wood and stucco.

It's a house that seems to be in a state of arrested motion, propelling you forward, with an easy flow of space between indoors and out through the French windows that wrap the ground floor. A lofty barrel-vaulted ceiling over the living area drops to a low soffit of sandblasted fir over the dining area to achieve intimacy and rises again over the kitchen in

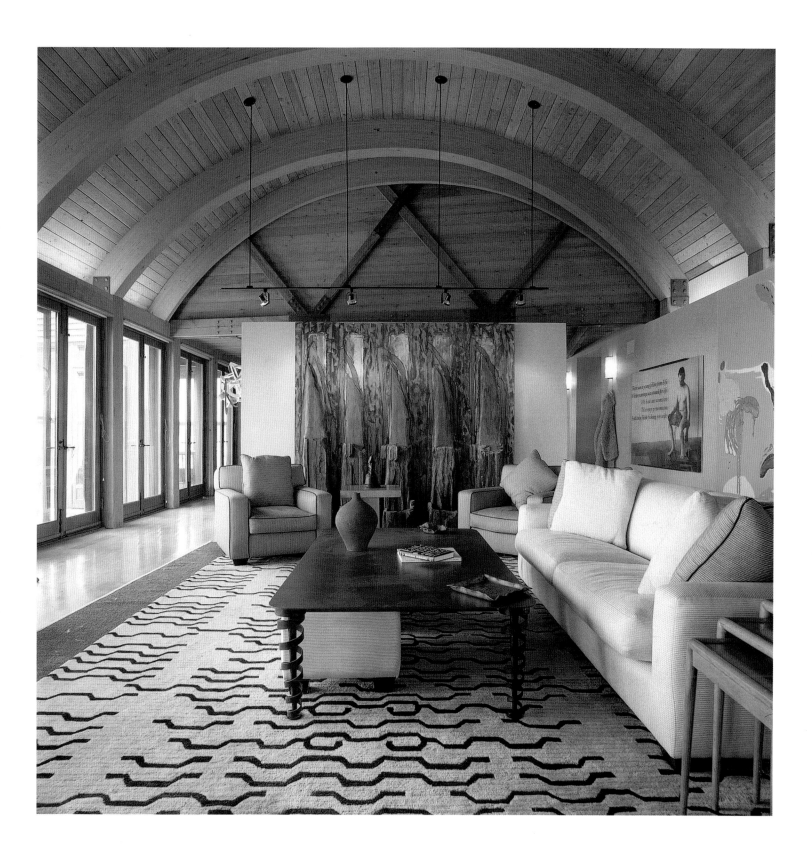

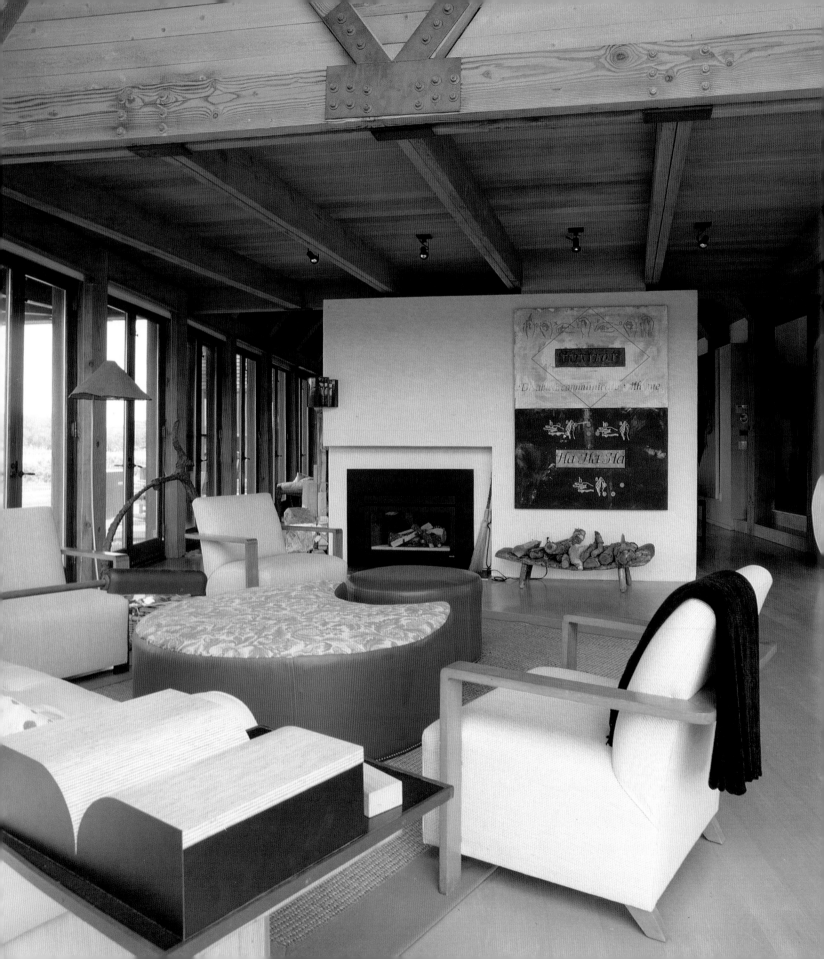

back. The wood strip floor, rough textures, and steel brackets provide a loftlike setting for cutting-edge artworks. The second-floor master suite extends from a circular bathroom in the silo (with a spiral stair leading down to a sunken sitting area) across to a tower with a glass-walled office and widow's walk above. The owners can also stroll out along a pierlike walkway to the gazebo and immerse themselves in the world of nature. Another indoor-outdoor experience is offered by the pool, where two shedlike cabanas emerge at an angle from a curved stucco wall that incorporates a bar.

Looking back at this house from the water, it is easy to imagine that a group of artists decided to pool their resources and live side by side in a row of structures, each of which expressed a different, quirky personality. And yet they come together as naturally as the scattered buildings of a New England farm.

Montauk
Eothen
Rolf Bauhon, 1931

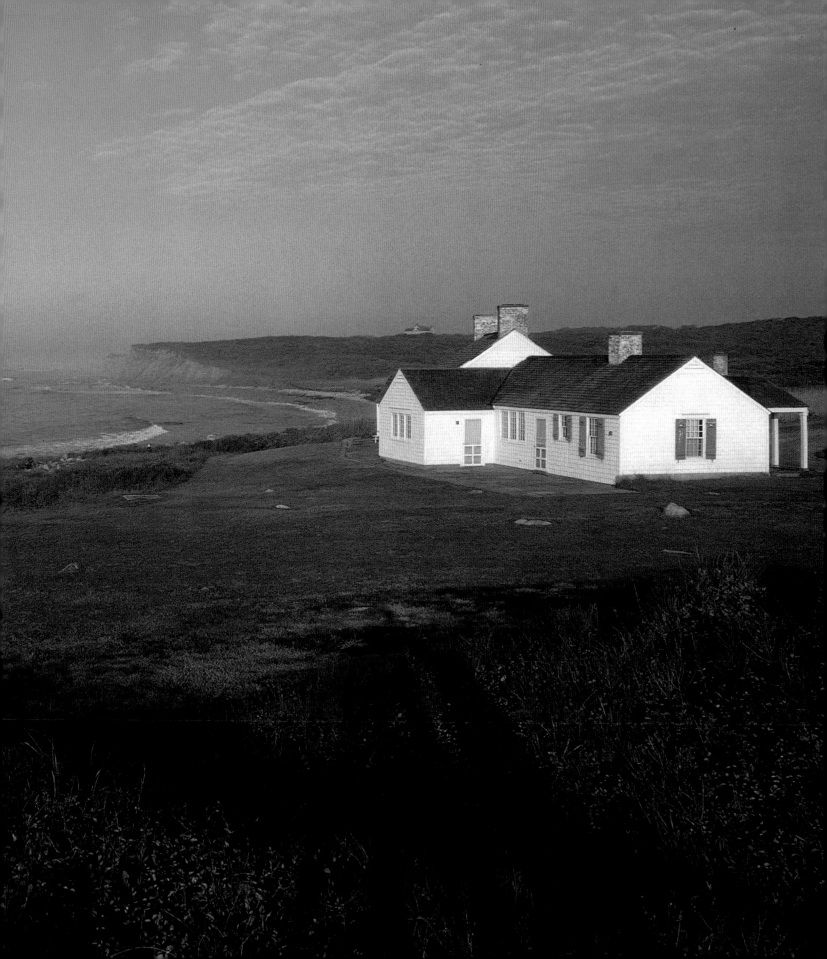

Eothen is Greek for "from the east," and it's a doubly appropriate name for a house that was built by a classical scholar for a Princeton classmate and is located at the far southeastern tip of Long Island. You reach it down a long rutted drive, past signs warning you to keep out, and turn into what appears to be a picture-perfect Colonial farmyard with a house, four cottages, and a stable ranged along one side of a small pond, with the pounding surf a few yards beyond.

Rolf Bauhon, a gentleman architect, created this retreat in 1931, at the nadir of the Depression, for Richard Church, a rich bachelor and heir to the Arm & Hammer baking soda fortune. Church's family had long owned the twenty-two-acre site and camped here during fishing trips. The buildings, with their white clapboards, faded blue shutters, and brick chimneys, have a gentle patina that is the product of weather and meticulous craftsmanship. Bauhon felt this was his best work, for the way it responds to the wild moors, peat bogs, and boulders of this island on the land that was

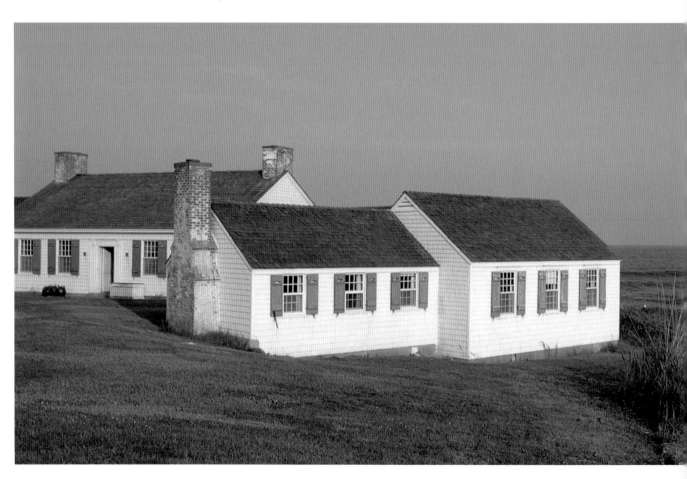

formed by glacial action at the end of the last ice age. The area around was bought and subdivided in 1880, and three original Stanford White houses survive, but remoteness protected it from further development for another century. The latest beach houses are almost out of sight of Eothen. It remains a magical place that could be at the end of the world.

It is now owned by Paul Morrissey, who comes out as often as he can and is fiercely attached to the house. It's easy to see why. The proportions are harmonious, the details refined, and the buildings feel as though they are deeply rooted in the land, offering a snug haven in the worst storm. Indeed, they survived the devastating hurricane of 1938 and have required little maintenance in their seventy years. At a time when $5,000 bought a decent family house, Bauhon spent that much on the random-laid floor of bluestone, which was shipped here from New York when some old streets were repaved. Even more was spent on the distressed paintwork that makes

the walls and closets look much older than they are. Halston, a former owner, misguidedly repainted the kitchen, and that is now being patiently restored to its original condition. The hand-hewn beams and open pitched vault in the living room are set off by a frieze of red and green squares. In the dining area, Windsor chairs are drawn up to a table designed by Eleanor Roosevelt with two of her friends before FDR went to the White House.

On a blustery day, there is a wonderful contrast between this warm, civilized retreat and the surf tearing at the rocks just beyond. It's reassuring to remember that this simple shelter withstood the worst storm of the past century and is likely to resist many more.

89

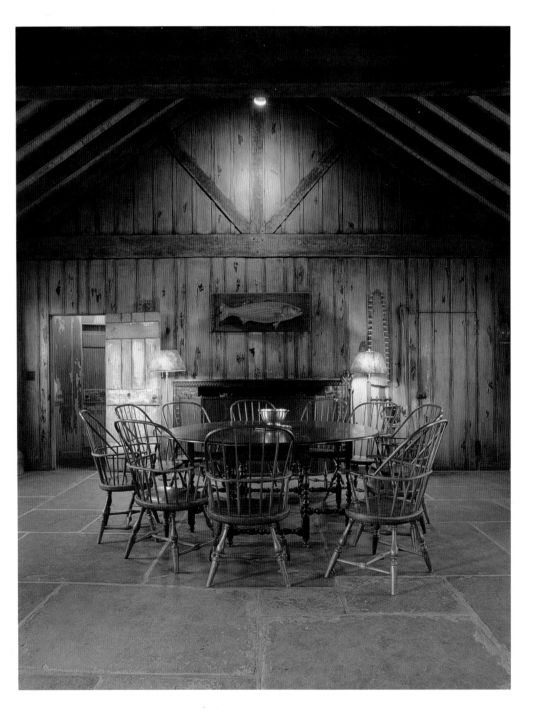

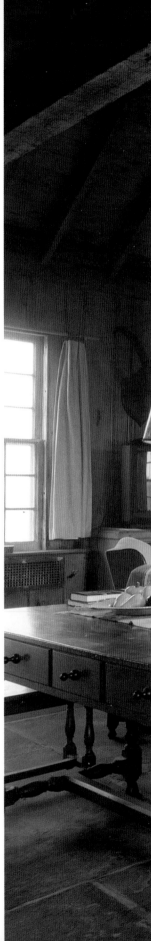

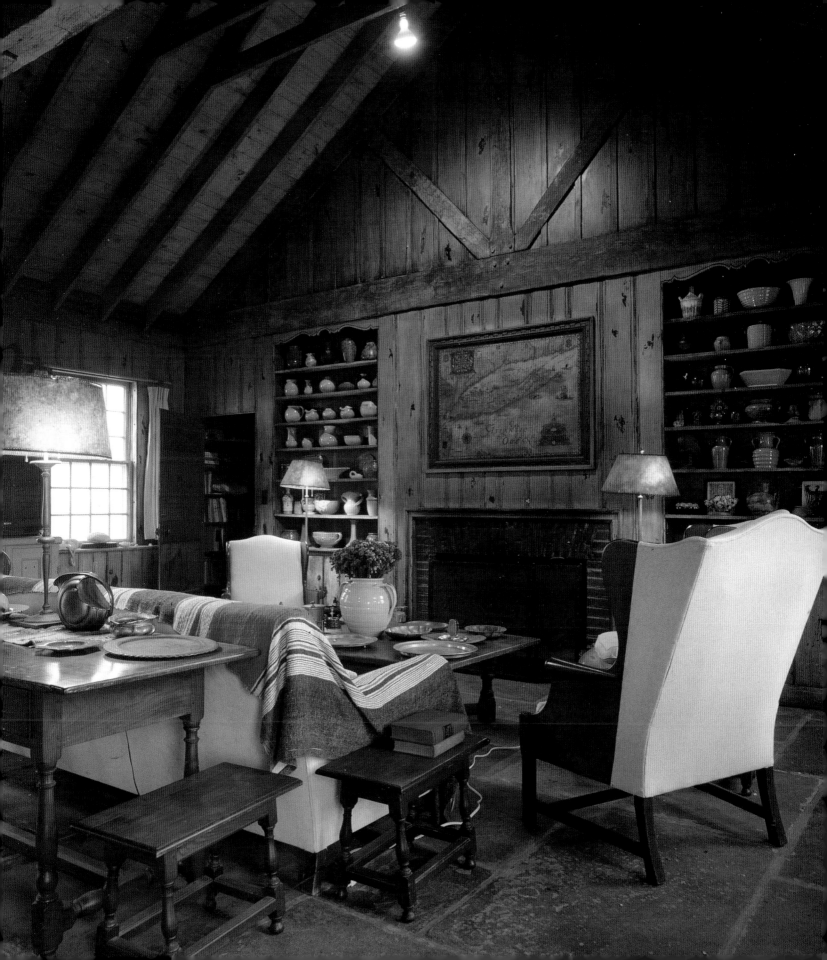

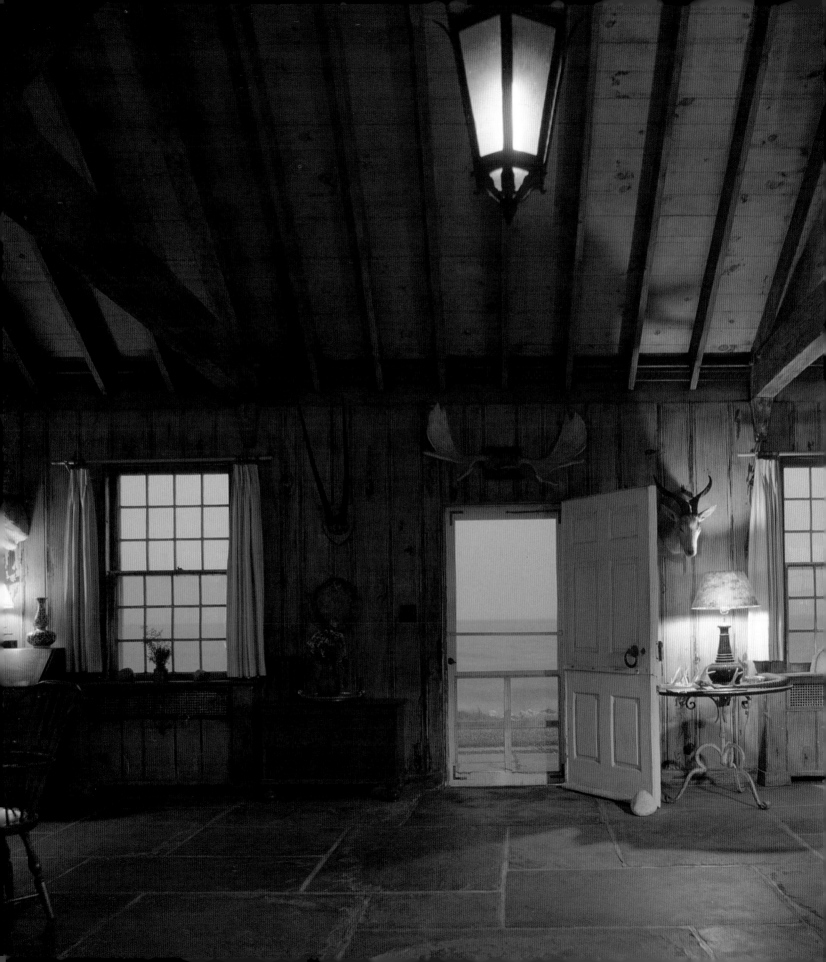

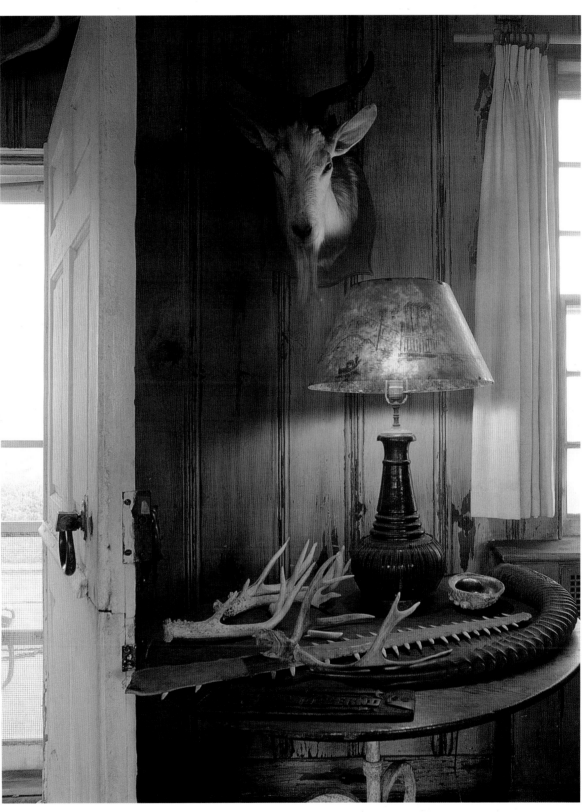

Block Island
Coxe-Hayden house and studio
Venturi, Rauch and
Scott Brown, Architects
1980–81

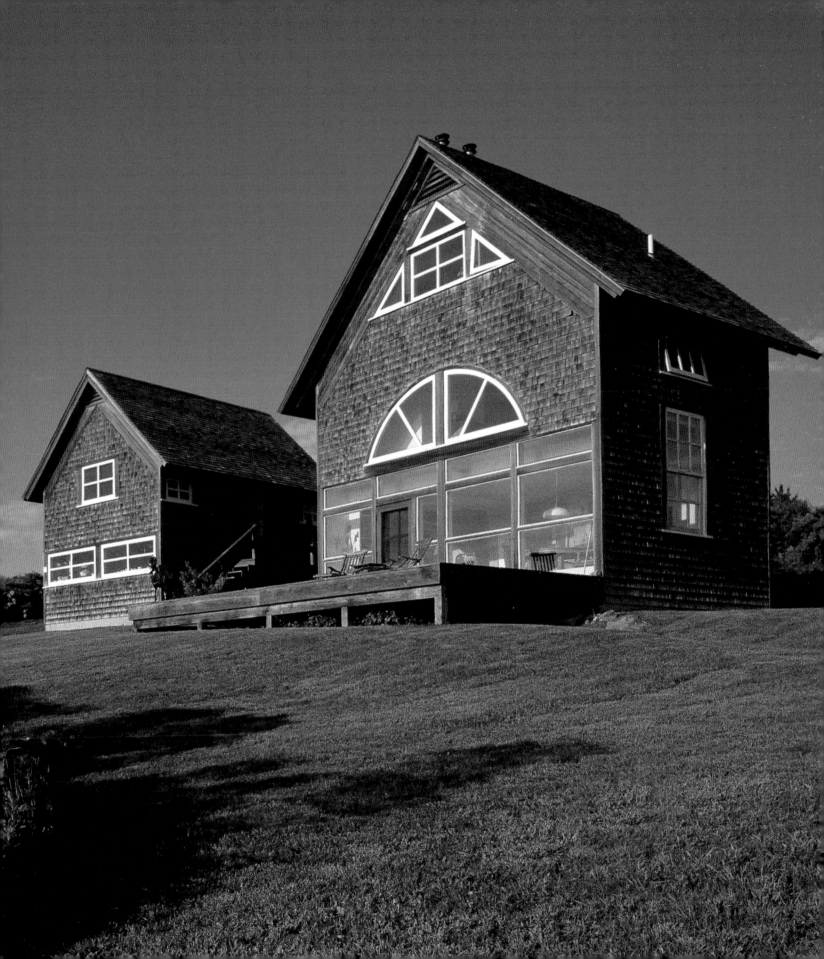

Block Island is an hour by ferry from the tip of Rhode Island, and remains an old-fashioned, unpretentious place—a reminder of how Martha's Vineyard must have been before it became a haunt of the rich and famous. The 1938 hurricane leveled many of the old farm buildings, but some handsome nineteenth-century summer houses and resort hotels with wraparound porches survive. Over the past two decades it has been discovered by the newly affluent, but much of the island remains a nature preserve, and families still return to the same houses each summer, swelling the hardy band of permanent residents who brave the 100 mph gales of winter.

For Weld Coxe, a Philadelphia-based management consultant to architects, it marked the end of a long search for a second, waterfront home. As he recalls, "Chesapeake Bay had no beach, New Jersey and Delaware were overrun, Long Island Sound was all rock. Here I was able to find a bargain—a gently sloping two-acre lot, looking across a pond to the oceanfront dunes and a vintage lighthouse." He was also lucky enough to catch one of his clients, Robert Venturi, at a slow time, and commission him to design a house and studio for a mere $50,000 plus a 20 percent commission—the smallest job that firm has ever done. Venturi needed little persuading. As they drove around the island on a cold December day, he remarked: "An architect should pay to build on a site like this."

"Keep it simple, and make it architecture" was the key instruction in Coxe's eleven-page memo to Venturi, in which he described his need for three rooms—one for working, one for sleeping, and one for eating and sitting. "First and foremost, this will be a writing studio," he wrote. "For reasons I do not understand, I write best when I can see a vista of moving water." That put the studio at the top of the house, over the bedroom, which also demanded a view and privacy, with the living spaces at the bottom, opening onto a deck. Coxe described in precise detail how he paced up and down, took naps, and read sitting up at a table. He asked for a house that was energy-efficient and easy to build (since everything has to be brought in from the mainland, and skilled labor is scarce). And he explained that "I feel stifled in boxy, rectangular rooms. Capture a beautiful view, change the loft of the ceiling, or vary the angle of the walls, and the space will feel more energizing for me."

Coxe had chosen the right architect for the job. "Meaning can be enhanced by breaking the order," Venturi had written fifteen years before. "An artful discord gives

vitality to architecture," and he demonstrated that skill as he fulfilled his client's wish list in one gray shingled cottage, and put a workshop and two guest rooms into a smaller sibling. At first sight they appear almost generic, but a second glance reveals how artful and vital they actually are. Windows are scaled and positioned not to achieve a symmetrical pattern on the facade or delineate the floors, but to frame views and pull exactly the right amount of light into each room. The rounded "eyebrow" window to the east frames the vista from the bed and balances the wall of glass that opens onto a broad weathered deck.

Attic windows at front and back balance the lighting of the studio, and a tall strip to the north lights the staircase. Floors are pulled back from these windows, and the varied width of their painted boards and a broad baseboard subtly enhance each

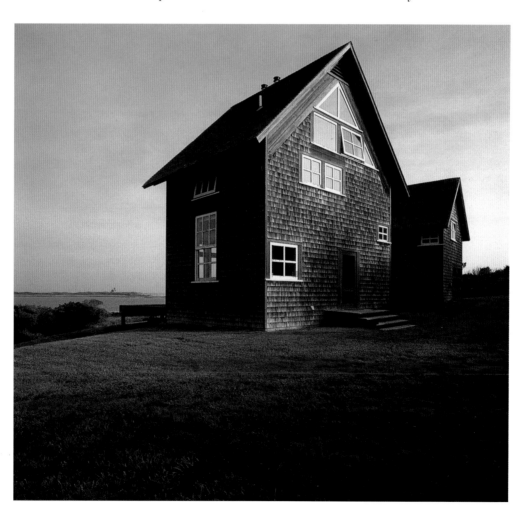

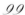

room. An aqua-colored inner wall is set at an angle to screen off the kitchen, define a vestibule, and conceal a narrow rear staircase. Even the open linen closet was designed, and Venturi wrote to Coxe to suggest that it could double as a Warholian composition if the white towels and Clorox bottle were neatly arranged on the shelves.

Construction was a family project, with Coxe's late wife, Mary Hayden, as administrator, and his son as contractor. The house won several awards, and its cypress boards and shingles have aged gracefully. It has given intense pleasure to its owner, who observes, "In my job, I worked with many leading architects, but didn't know a lot about the subject. It's so nice after thirty years to learn, firsthand, what makes architecture important."

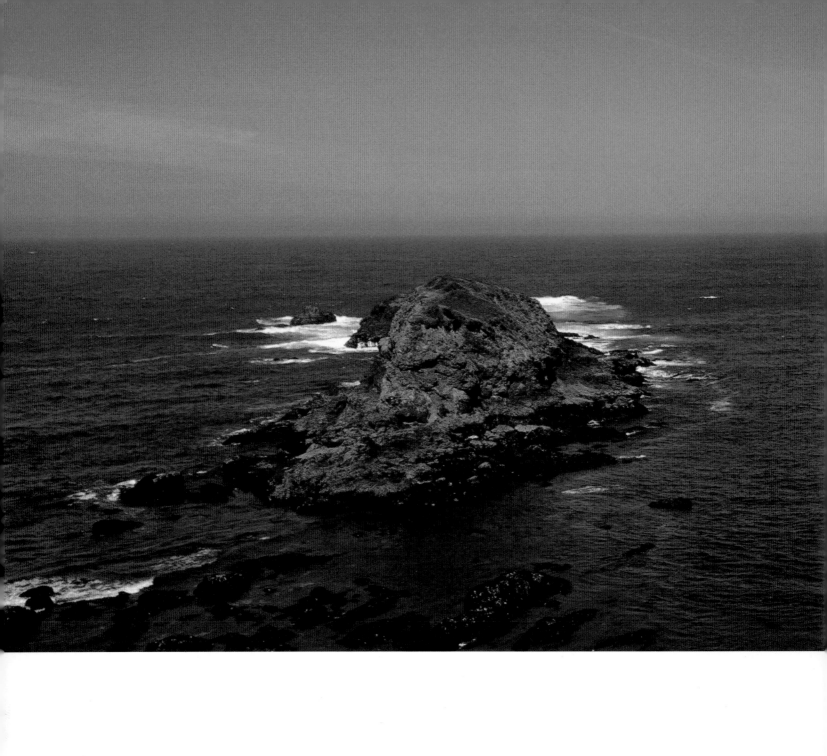

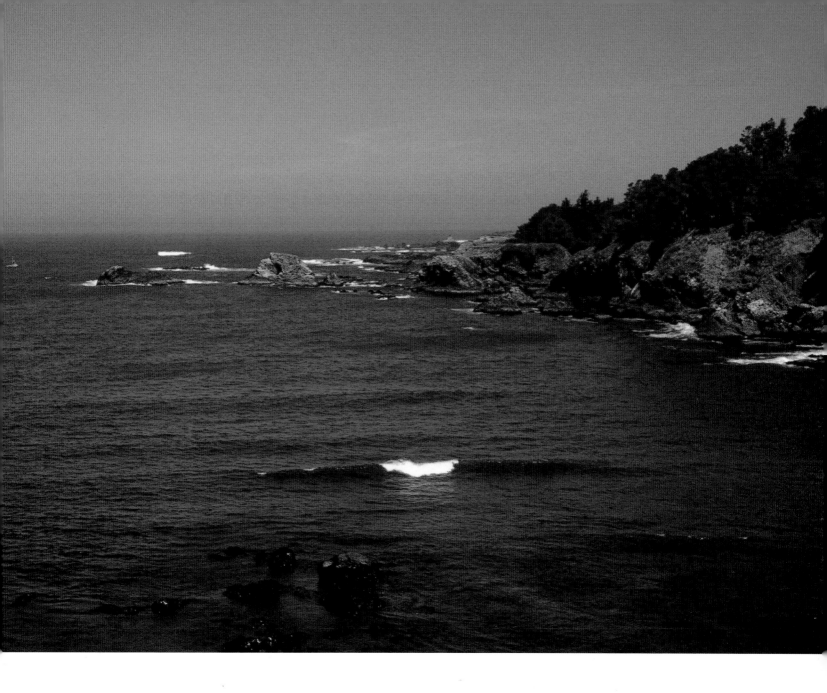

The Northwest

Puget Sound

The largest expanse of landlocked ocean on either coast: a paradise of islands, inlets, and bays, formed by glaciers during the last ice age, and scattered around the densely forested Olympia Peninsula. It was named for Peter Puget, aide to the British captain Vancouver, who arrived in 1792. Long before, the Native Americans who fished and hunted here tried to explain its origins. According to a legend recounted in the *Smithsonian Guide to the Pacific States,* "the region was created when Ocean, hoping to keep his children Cloud and Rain close to home, carved a trough and molded the dirt into a mountain range. His children never strayed east of this range, the Cascades."

Locals take a perverse pride in the soft gray light and frequent drizzle, though the annual rainfall is no greater here than in many other places, and it does nothing to spoil the fun of sailing, and fishing, hiking, and climbing. In fact, outdoor activities seem to flourish as strongly in the northern mists as they do in the year-round warmth of the south, and the land is protected by old money and state parks from the sprawl of Seattle and Tacoma.

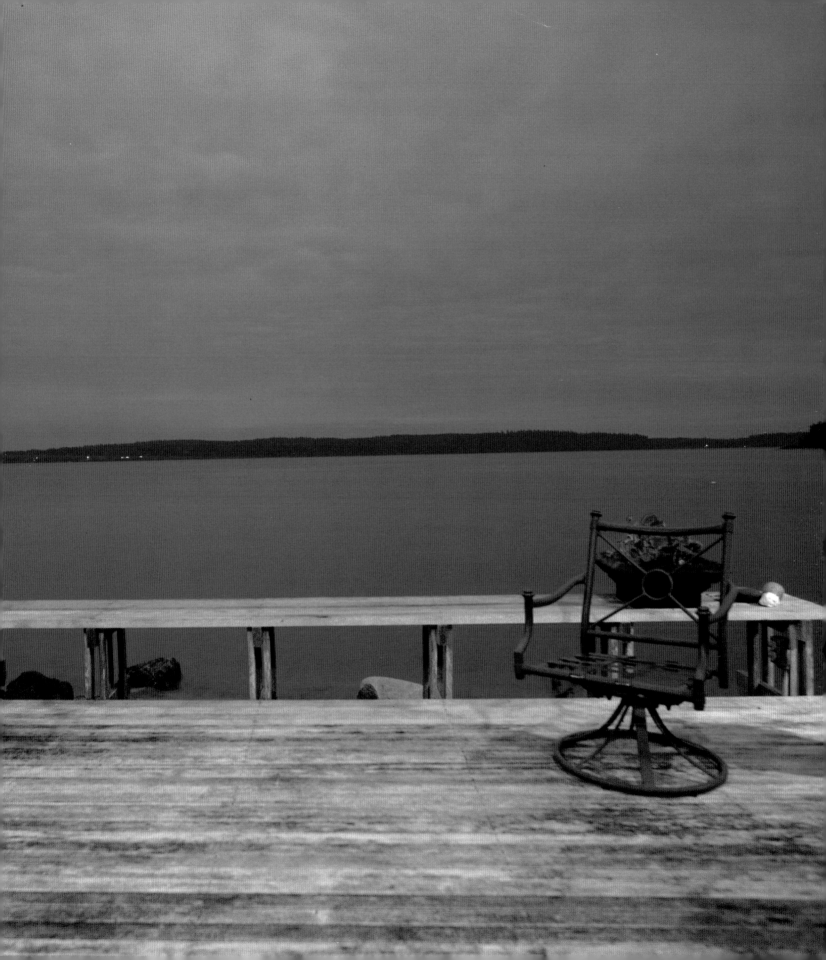

Gig Harbor
Dafoe house
Kirk Wallace McKinley,
1962

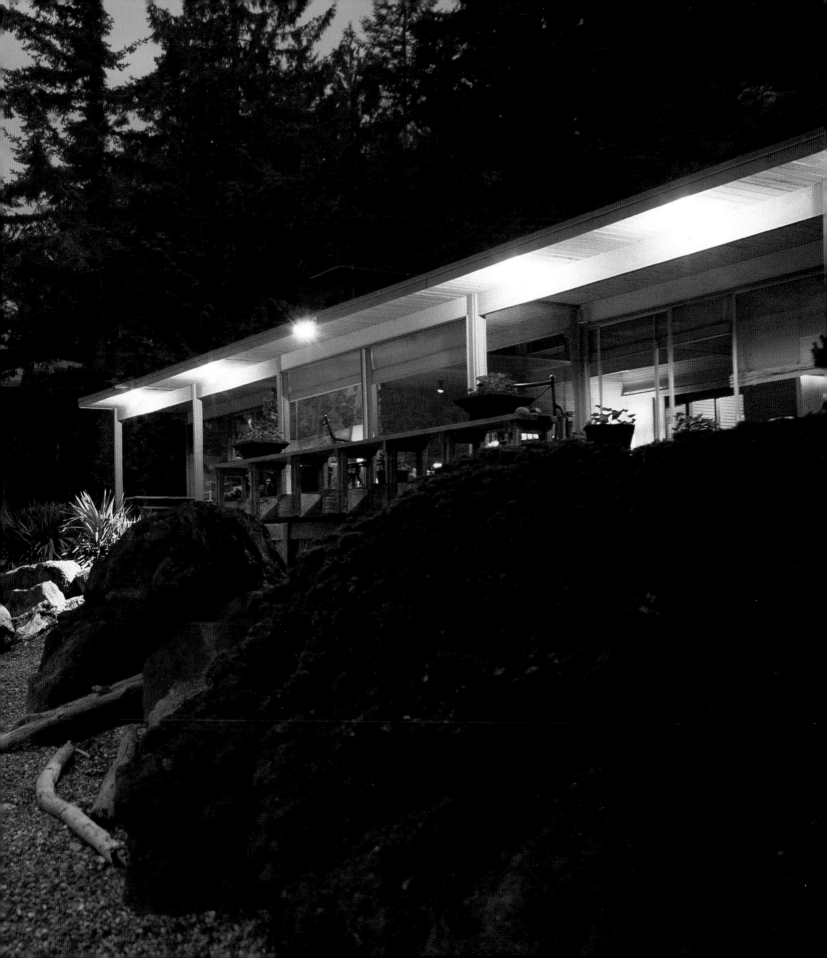

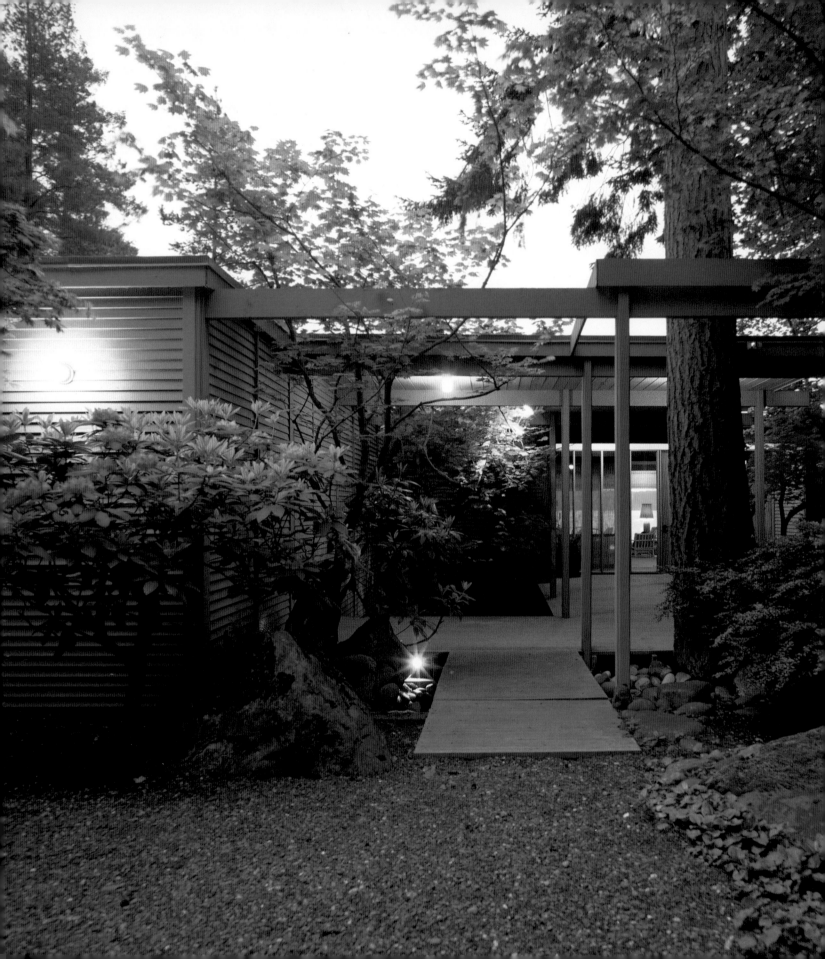

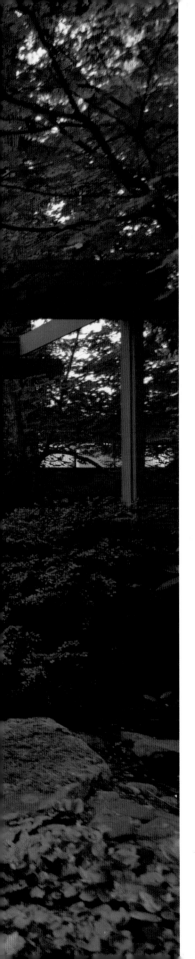

People who live on the Olympia Peninsula or spend their vacations beside its beaches put a high value on natural beauty and tranquillity. For generations, they've refused to sell out to developers, and have spared themselves the blight of marinas, speedboats, and jet skis. William and Margaret Dafoe bought a waterfront cottage in the fifties and began weekending there. Friends settled close by, and this persuaded them to leave their home in Seattle and live by the Sound year-round. They picked Paul Hayden Kirk, a talented local modernist, to design a new house for year-round living, and became close friends with the architect while lodging in a cabin on the site during construction. The cottage was donated to a neighboring church and trundled away on rollers.

The house emerges from the forest, steps right up to the shore, and is supported on a massive four-foot-high concrete foundation to withstand the storms that can send waves crashing onto the deck. In summer, the water may be as still and luminous as a Finnish lake, and you can walk for miles along the narrow beach, pausing to dig for a geoduck clam and admire the distant prospect of Mount Rainier. However, the flotsam of bleached trunks and the dense carpet of shells tell a different story, and landscape designer Richard Yamasaki responded to that wildness by bringing in boulders to protect the house.

If Mies van der Rohe had built in wood rather than brick and steel, he might have designed a house like this: a taut geometric post-and-beam structure with a flat roof, clapboard facade, and a window wall opening onto the raised deck. An elegant pergola extends from the house into the forest, and a canopied boardwalk leads inside. Old-growth clear Douglas fir is used throughout, and thanks to its density and the quality of the carpentry, it has sprung no leaks and has required almost no maintenance in forty years. The exterior, once the same honey tone as the paneled ceiling and interior walls, has weathered to a silvery gray. The deck and its painted canopy link a sequence of open living areas and bedrooms.

Roll-down matchstick blinds shade the sliding-glass window wall, and the light reflected off the water is balanced by pop-up clerestory lights in the living room. When the wind howls, you can retreat into the stone "cave" that surrounds the fireplace. Interior designer Alan Van Salisbury designed the tables, wood chairs,

and benches to complement the timeless beauty of the house. It was Kirk's own favorite among the many he designed: a structure that seems to float above the beach and commune with the water. There's a pervasive sense of remoteness and serenity, even though the house is just an hour's drive from the city. However, the greatest lure for Steven Shaw, the Dafoes' son, who spent his boyhood here, is to walk out on the deck at high tide, cast his fly on the water, and catch a Cahoe salmon for breakfast.

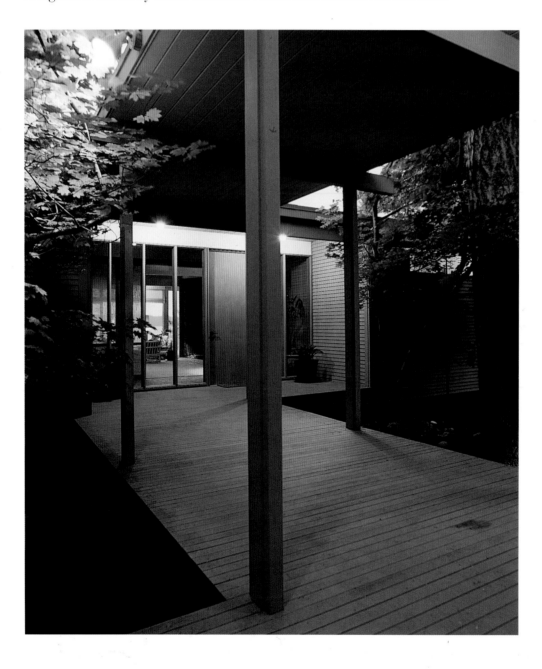

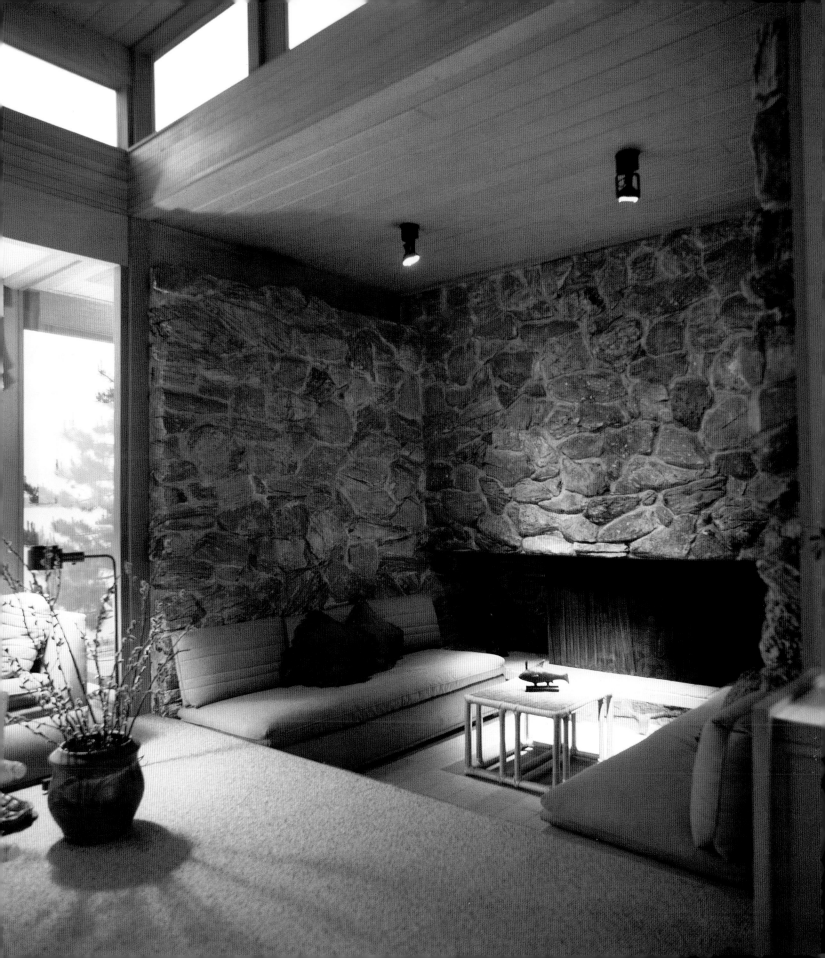

Bellevue
Pleasure Point house
Olson Sundberg Architects,
1997–99

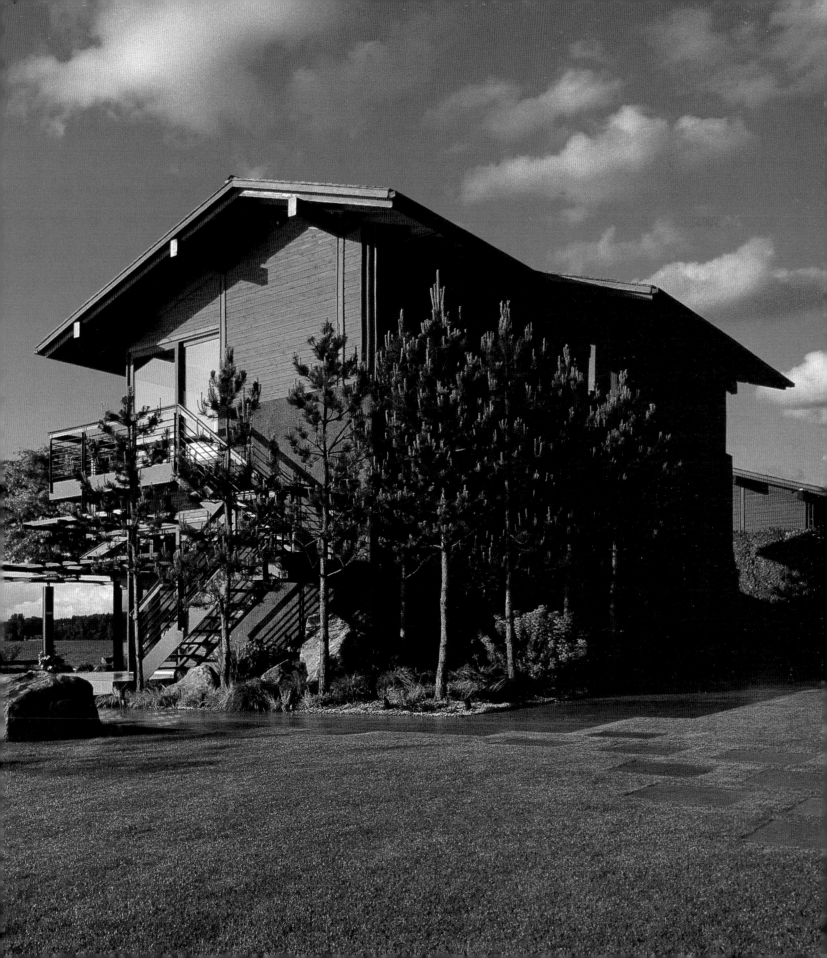

"Living on the water gives you a huge backyard, and nobody will ever be able to build out there," exult a professional couple who live on the edge of Lake Washington, looking across to Mercer Island, a short commute to downtown Seattle. "You can tell what the weather is going to be, there's always something peaceful to look at, and the lake glitters on even the gloomiest day."

Lake Washington has fresh water, though you can sail out through a long narrow channel to Puget Sound, and it's well protected from storms. The couple have always lived in this neighborhood, and found much to admire in the original house, which local architect Roland Terry designed in 1959. However, after ten years of raising two daughters in a house with a confining plan and cramped kitchen, bathrooms, and closets, they decided it was time to upgrade. They looked at other properties, but found nothing affordable that was as well situated,

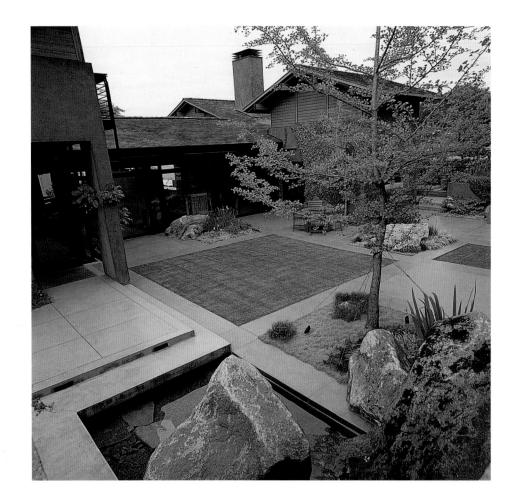

112

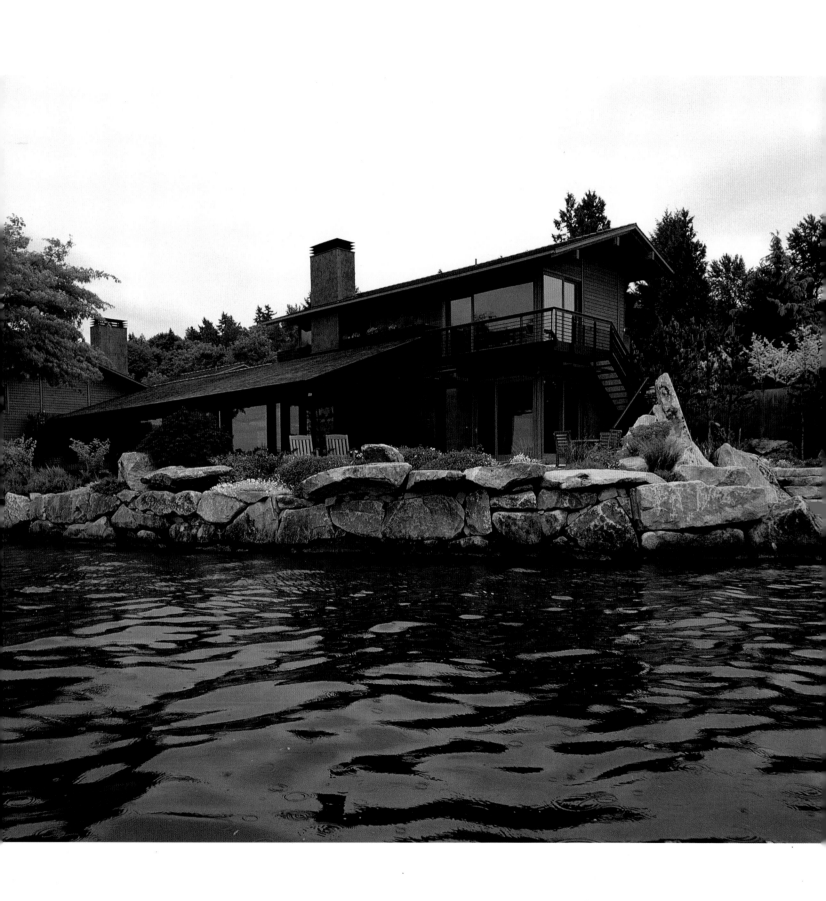

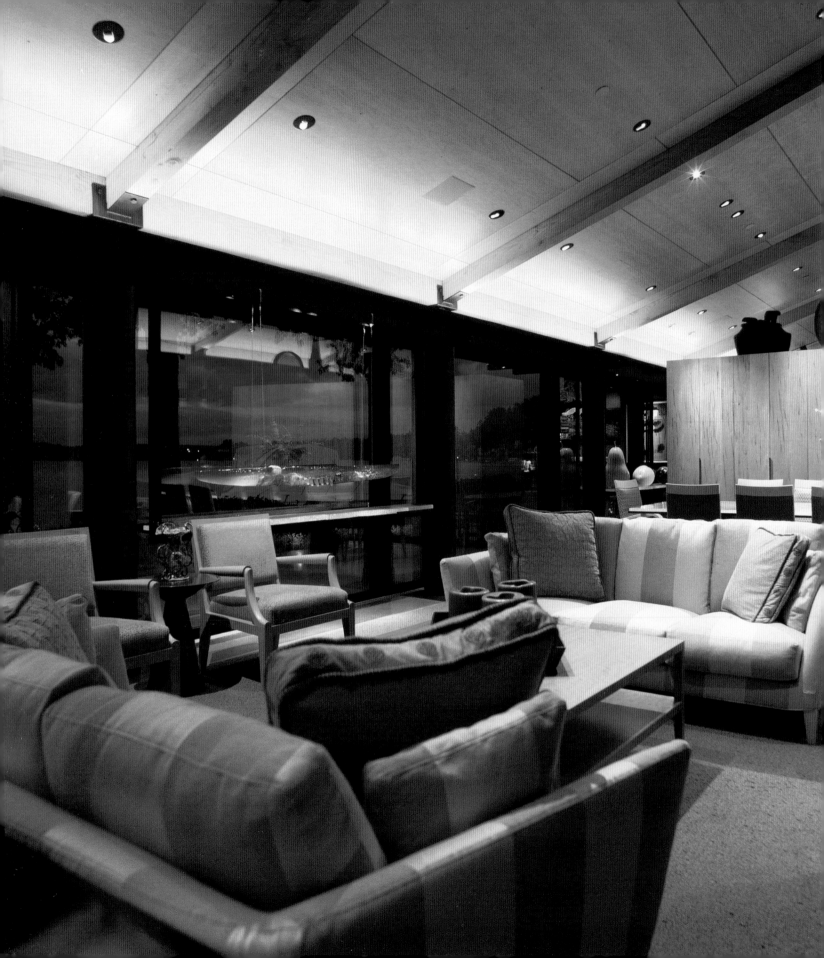

and invited Olson Sundberg, a Seattle firm much admired for their Northwest contemporary houses, to do a remodel. Very quickly the owners realized that they would have to give up most of the existing structure to achieve the efficiency and openness they were seeking, and they seized this opportunity to bring the building and landscape into harmony.

Over the next year, they collaborated with partner-in-charge Tom Kundig on a design that was open yet sheltering, flooded with light but energy-efficient. The foundations and few walls of the old house were retained, along with the former boathouse that extends over the water and now contains an exercise center. The central living area is enclosed on either side by glass wall panels that you can slide open on fine days to eliminate the barrier between courtyard and lake, or close to provide protection from weather or the noise of speedboats. This transparent bridge links two pavilions with solid walls containing new upstairs bedrooms for the parents in one, and for the daughters in the other. The second-floor rooms, with their broad-eaved shingled roofs and stained cedar siding, sit lightly atop the khaki shotcrete walls (integrally colored concrete sprayed onto a wood frame, sanded, and troweled) of the ground floor, suggesting huts resting on rocks. A black steel trellis supported on round steel columns extends over the terrace and will eventually be covered with wisteria to soften the hard edges of the house. In the living area, the shallow-pitched maple vault and cabinetry of carefully matched spalted maple play off a dark terrazzo floor, creating an effect of calm and understated luxury.

Landscape designer Bruce Hinckley transformed the courtyard, which was formerly overgrown and soggy, into a Japanese-inspired outdoor room of rocks, moss, and close-cropped grass. A line of pavers leads around the house to a waterfront terrace that provides easy access to the tiny beach. Water, circulated by a pump, courses down beside the steps that descend from the dead-end street and flows into a small pool in the courtyard, producing a soothing sound and a sense of motion, while building anticipation for the lake.

The owners' gamble has paid off in a house and garden that unfold like a Japanese screen, leading your eye from one intriguing composition to the next, drawing you through layers of stone and glass, moving water and greenery to the liquid expanse of the lake.

Northern California

California's Pacific Coast Highway extends over eight hundred miles from Oregon to the Mexican border, achieving a dramatic climax at the midway point as it snakes up to Big Sur, a thousand feet above the waves. However, for sustained beauty, the tortuous drive along the rocky, undeveloped shore of Mendocino and Sonoma counties may be unrivaled anywhere in coastal America. Route 1 hugs the edge of the cliff as tightly as a spandex bathing suit, inducing a tension that can be relieved only by pulling off onto one of many signposted viewing areas. From there, you can enjoy the big picture of forested mountains cascading down to the ocean and the surf tearing at their remains as the sun shimmers through a mist of spray. Jutting headlands alternate with coves and canyons as far as you can see, or quickly fade into a blanket of sea fog. Even in summer, it is usually cool and windy.

With luck you will have parked your car or bike at a point from which you can scramble down to a tiny shingle beach and experience the power of the surf close up. Pelicans and cormorants maintain a steady patrol, breaking their glide to drop almost vertically into the turbulence, and every dark and jagged rock supports a colony of barking seals or keening seabirds. No peaceable kingdom this, but a thrilling battle for survival.

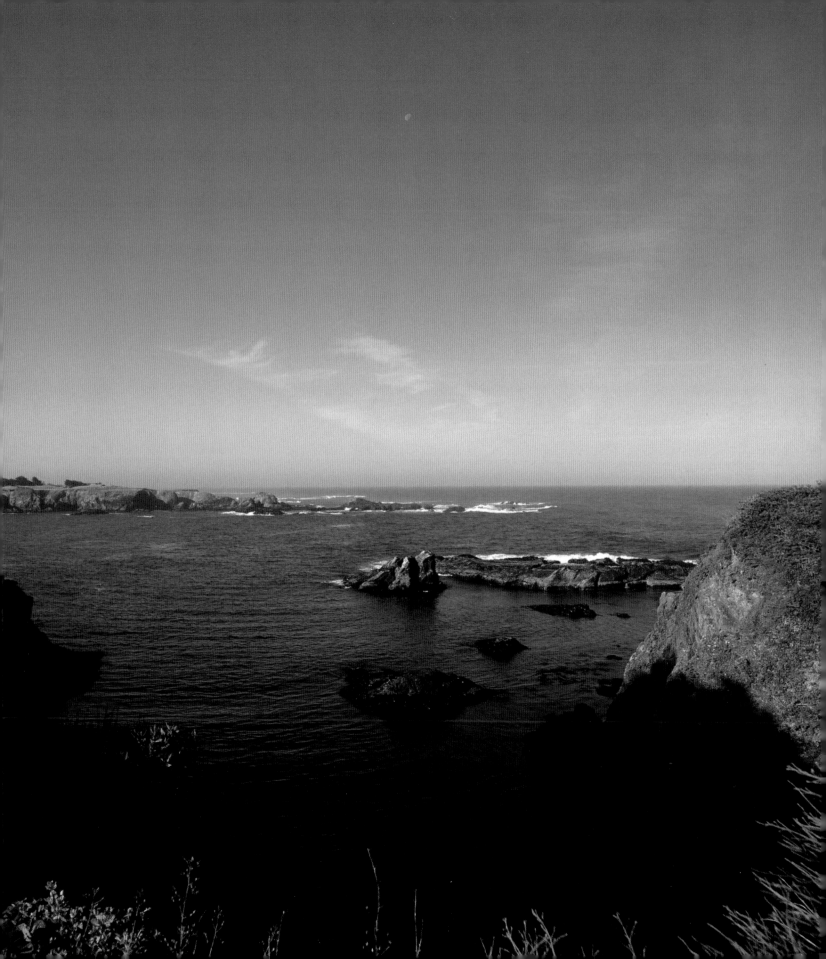

Caspar
The Wave
Bart Prince, Architect,
1996

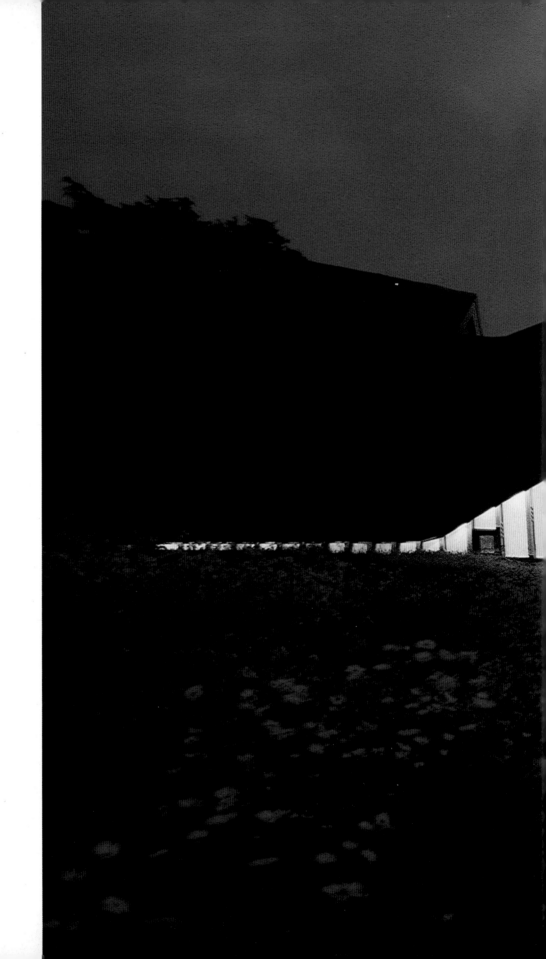

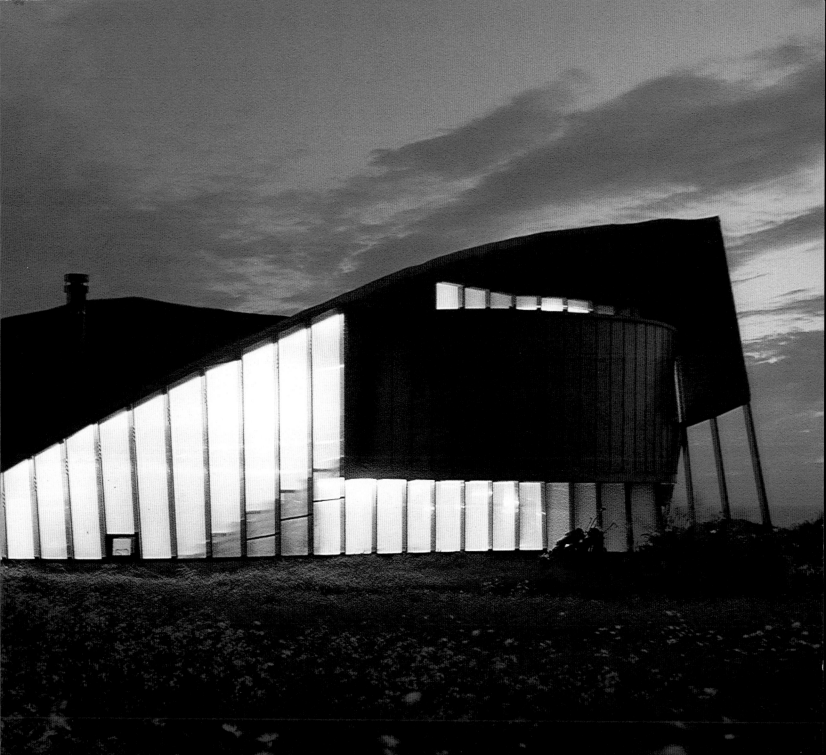

When Boyd and Mary-Kay Hight commissioned a daringly different second home on the cliffs of Mendocino County, they anticipated opposition to the design from local authorities intent on maintaining the tradition of Cape Cod buildings. Instead, the big debate centered on the reaction of the whales. Would these migrating leviathans be dazzled by reflections off the expansive windows and swim off course? It was decided they would not, and so far none has washed up on the beach.

Aptly dubbed "The Wave" while still under construction, the house takes its cues from the landscape, as do all the buildings of Bart Prince. The Albuquerque-based architect denies any intention to mimic nature, but admits that he was inspired by the quality of the light, the sweep of the coastline, and the pounding of the surf. "I wasn't

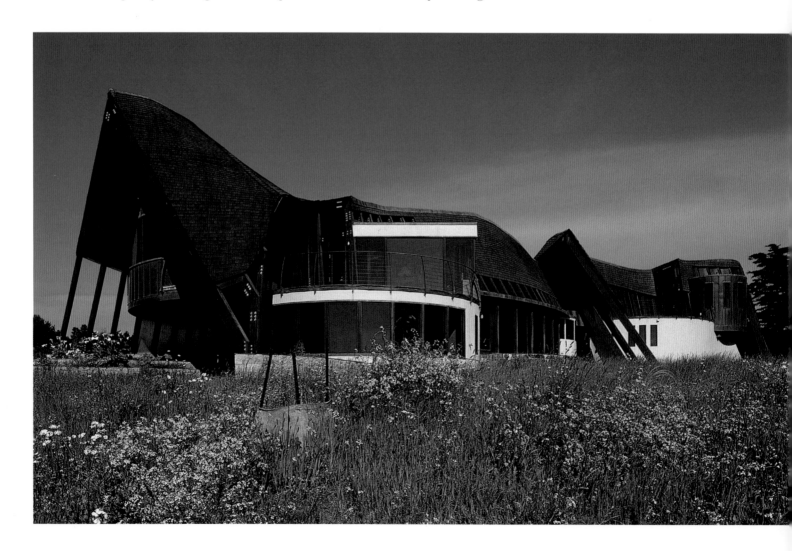

thinking of a wave or a whale as I worked on the design," he insists. "Other people may see those things, just as they perceive a likeness in the shape of a cloud. For me, the analogy is with music, which, like architecture, has structure, color, and a sense of mystery. One of my favorite pieces, Debussy's *La Mer,* expressed the composer's feelings about the sea. Music also soars free of gravity, and though buildings cannot do that, it's an idea I try to express in my work."

For Prince, the first step in every commission is to explore the site with his clients and discover their needs. "I try to imagine myself in each of the spaces they have requested," he explains. "Where would I want to be when I woke up in relation to the views and the rest of the house? Designing from the inside out seems to me more interesting than trying to fit everything into a predetermined container." The product of this approach is an exposed structural frame that is as impressive and organic as a whale's rib cage or the timbers of a schooner. Prince created a pitched vault from a linear succession of massive Douglas-fir beams, elaborately bolted together to form sixty-four angled members that differ in profile and orientation from one to the next. These varied angles rise to create a soaring vault over the central living spaces and embrace upper-level bedrooms at either end. They twist and turn like a living creature, fanning out to expand and compress interior space, and are tightly wrapped in plywood and an outer skin of cedar shingles.

On this bare headland, it made sense to design the north facade as a windowless slope to allow the prevailing winds to sweep over it, and open up the south of the house to the sheltered terrace as well as to the panorama of rocks and ocean. As you approach, the house seems to be growing out of the land. It reveals its openness only as you enter or walk around it, and see how the frame breaks free of the skin to define patios and mediate between earth and sky. The baronial living room, comfortable kitchen, and intimate reading room each offers a different spatial experience and angle of view. The rough-textured wood beams and copper piping, Brazilian hardwood floors, Navajo rugs, and Berber weavings create a feeling of warmth and human scale. Mary-Kay Hight is an art historian and an ardent architectural preservationist. She and her husband spend most of the year in a Mission Revival house in Santa Monica, but this muscular response to a wild coastline satisfies another part of their souls and offers a wonderful sense of escape.

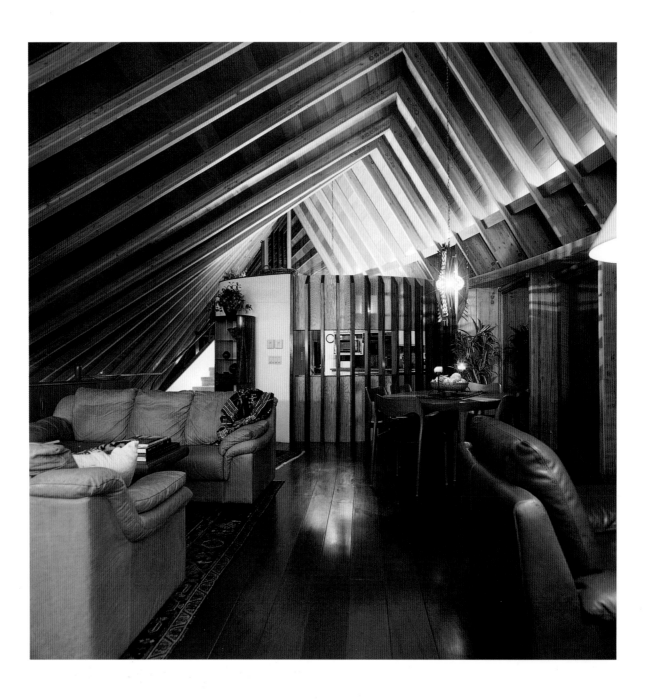

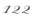

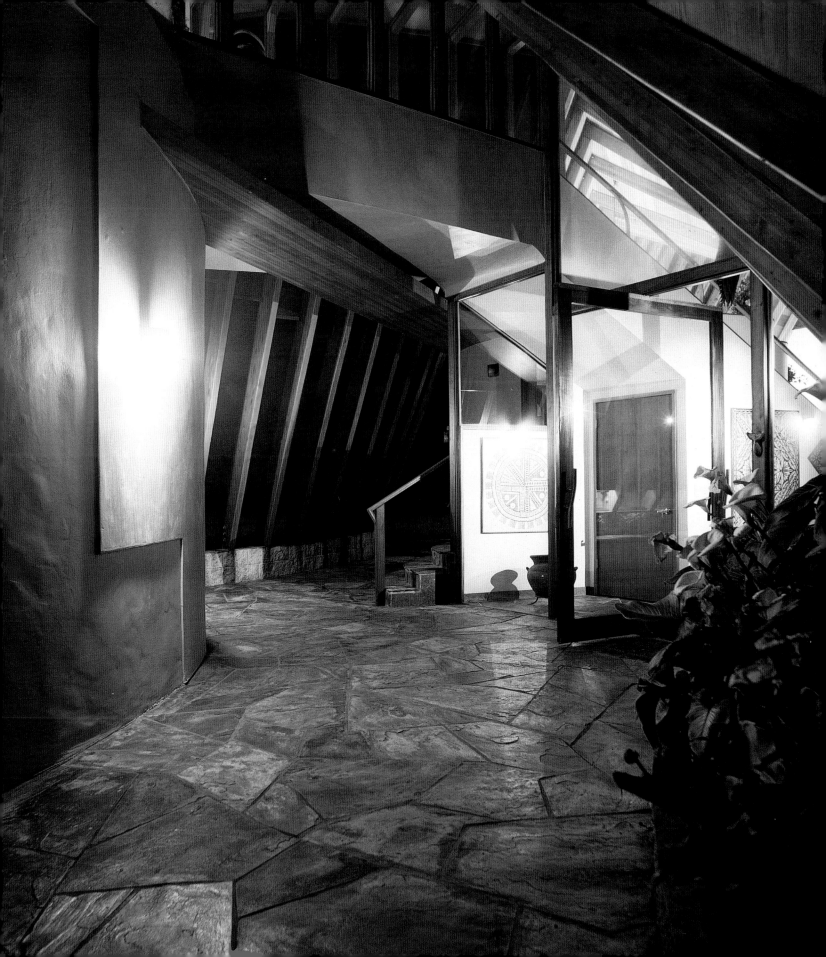

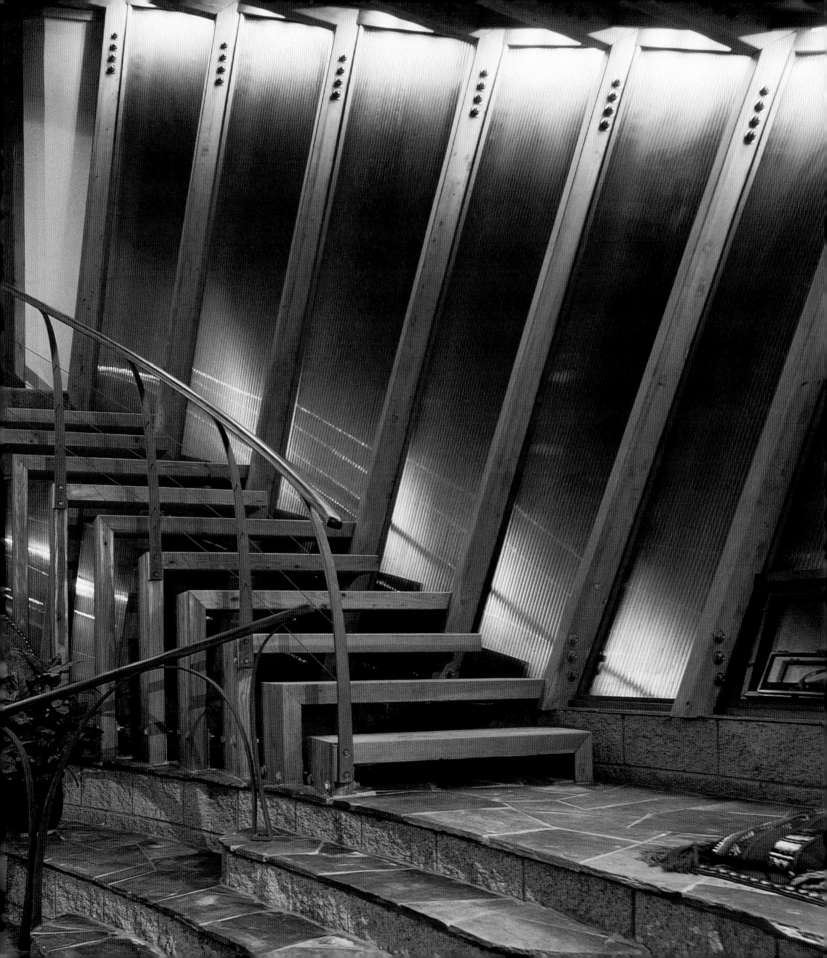

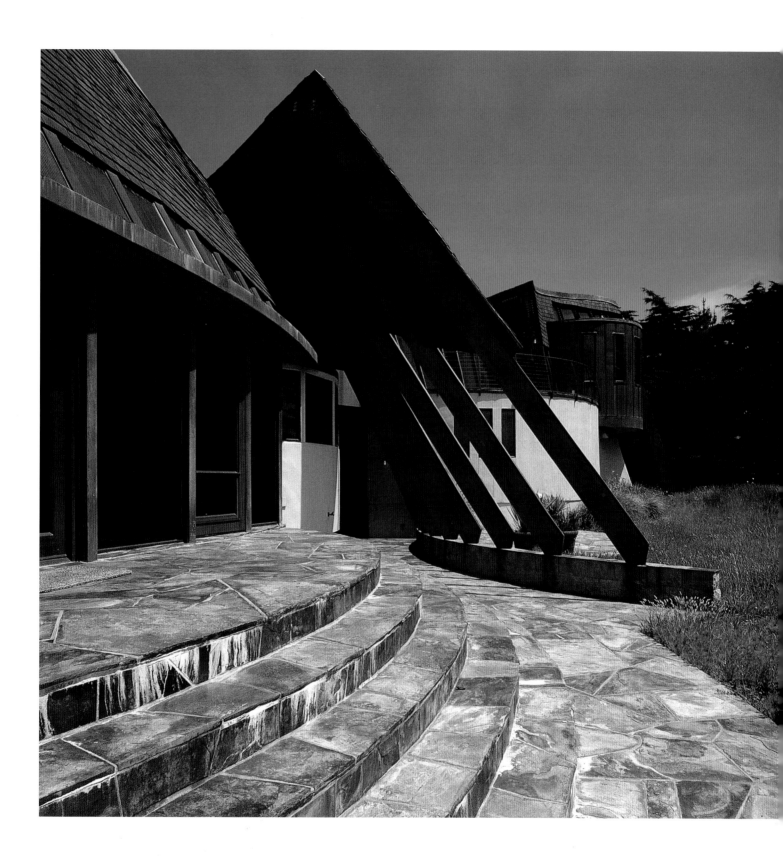

Sea Ranch
Yudell-Beebe house
Buzz Yudell & Tina Beebe,
1998–2000

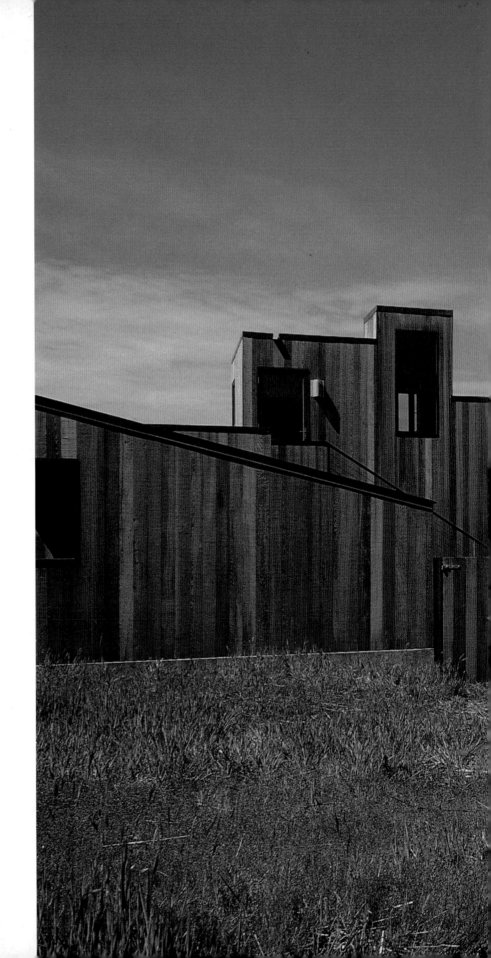

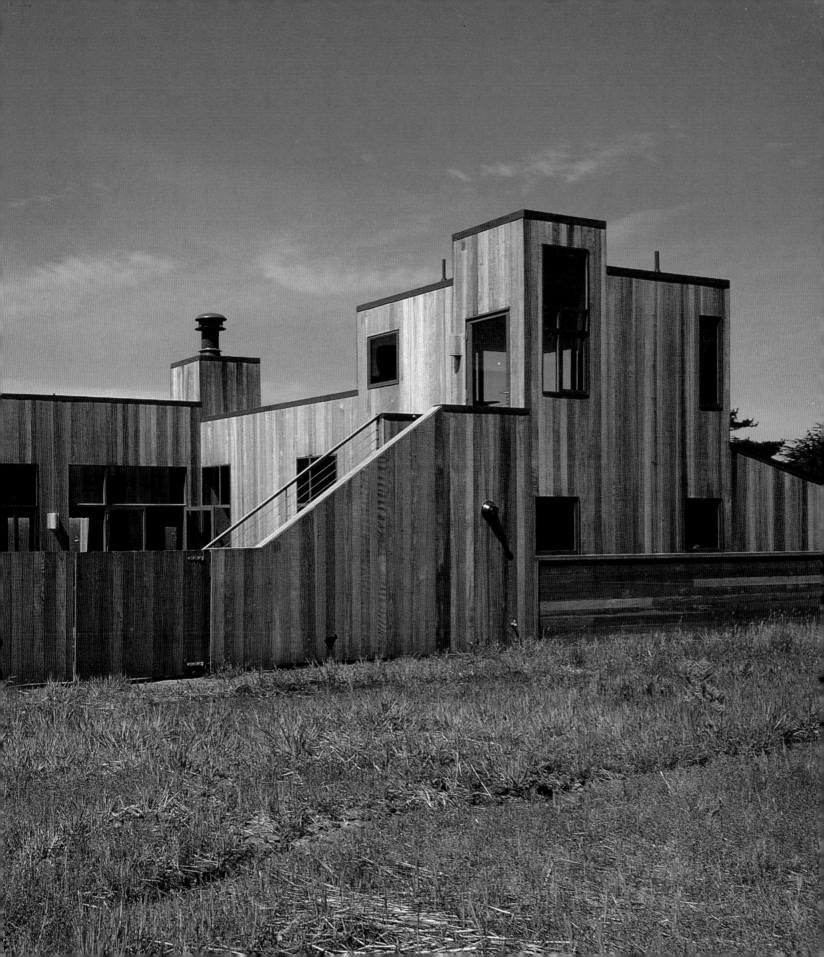

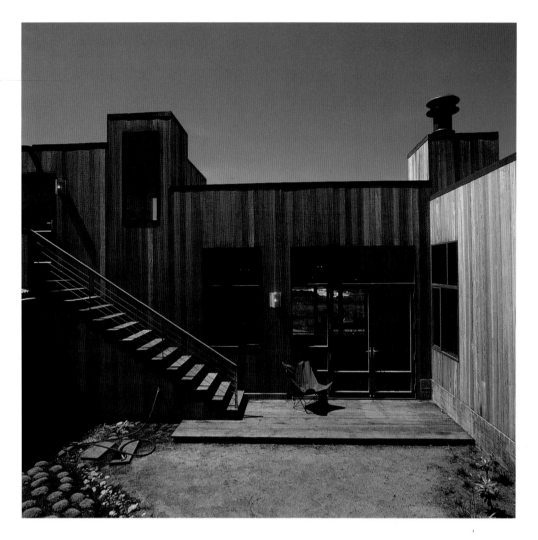

Home, for architect Charles Moore, was Sea Ranch—a model community of second
homes that straggles for twelve miles along a wild stretch of Sonoma County coastline.
Though he loved to travel the world and build houses for himself near the schools
where he practiced and taught, Moore returned as often as he could to this magical
place. The cluster of dark-timbered, shed-roofed condominiums that the firm of
Moore, Lyndon, Turnbull, Whittaker designed in 1965 became an architectural icon,
but many of the houses that fleshed out Sea Ranch were pale copies of that bold
structure. Buzz Yudell, a partner in the L.A. office of Moore Ruble Yudell, and his
wife, architectural colorist Tina Beebe, spent many happy days in their former chief's
condo and became as attached to the place as he was. Now they have gone back to first

principles in building their own second home, which captures the powerful spirit of the original without mimicking its forms.

The cost of land rises sharply as one approaches the ocean, but Yudell and Beebe were lucky enough to find an affordable site that has a clear view of the ocean across the long grass of a commons, but has more privacy than the homes facing onto the cliff-top path. There they have built a cubist compound of redwood siding on a concrete base with shallow-pitched corrugated metal roofs that seem to disappear as you approach. From the entry, it evokes the false facade of a Western town, but the composition changes dramatically as you move around. The mandatory height limit was sixteen feet, which led them to put the lofty living areas on the ocean side and to add two upstairs studies, one atop the intimate master bedroom, the other above the kitchen. Both these belvederes are reached by open stairs leading up from an enclosed garden court. The front walkway leads in from a semi-enclosed parking area to a covered deck that links the house and a spacious guest room.

"My idea of luxury is a small house on a large lot—living lightly on the land," says Beebe. "We agreed we didn't want the traditional Sea Ranch post-and-beam house with exposed fir walls and concrete floors. We did want warmth, woodsiness, and bounced light; a house that was big enough to stay in for more than a weekend, but smaller and more informal than our house in Malibu." Those desires produced a house of two thousand square feet that feels much more spacious than it actually is. The monopitch roofs slope down toward the ocean and the prevailing wind, framing the views and modulating the sun from the south. The slope also creates an alternation between soaring and snug interiors, while windows on the tall northern and eastern walls pull in light.

The soft-toned stucco walls were splashed with pigment (even with coffee grounds in one experiment!) and the exposed fir joists complement end-grain hemlock floors and beech cabinetry. Concealed tungsten fittings wash walls with light, and there is a sparkling constellation of suspended halogen lights with tiny reflective shades by Louis Poulsen. Built-in furniture and cabinets are augmented by quirky crafted pieces. Following the example of Moore, the owners have tried to incorporate memories of favorite places, especially of Japan and Scandinavia. And Beebe, who labors hard to nurture a drought-resistant garden in Malibu, bought

129

rocks from a dealer in Santa Rosa and placed them to look as though they had always been there. It's what she calls her "no-maintenance" garden, serving as a focus for the commons, and a counterpoint for the rocks on the shore.

"Buzz and I like building together and having a lab for new ideas, but most of all we like living here," says Beebe. "I'm from Oregon, and I get depressed when I'm trapped in the desert or by the long periods of sun in a Malibu summer. Sea Ranch was started by friends and mentors with good intentions; it's appealing for its beauty, climate, history, and associations."

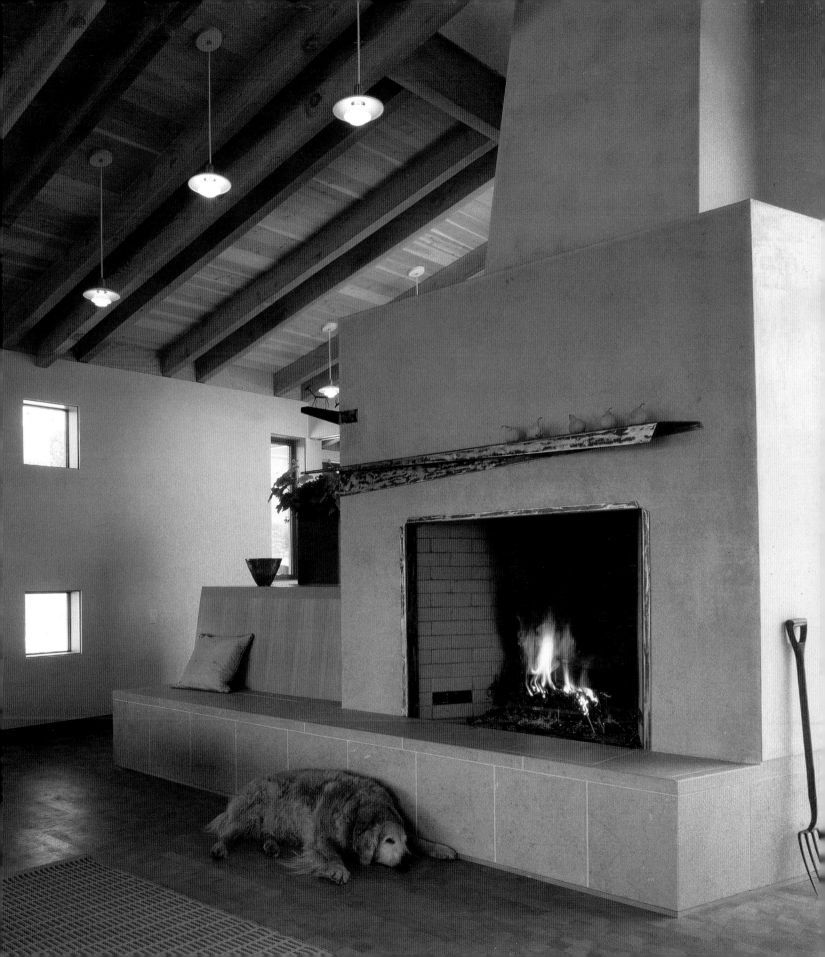

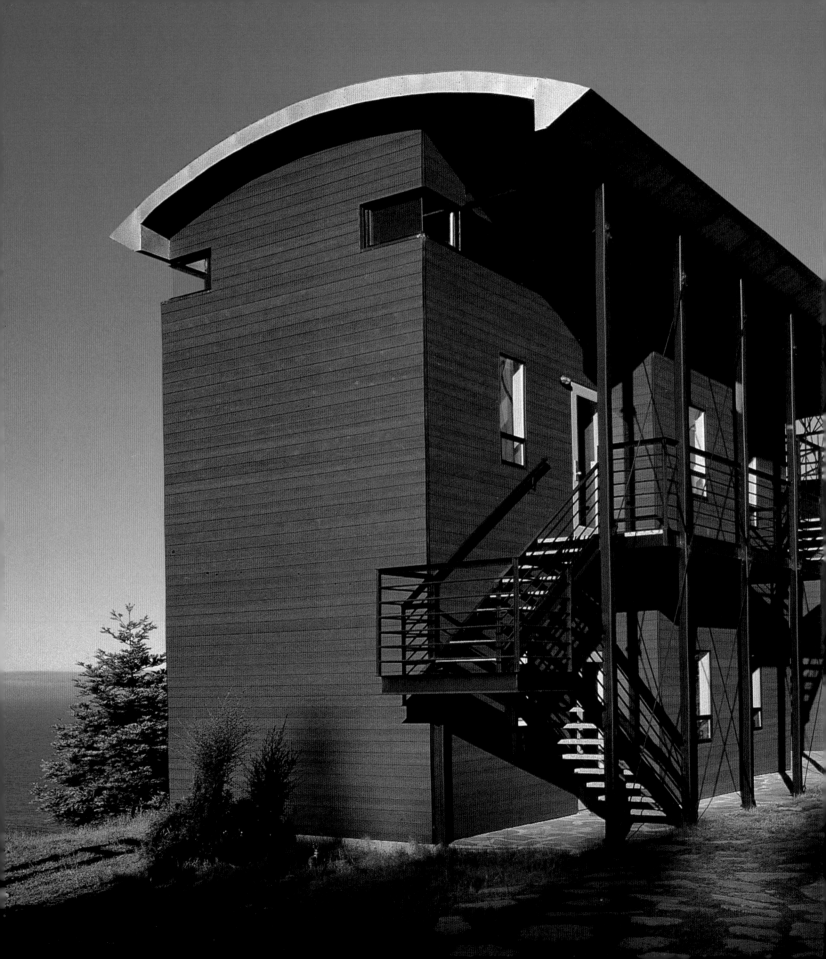

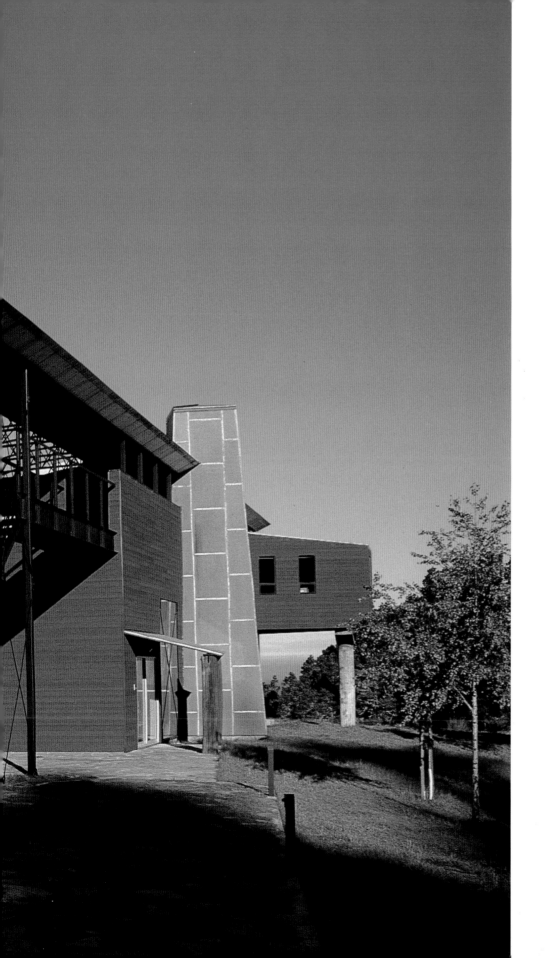

Stewarts Point
Beach house
Joan Hallberg, 1992

At the southern threshold of Sea Ranch, 350 feet above the ocean, stands a house that is as rugged and dramatic as the coastline it overlooks. Three redwood pavilions are bolted to a concrete base and linked by a bowed metal vault that is raised above a central roof terrace and connecting walkways. Its linear plan and blunt forms evoke the sawmills that occupied this natural ledge when the forest was being cleared for ranching, just as the Moore, Lyndon, Turnbull, Whittaker condominiums in Sea Ranch suggest barns or mine housings. However, in both instances, the architects were responding more to the site than to historical references, looking for ways to fit their buildings into the landscape.

When the client picked Joan Hallberg, an architect who was then practicing locally, he told her to design something "a little different from the Sea Ranch vernacular. I didn't set out to provoke a controversy," he recalls "However, I told

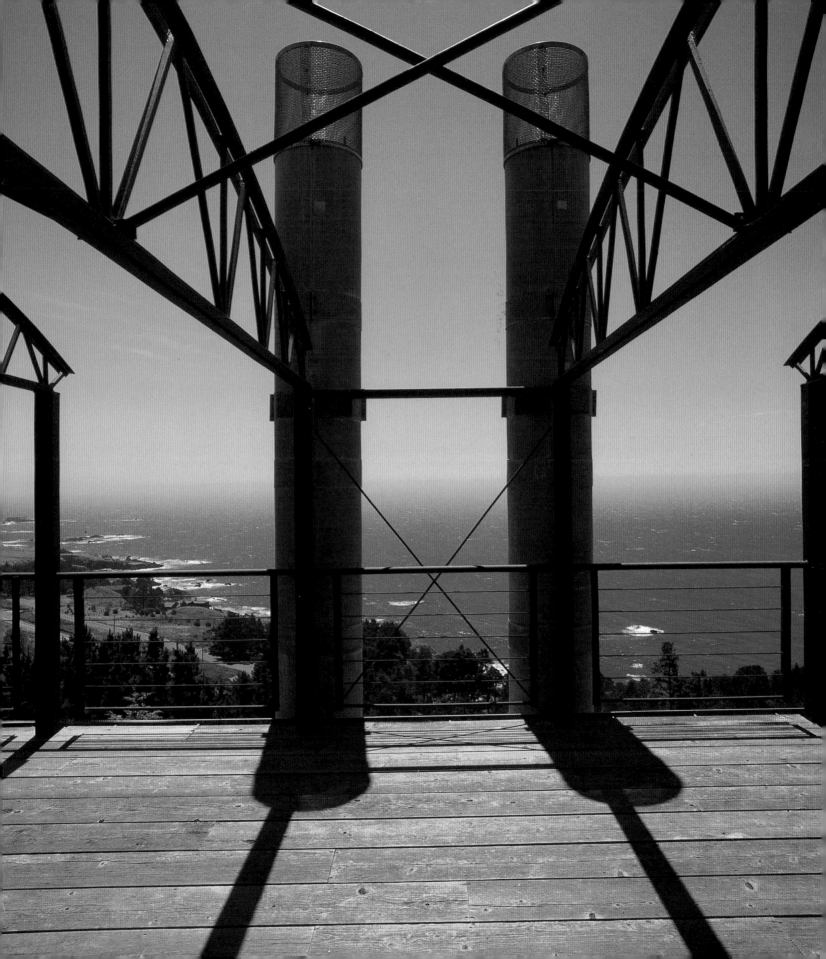

her: 'If we do a house that everybody likes, it's a failure.' We did not fail." Beyond the controversial design itself, the owner sparked even stronger criticism by clearing a stand of diseased bishop pines that blocked his view of the sea. Now that the house has weathered and trees again conceal it from the highway, the protests have subsided—but they showed how obsessed people can become with the familiar. Sea Ranch began by breaking away from the tame and conventional when there was no one around to object; now it's become a settled, rather self-conscious community.

Despite the contention she stirred up, Hallberg made most of the right choices for this elevated, exposed site. The house respects the landscape by standing up to it;

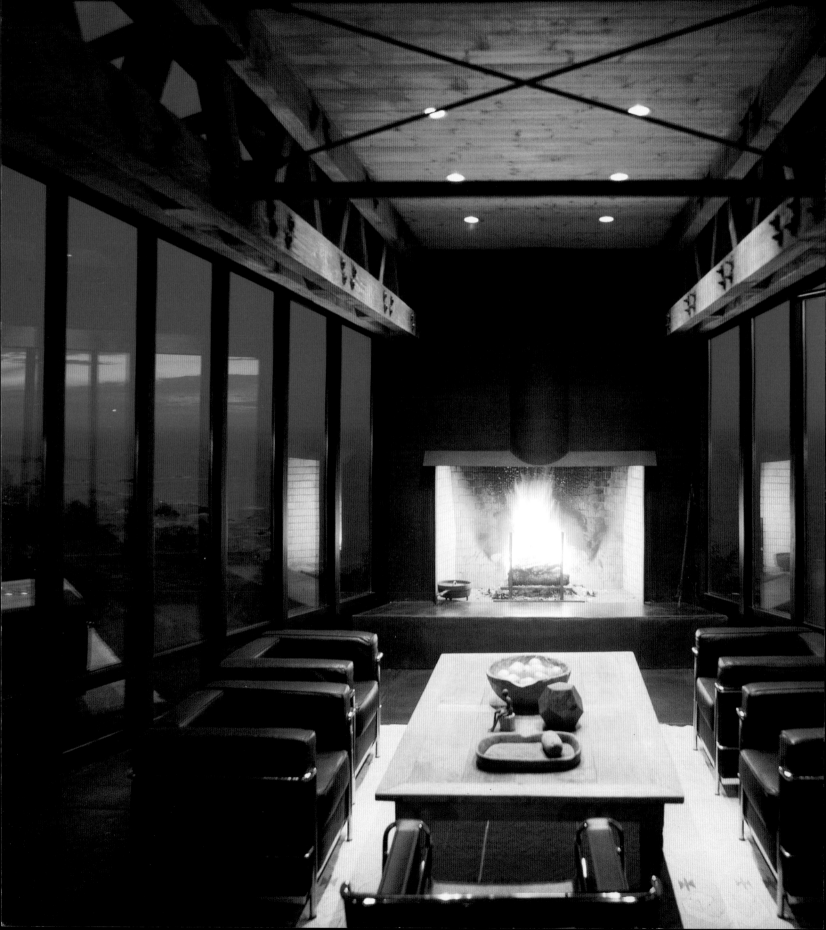

something gentle or picturesque would have seemed puny from below. The massive structural frame of timber and steel beams withstands the battering of the winds that blow up and down the coastal strip. The gaps between the three pavilions—and the way they seem to dissolve into an airy superstructure—break up the mass of the seven-thousand-square-foot house, ensuring privacy for owners and guests.

Hallberg's greatest challenge was to create a low-maintenance, energy-efficient house that was open to nature but resistant to the occasional extremes of heat and damp cold. Every element of the house was carefully designed to achieve this goal. The east pavilion has two floors of guest rooms above the garage. The central living room is fanned out to narrow the south-facing opening and reduce the wind-tunnel effect. A sunken, fully glazed dining room links the living area to an expansive open-plan kitchen. This leads into a steel-framed glass solarium that juts forward like a ship's prow, with a hearth at the point, creating an ideal space for entertaining. The projecting room shelters the south-facing terrace, which is shaded by a plastic canopy. Above is an office and the master suite. Massive, open-web wood trusses over the principal rooms brace the structure against the pressure of winds off the ocean. Energy regulations limit the amount of glass, so this is concentrated in the living areas, and the bedroom windows are kept small. Openings in the double glazing permit cross ventilation and convection cooling in summer.

Each room has a different height, and this creates a constant shift of scale and perspective as you walk around and through the house. The corrugated metal roof canopy with its stainless-steel knife edge floats free of the three pavilions, except for a pair of chimney flues and a hexagonal stair tower. Like the rocks on the shore, the house is massive yet hollowed out, giving it a poetic aptness that transcends all considerations of style.

Southern California

As you drive south along the Pacific Coast Highway from Big Sur, past Hearst Castle at San Simeon, to Santa Barbara, the shore remains almost as wild and undeveloped as it is to the north. By contrast, the last 250-mile stretch is increasingly crumbly, as the rocks turn to shale and are ground down by wind and wave to create wide sandy beaches. In the absence of cliffs, sounds, or barrier islands to hold development at arm's length, the coast becomes increasingly urbanized. "Surfurbia" was the term that Reyner Banham, a sharp British observer of California, coined to describe the succession of beach towns that meander down the coast from Santa Monica, through Manhattan and Huntington beaches, to Balboa Island. The marine base at Camp Pendleton interrupts the flow, but it resumes just north of San Diego and continues on to the Mexican border.

This is the land the Beach Boys celebrated, the domain of the surfer and lifeguard, of hedonists on beach towels and Rollerblades, of the body beautiful and a tide of suntan oil. Each community has its own character, but the beach itself is open to all, a public realm to be shared by bums and moguls, gilded youth and immigrant families, all taking refuge in their

undress from the privatized and economically segregated city. For Los Angeles in particular, it's an important safety valve: a release from stifling tenements and gridlocked freeways, race tensions and an absence of public parks and squares. Despite the pollution scares, pervasive fog through early July, and scarce parking, everyone goes to the beach and finds in it fulfillment, whether through nudism or volleyball, exercising a dog or working out, lazing or building sand castles.

Southern California
Oceanfront house
Andy Neumann, Architect, and
Carlson Chase Associates, 1995

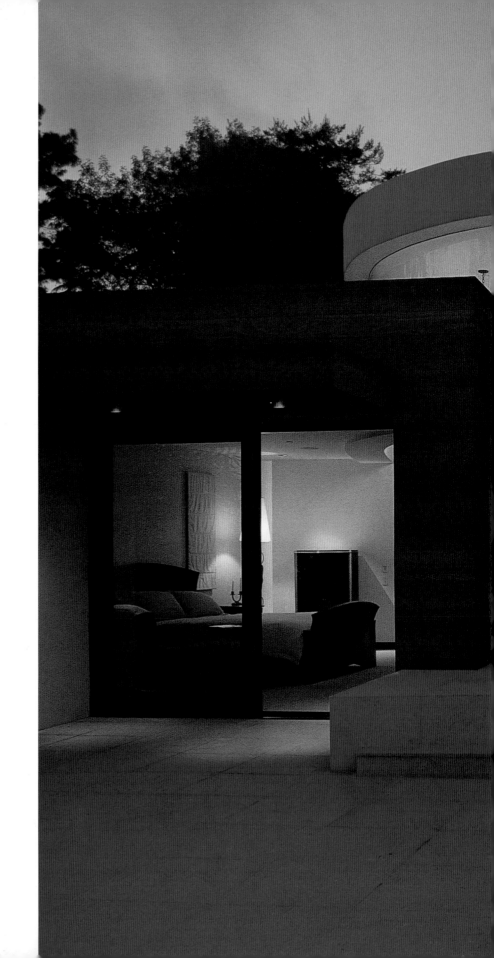

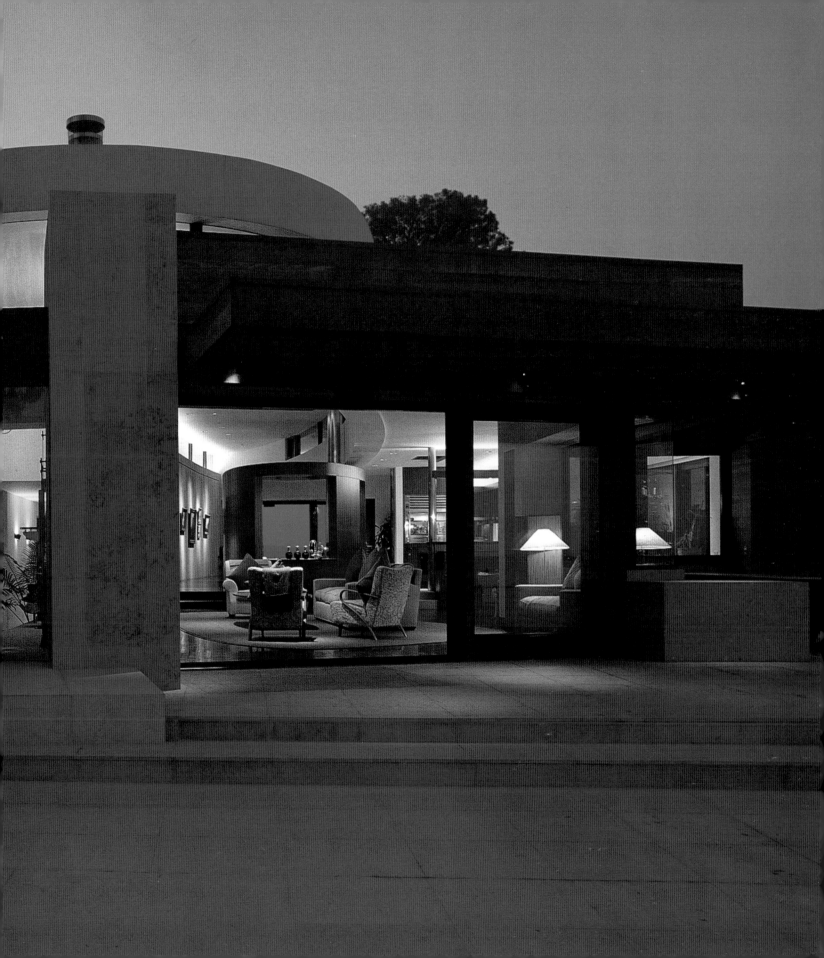

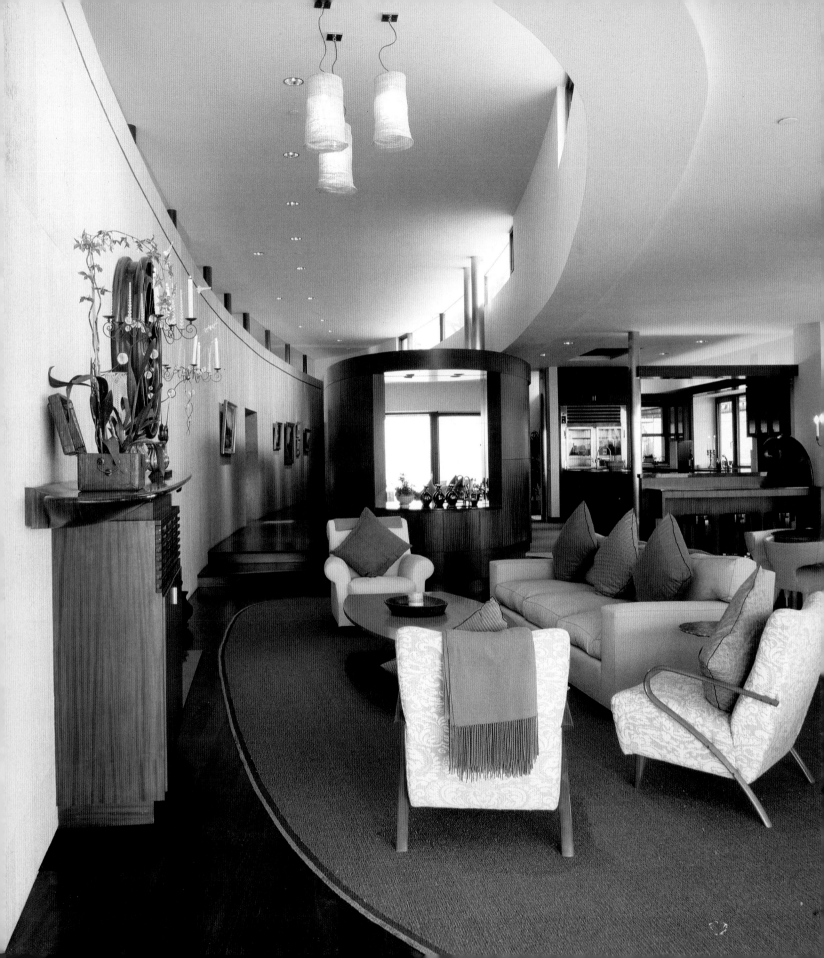

A couple with three small children asked architect Andy Neumann and designer Peter Carlson to give them an oceanfront house that was "practical, Japanese, and beachy," using natural materials to achieve a feeling of warmth and comfort. To shield the house from its neighbors, Neumann pushed solid walls to the edge of the lot and used a sinuous gallery and spinal wall to separate living spaces on one side from bedrooms on the other. "The site dictated what we could and couldn't do," he observes, "and the curved wall is like the backbone of the house, pulling together the trapezoidal rooms that radiate from it."

The house conceals its intentions, and the ocean view, from the grassy arrival court. You see nothing but an expanse of patinaed copper over the garage, a translucent window, and a projecting wall beside the entry drawing you inside. The sinuous curve of this wall echoes that of the beach it overlooks. Natural light floods in from expansive windows at the south end, which wrap around one corner and open onto a redwood deck. The glare off the ocean is balanced by an elliptical clerestory that projects up from the flat roof. For Neumann, "It suggests the strip of sky over the wall that shelters

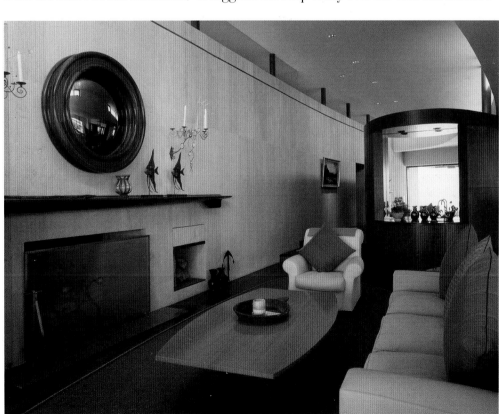

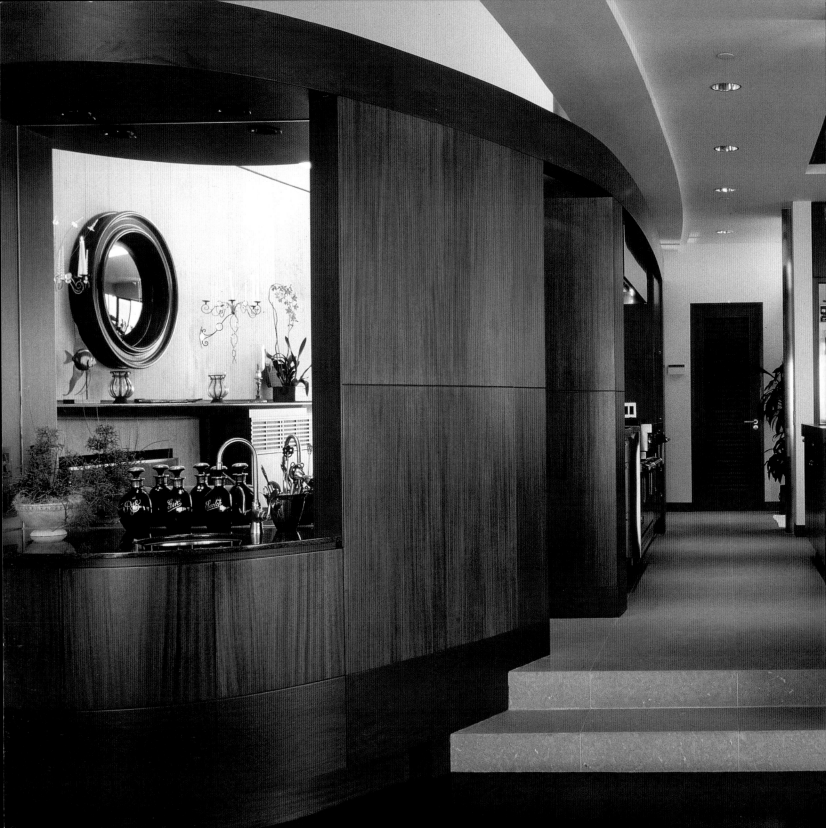

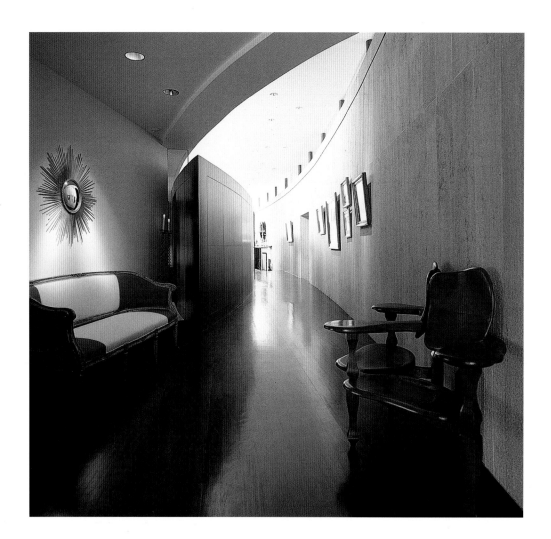

the inner patio in a traditional Spanish house." It also becomes an integral element of the interior as it casts a constantly shifting loop of sunlight on the wall, creating a sparkle in the flecks of mica embedded in the stone.

Carlson had designed a restaurant for the client and he became involved at an early stage of the design, helping to select materials and a palette that would achieve a sense of unity and flow within the 5,100-square-foot house. He worked with the architect and client to select raked Cluny gris French limestone for the walls, and mahogany (from sustainable forests) for the floor, cabinetry, and a central boatlike pod that contains the pantry and laundry room. The juxtaposition of rough and smooth, flat and curved surfaces reinforces the feeling that you've walked into a seashell.

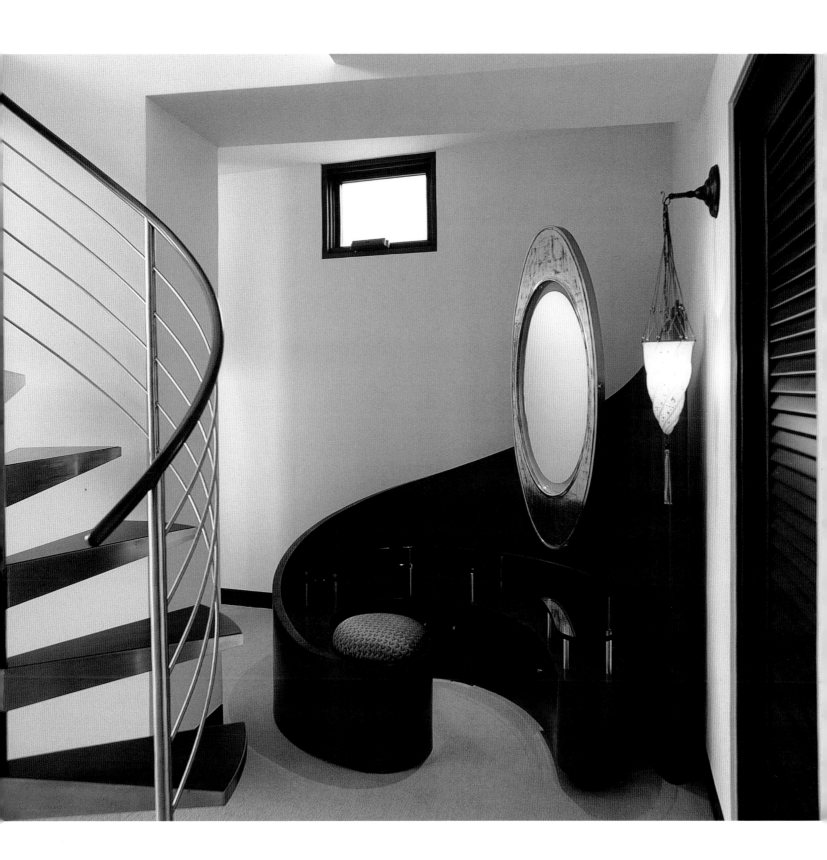

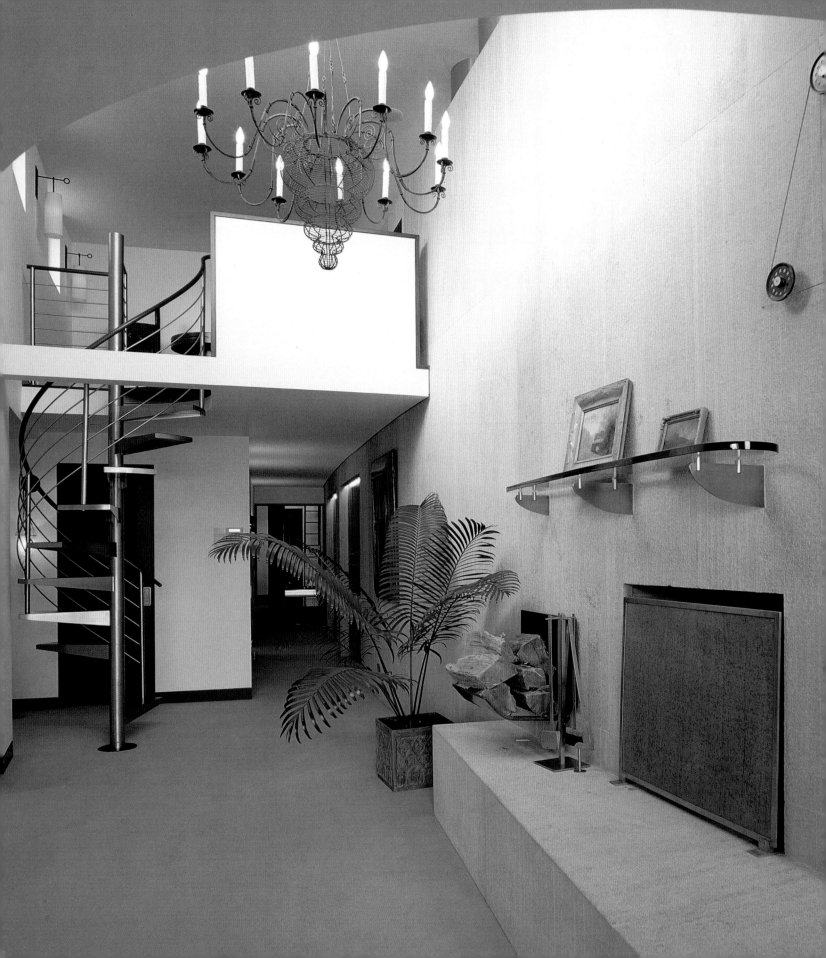

The client asked for cotton upholstery to accommodate kids in wet bathing suits and the relaxed lifestyle of a beach house, and Carlson picked neutral sand and putty tones for the fabrics and carpets. Subtle textures enrich the simplicity of the living areas, and low-key furnishings are enlivened by whimsical accents, including a mantel in the form of a vintage surfboard, and an early-nineteenth-century French chandelier of turned wood spools. A few one-of-a-kind pieces are strategically placed throughout, notably a 1930s French daybed, with a circular back panel covered in shagreen, which occupies a niche in front of a window that frames a walled Japanese garden.

In the master bedroom, Carlson has paid homage to legendary European designers. The custom-designed sleigh bed has swiveling side tables inspired by Pierre Chareau, a floor lamp is modeled on the designs of Jean Royère, and a pulley system on the fireplace owes a debt to Carlo Scarpa. A spiral steel stair leads up to a small mezzanine-level study, simply furnished with a Depression Moderne oak desk and chair.

Neumann and Carlson have created an appealing mix of serenity and informality, understated refinement and outdoor living—plus one delightful surprise. The architect remembered how, as a small boy growing up in Holland, he used a cardboard periscope to look over the heads of the crowd and watch the queen ride by. Here, he has re-created that periscope on a large scale to bring light and a glimpse of the ocean to the guest bedroom at the back of the site.

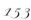
153

Santa Monica
Lewin house
Richard Neutra, 1938; extended
by Steven Ehrlich Architects, 1998

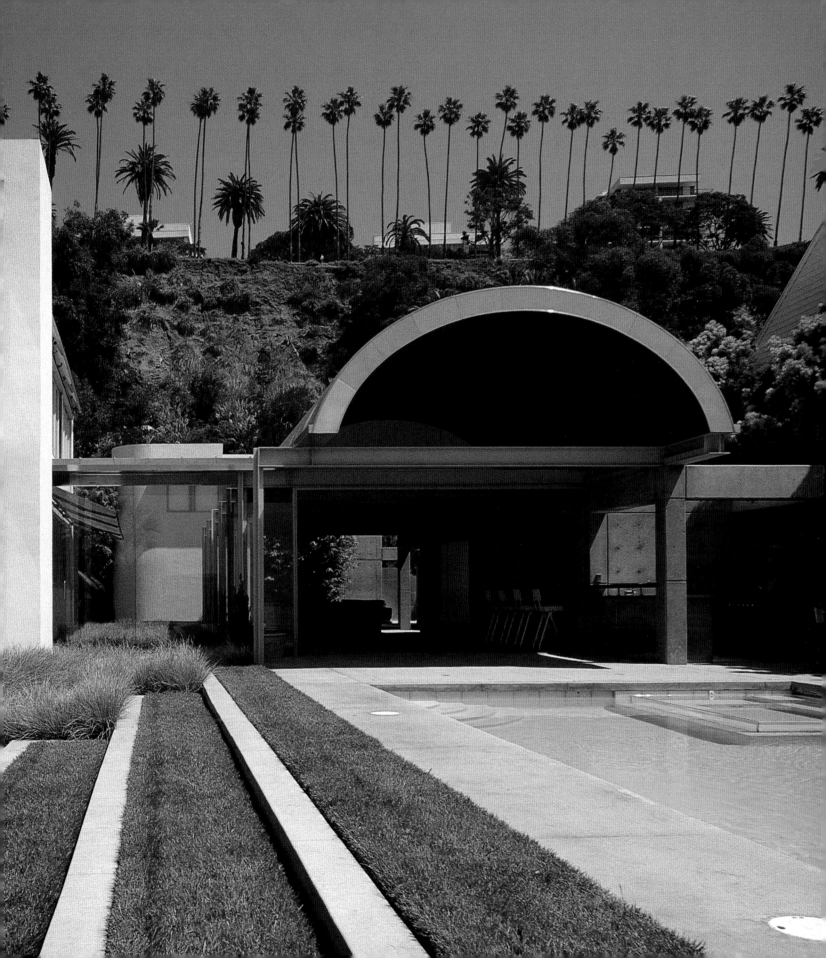

In the decades between the two world wars, Hollywood's aristocracy weekended at the beach below the Santa Monica Palisades, building ramshackle houses and partying with their peers. Silent-star Norma Talmadge was one of the first, entertaining A-list guests from Fatty Arbuckle to Rudolph Valentino, and her spread later became a bachelor retreat for Cary Grant and Randolph Scott. Battered fragments of compounds built by the studio chiefs, and by William Randolph Hearst for his mistress, Marion Davies, still survive, and this movie-set mix of English Tudor and Spanish Colonial includes one modernist gem: the 5,800-square-foot beach house that the Austrian émigré architect Richard Neutra designed for Albert Lewin in 1938.

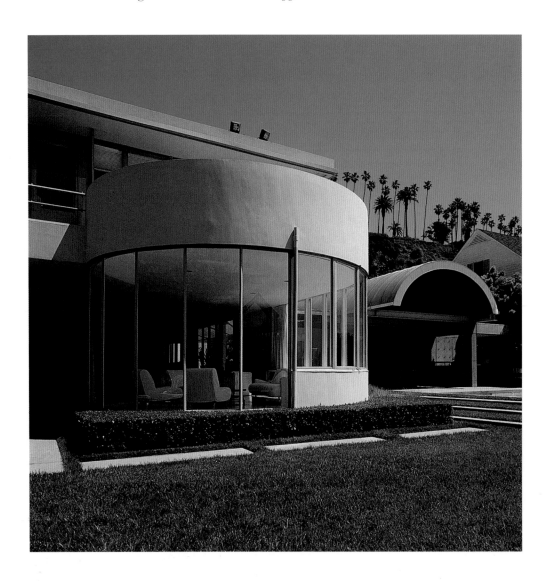

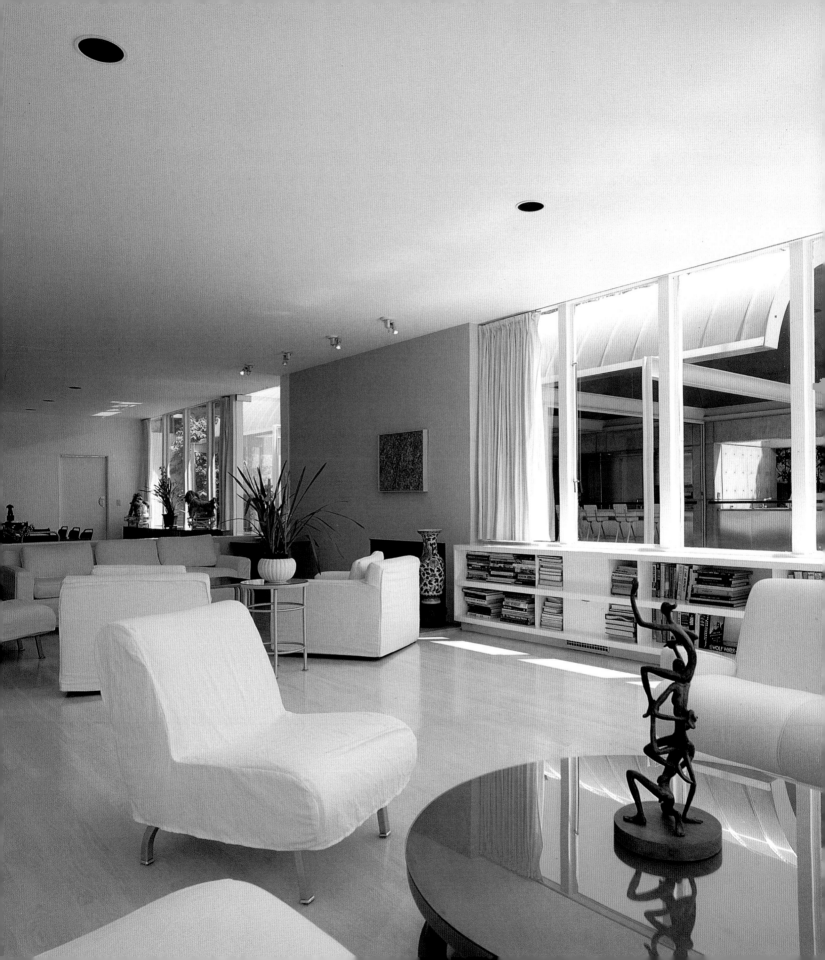

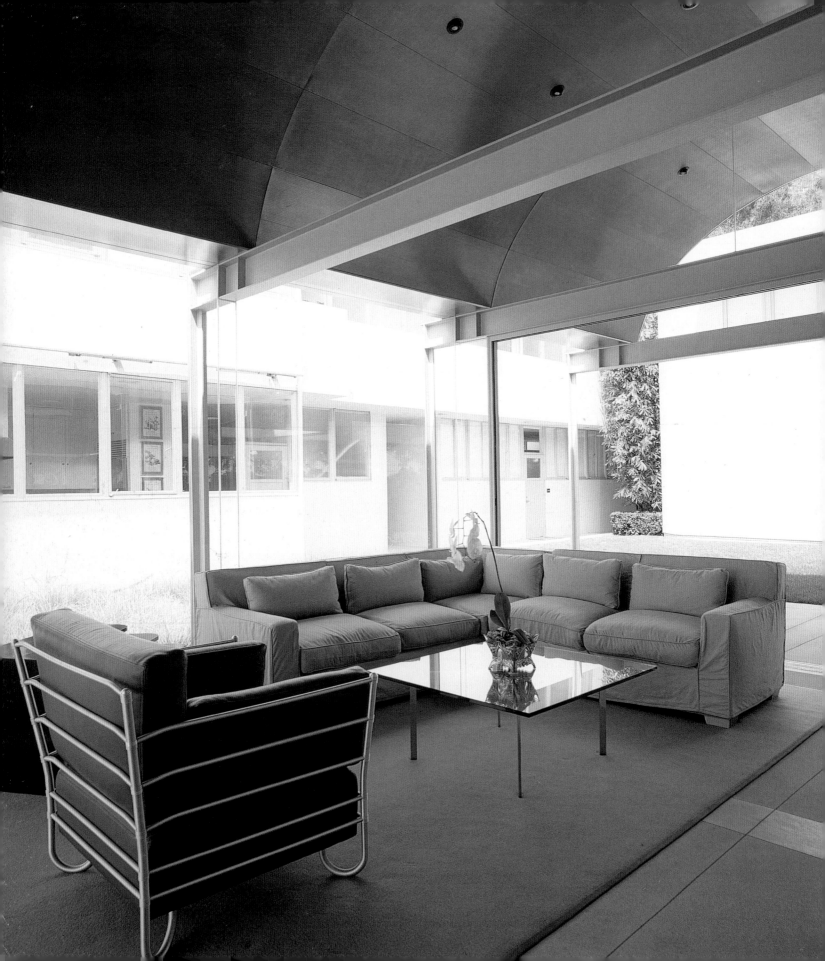

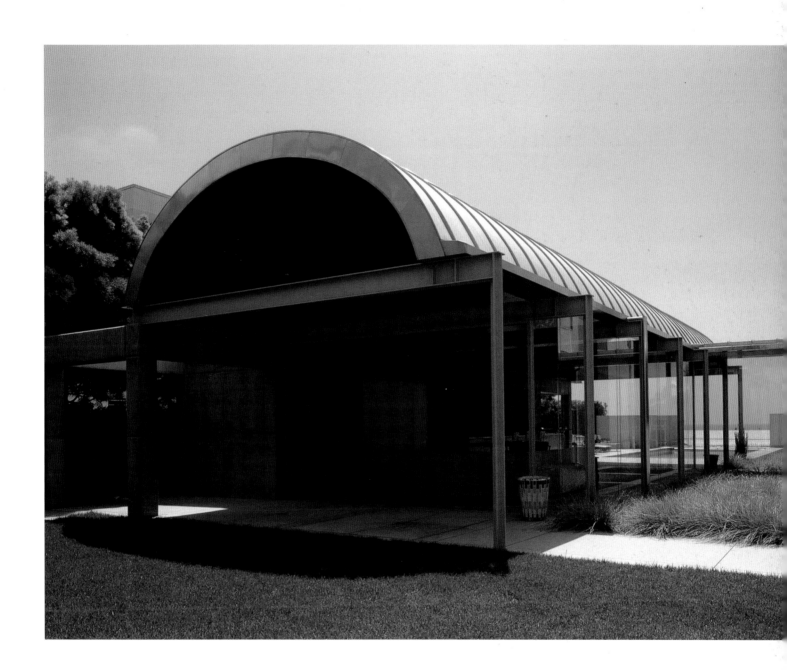

Lewin was Irving Thalberg's closest associate during that boy wonder's brief reign as head of production at MGM in the early thirties. He produced the prestigious *Mutiny on the Bounty* and *The Good Earth,* then moved to Paramount as a writer-producer-director, commissioned this house, and built up his collection of modern art. Max Ernst, Man Ray, and Jean Renoir dined here; later, Mae West lived here. In 1984, Gwathmey Siegel was commissioned to add a pool surrounded with Mexican tiles, a black granite hearth and bookshelves, dark gray, brown, and green walls. However, the changes were only skin-deep. The present owners bought it in 1988 and resolved to restore the integrity of this treasure, which recalls the sleek black-and-white elegance of a Fred Astaire set.

"My reaction was 'I have to have this house,'" the wife recalls, "even though it was too formal for present-day living, and intolerant of wet bathing suits, bare feet, and sand. When I had a child I considered moving to something tougher." Providentially the neighboring lot was auctioned off by the State of California, and the couple seized the opportunity to build new space for entertaining, additional parking, a guest apartment, and staff quarters—all integrated with an enlarged garden and a new pool. She interviewed local architects and selected Steven Erhlich, who had launched his practice in 1981 by building a studio next to Neutra's Loring house in the Hollywood Hills.

"It's important to understand the original and to complement it," says Ehrlich. He and project director Jim Schmidt extruded a guest bedroom over rebuilt garages, creating a seamless join, and extended the housekeeper's apartment over a second double garage. This provided parking on the busy highway, and the impassive new street front of white stucco, poured concrete, and brushed stainless steel helps shut out the roar of traffic, allowing you to hear the roar of the surf.

Behind this addition, floating like an ark in a sea of grass, is a pavilion with a curved stainless-steel vault, perforated on the underside to absorb sound, which subtly echoes the rounded glass bay of the house. The vault is supported on the inner side by slender steel outrigger columns, and to the south by massive concrete walls that enclose a kitchen-buffet and a sleek bathroom with a scooped steel sink that mimics the vault. A transparent walkway links it to the house, and the glass walls at either end can be fully retracted to open the interior to ocean breezes. The pavilion leads out to a pool and on to a motorized stainless-steel gate in the garden wall that slides open to reveal a lifeguard

station on the strand. Ehrlich describes his additions as "a dance between symmetry and assymetry, energy and repose."

The pavilion provides all-weather shelter for black-tie receptions and beach parties as easily as it does for games of Space Invaders. It has taken the strain off the old house, which has been buffed and polished, and furnished with museum-quality aluminum-framed chairs, chaises, and tables by Warren MacArthur, Neutra's contemporary, and other modern classics. Bathrooms and dressing rooms survived the years in their original state, and they provide the cues for the addition of period sconces in the corridors. In the pavilion, McArthur's high stools are drawn up to the bar, and one of his armchairs joins other pieces on a gray rug, giving you a sense of being indoors and outdoors at the same time.

"We didn't want a trophy house, but we got a powerful piece of architecture and a lot of sensible improvements that make the whole house more livable," say the happy owners.

Capistrano Beach
Glass house
Rob Wellington Quigley,
Architect, 1989–93

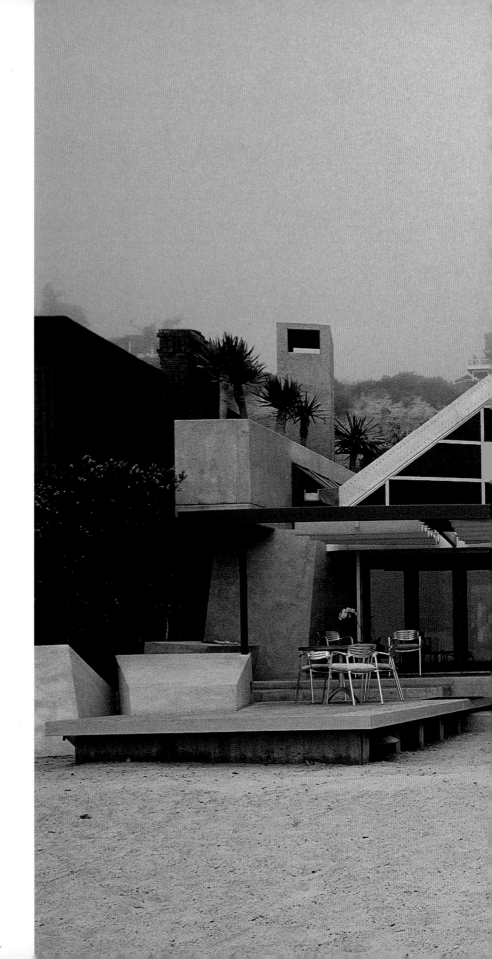

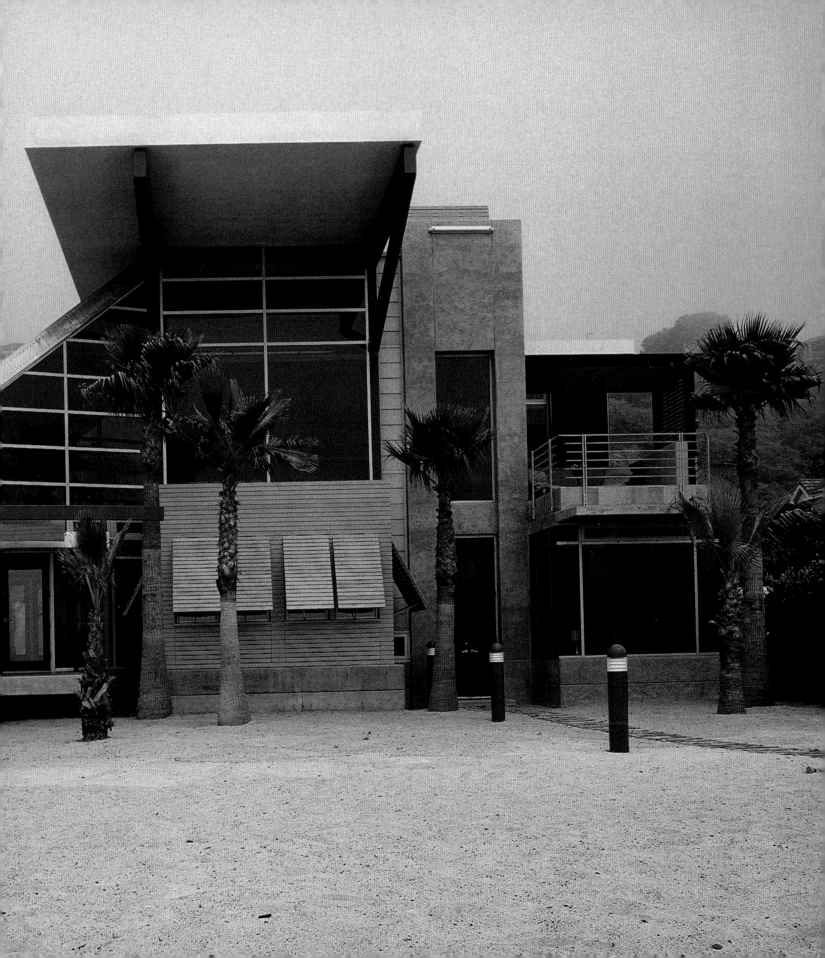

Rob Wellington Quigley is an architect with a conscience, who has won awards for affordable housing in his native San Diego as well as for his modestly scaled public and institutional buildings. Yet his finest work may be this powerful, meticulously crafted beach house, located between a broad sandy beach and windswept bluffs. The clients wanted a rigorous structure of concrete, steel, and glass—a work of art to showcase their collection of contemporary paintings and sculptures. They loved the idea of a greenhouse, yet they needed solid walls and protection from the glare of the sun and the corrosive salt air. And they asked their architect (chosen because "he seemed to listen to what we had to say") to capture the excitement of living at the edge of the ocean.

These contradictory demands stimulated Quigley, whose inspiration soared. He draws you in through a blank facade, around a curved translucent Kalwall screen, and into a pitched tent of glass. The transition is artfully choreographed, moving you around the triple garage with two guest suites above, into a walled garden that is dominated by a massive rock, and slowly disclosing what lies behind. Solid walls to north and south define the edges of the narrow site, and curved or eroded forms to east and west dramatize the shifting natural boundaries. On the beach side the house has a massive sculptural presence that is enhanced by its small, traditional neighbors. Smooth concrete blocks seem to tumble down from the chimney like a rock cascade. A boldly jutting roof plane shades a huge expanse of glass and is balanced by a canopied deck over the projecting dining room.

Though the house encloses only 3,700 square feet, it feels much larger, thanks to the soaring volume and complex geometry of the great room. To anchor the house in sand with a minimum of caissons, concrete floor slabs are cantilevered off a two-story poured concrete spine. This is expressed as a linear sequence of square columns marching two by two from front to back. The gray concrete columns and massive walls have the rough texture of a beach pebble, and this plays off the tan limestone pavers, the muscular steel frame of the glass vault, and the asphalt shingles that wrap the wood-frame second-story bedroom walls, inside and out. The most innovative feature is the glass canopy, a sandwich of two tinted layers, one printed with tiny dots to eliminate glare and 99 percent of ultraviolet rays, the other embedded with microscopic pieces of metal to deflect solar heat. No shades are needed to protect the

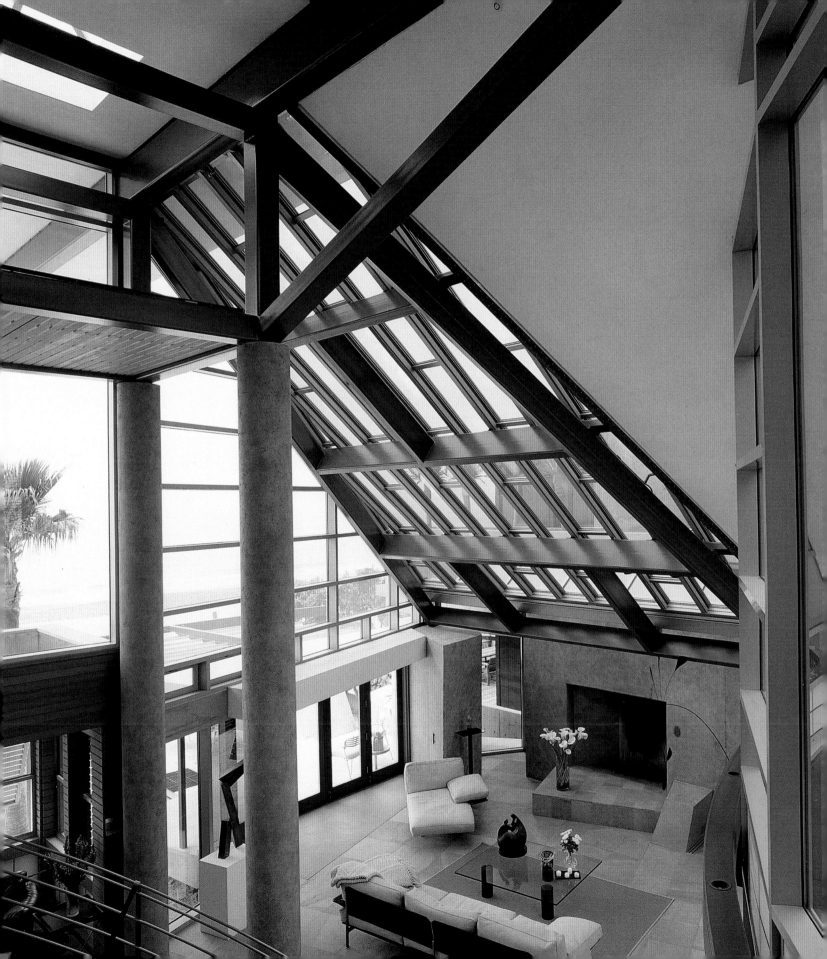

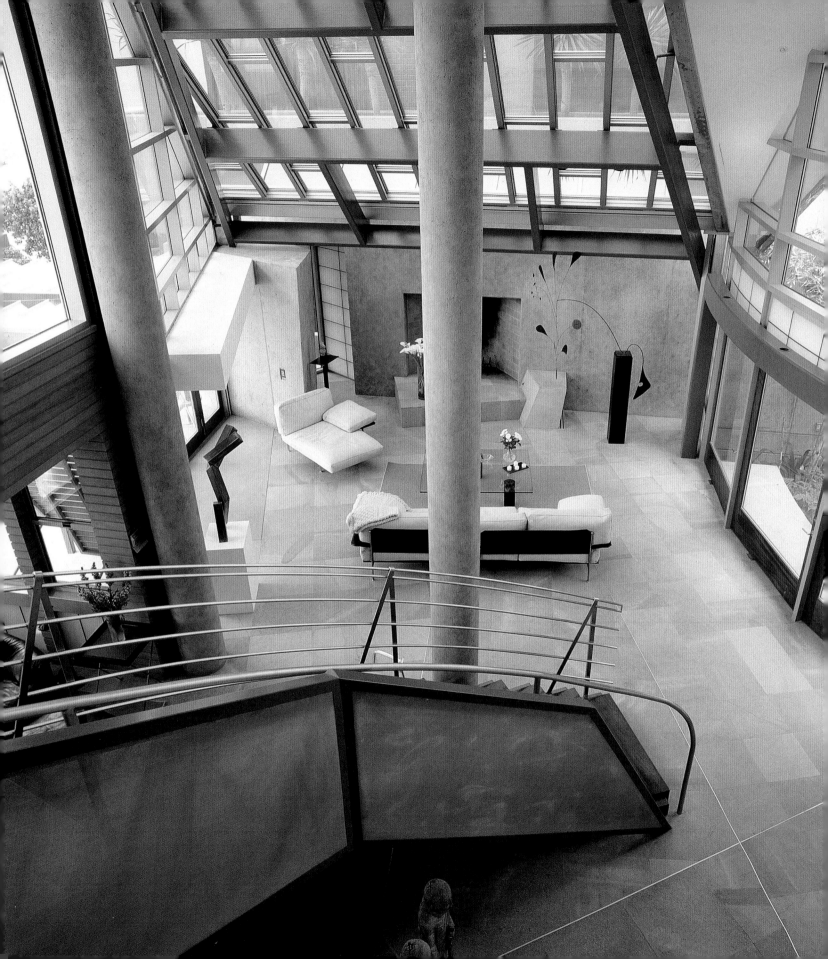

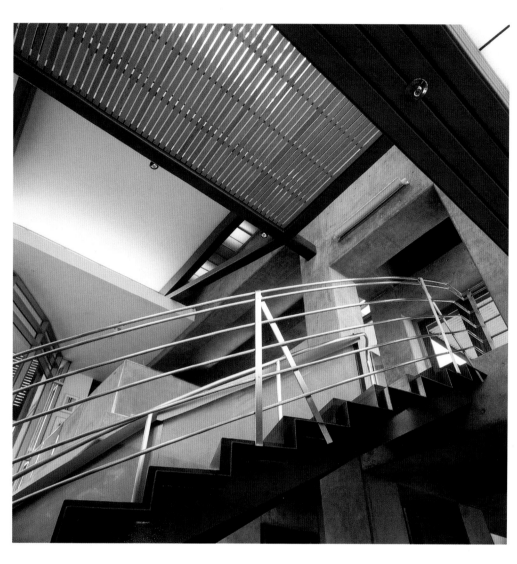

art, even when the sun is shining directly in. "Ten years ago, this technology didn't exist," says Quigley, "and it would have been impossible to build this way."

A curved staircase with mahogany treads plays off the curved glass wall with its pivoting windows opening onto the front yard. Other windows can also be opened to provide cross ventilation and evacuate hot air. The skylight above the stairs is shaded by suspended redwood battens. The master suite occupies most of the mezzanine, and the progression of deck, bedroom, dressing area, bath and circular shower (with a slit window for views and morning sun) are separated by the concrete spine from a tiny office that is cantilevered out over the living room and enclosed with a steel mesh balustrade.

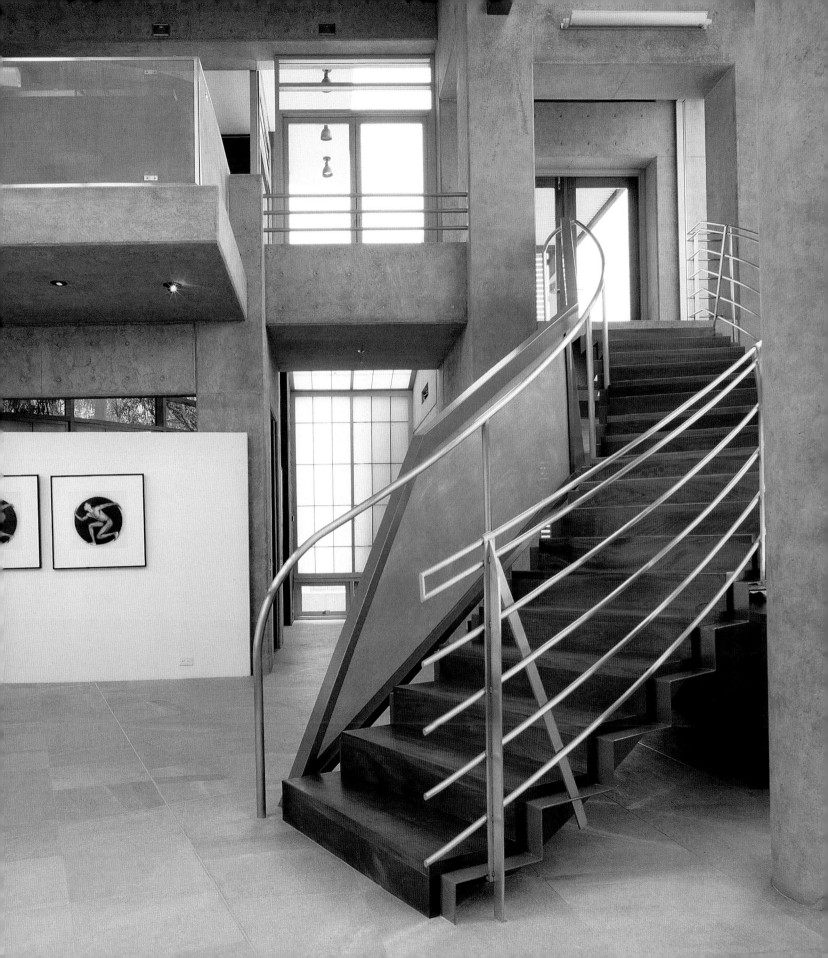

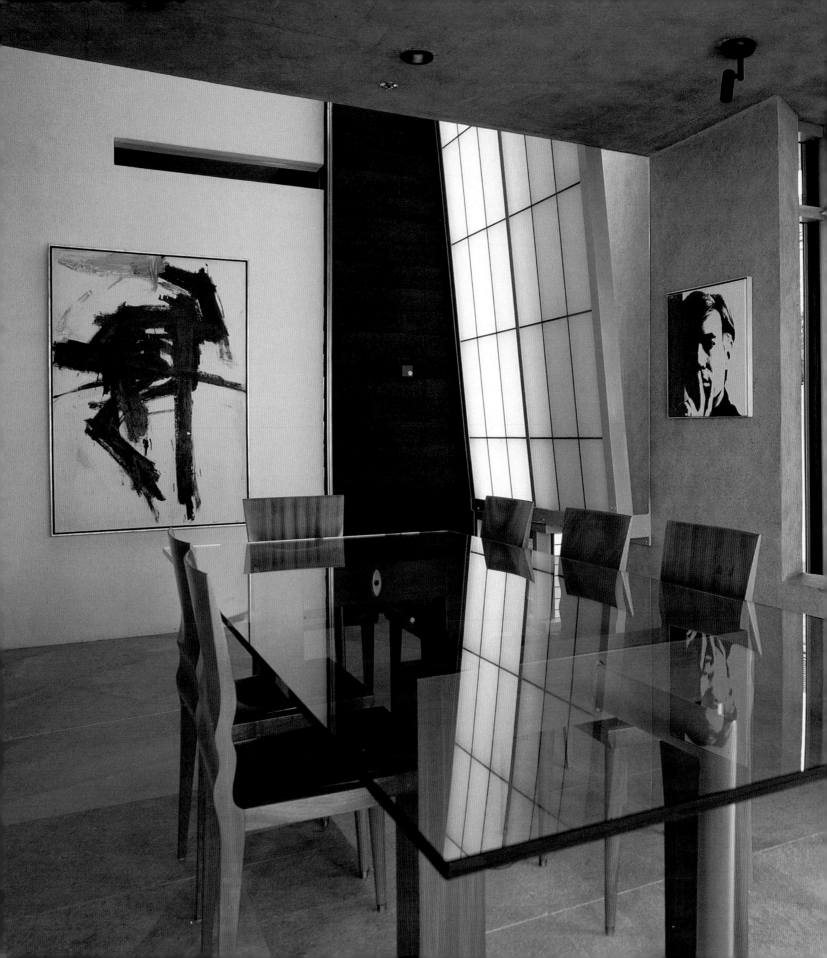

Away from the central volume, the house has an intimate scale. A tiny media room projects out to the beach and is shaded by wooden slatted shutters that can be propped up like jalousies to admit cool breezes and bars of sunlight. It's the perfect retreat on a hot summer day and was inspired by the miradors (screened balconies) of the Spanish Colonial Torre Tagle Palace in Lima, which Quigley explored on a trip to Peru. Most of the art is also modestly scaled. A bedside Giacometti is juxtaposed with a row of primitive clay figures, and a pre-Cycladic marble head called *Stargazer* complements a tiny sketch by Roy Lichtenstein. On a larger scale, there's a Calder mobile and a massive abstracted bronze figure by William Turnbull, silhouetted against the Kalwall screen.

These artworks bring an intensely personal character to a house that itself resembles a massive sculpture—a kind of man-made rock on the shore.

171

Malibu

The recently incorporated city of Malibu straggles for twenty miles along the Pacific Coast Highway, much of which was blasted from the hills that hug the ocean. It was named by the Chumash Indians and became a Spanish land grant, the Rancho Topango Malibu Sequit. In 1891, Frederick H. Rindge, the frail heir to a textile fortune, bought a sixteen-thousand-acre tract (over three times the spread of Sea Ranch) hoping to develop what he called a "California Riviera." Like so many dreamers, he died (in 1905) before he could begin, but his widow, Mary Knight, determined to keep it for herself. She built her own railroad to exclude the Southern Pacific, tore up roads, and patrolled the fences on horseback. For twenty years she fought demands for a public right-of-way until her fortune was depleted and she lost her last appeal to the Supreme Court. The coast highway was built, but she may have put a curse on it, for the six lanes are repeatedly blocked by rock and mud slides, or menaced by wildfires that race down the canyons.

The name has evoked Hollywood glamour ever since Malibu Colony was established in the 1930s as an exclusive gated community, but many of today's grander estates are located far beyond that first enclave, and the houses that wall off the beach are as tightly serried and generally

undistinguished as barnacles on the pier, despite their soaring prices. Sandy beaches are punctuated by rocky headlands, and the commercial strip rapidly gives way to wild parkland. As in the Hamptons, great wealth is attracted by a pleasing sense of remoteness (though the farthest reaches of Malibu are less than an hour's drive from L.A. or the San Fernando Valley), natural beauty, and—something that does evoke the French Riviera, or even the Aegean—an extraordinary clarity of light.

173

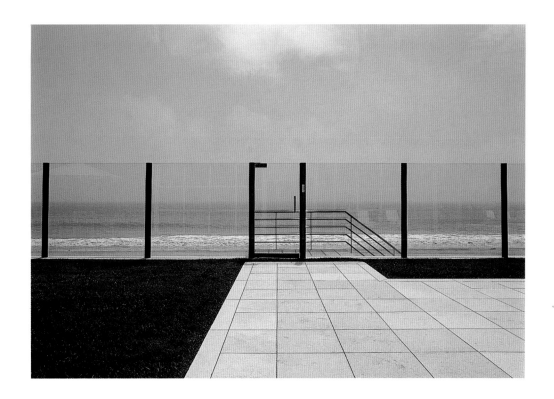

Malibu
Morton house
Kanner Architects,
1992–96

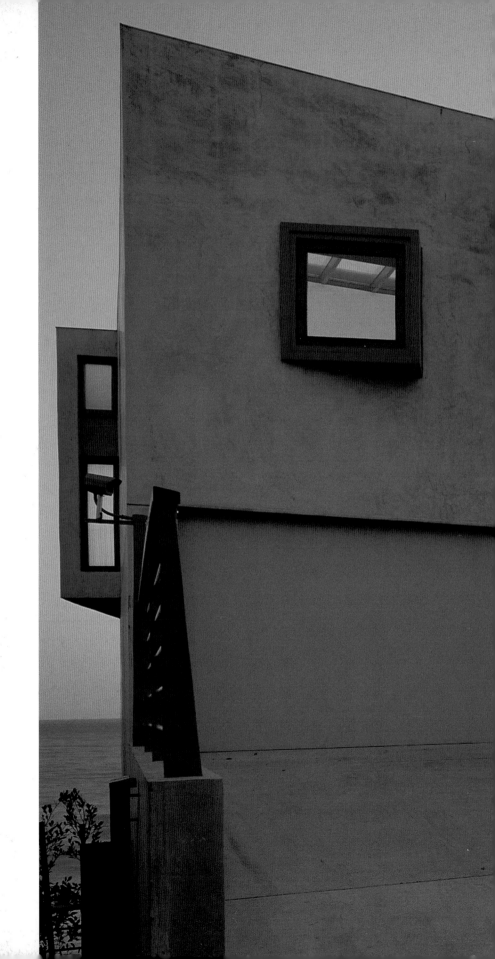

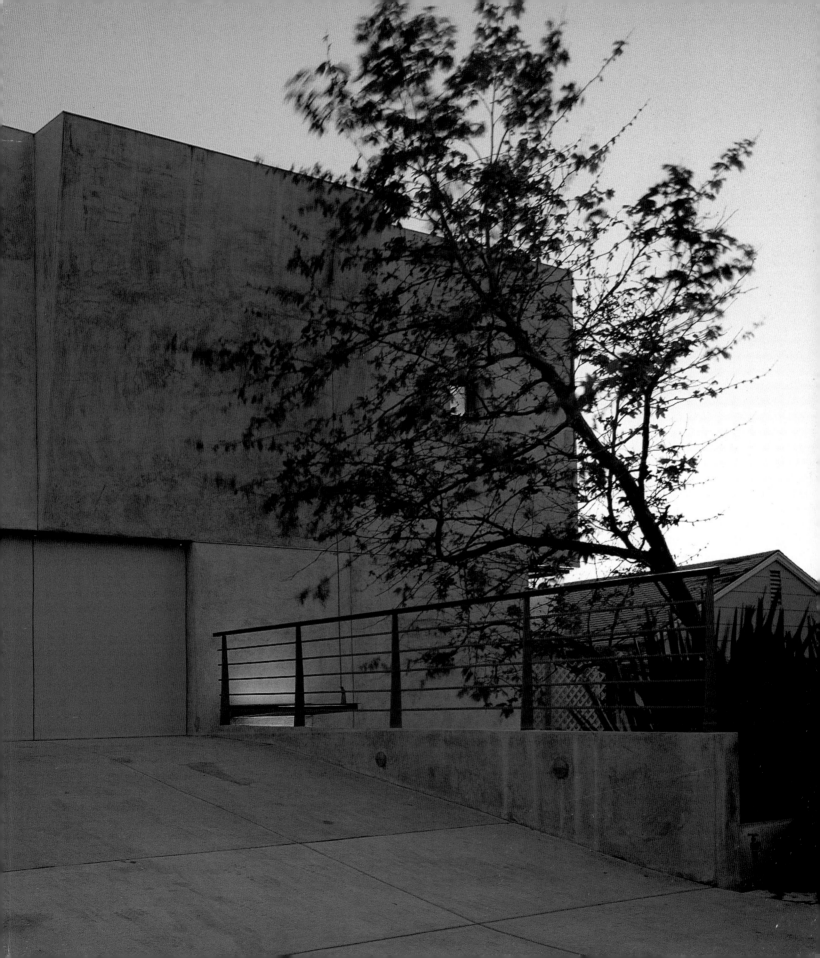

There's a positive side to the destructive power of nature, for new growth quickly pushes up from the ashes of a forest fire, and architects design stronger, sometimes better buildings to replace those destroyed by earthquake or hurricane. A major storm reduced the house that once occupied this oceanfront site to a cluster of pilings, and a subsequent owner commissioned Kanner Architects, an L.A. family firm that has built beach houses for themselves, to design a steel-framed, concrete-faced, 39-foot cube that would withstand the tallest waves and the insidious impact of salt air.

Unlike many houses on the coastal strip, this one is located on a quiet road off the PCH, sparing it the assault of traffic. However, it extends over the water at high tide, making it much more vulnerable to storms, and requiring that it be set up high on massive concrete caissons. The natural slope is so steep that you enter at the middle level, and the drop from the street allowed the architect to add an extra level and still remain within the mandatory height limit. This deceptively simple gray box, with its surface grids of nine steel-troweled plaster

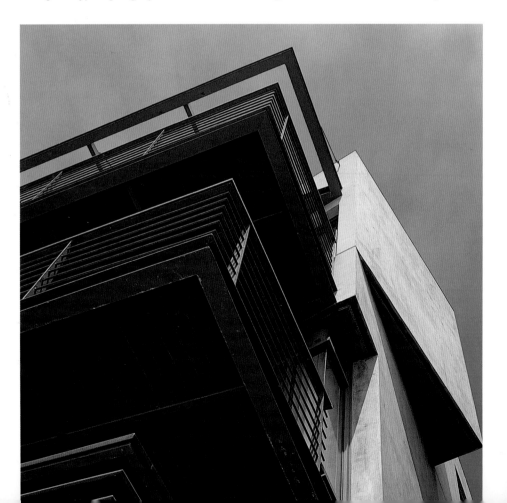

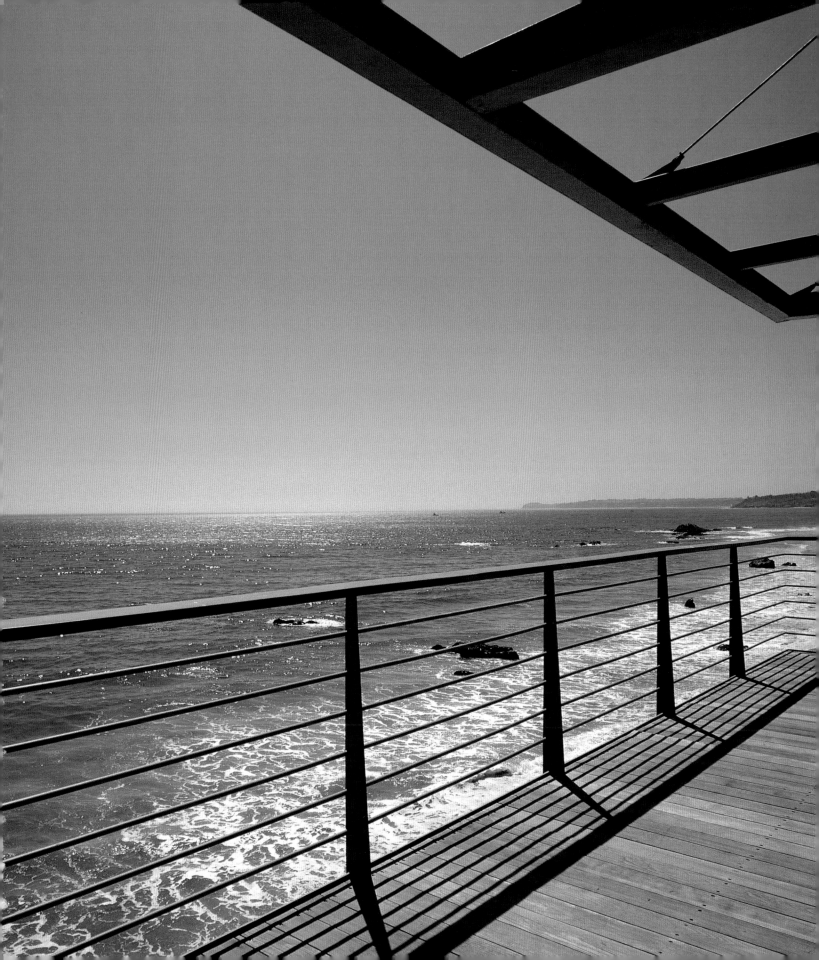

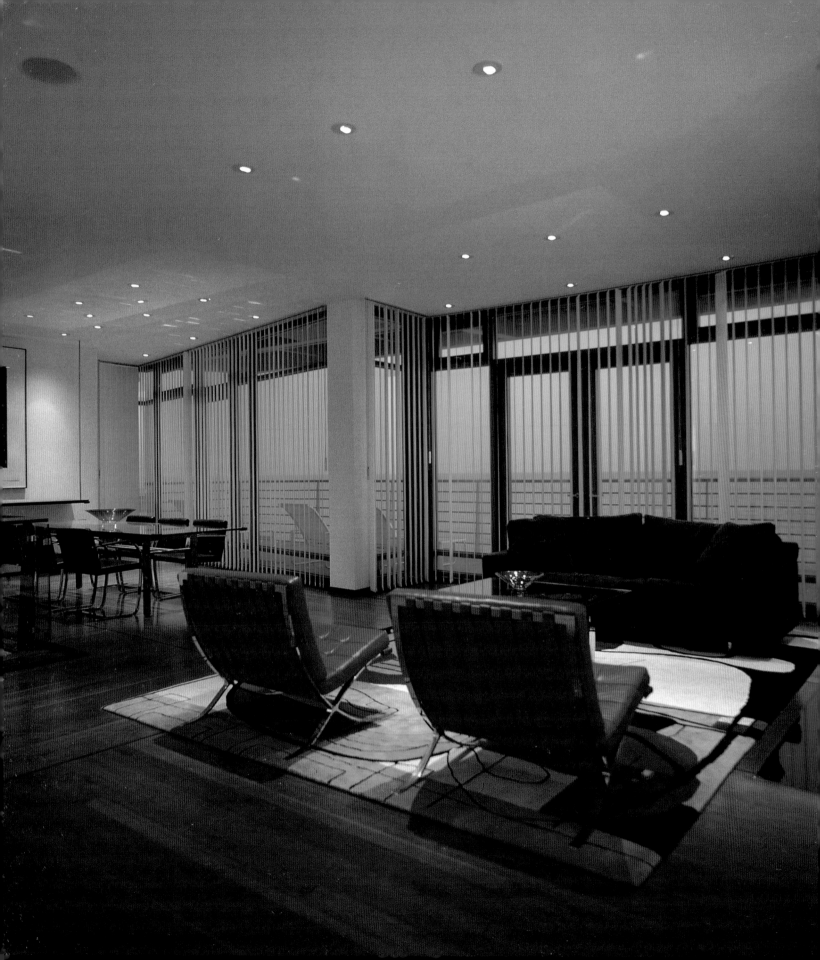

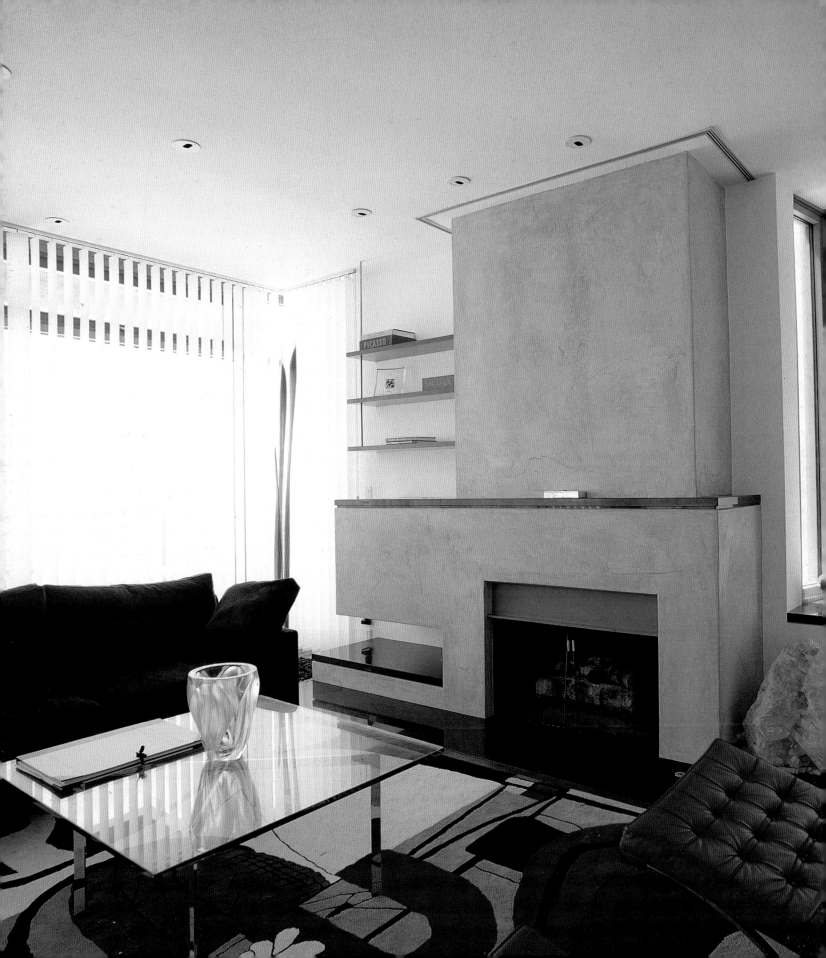

squares resembling a game of tick tack toe, was inspired by the bold concrete facade of Marcel Breuer's Whitney Museum in New York. One square on each side is fanned out, but other windows are positioned to pull in light and frame views, cutting across the grid and disguising the fact that there are four stacked levels at one corner. The solid walls assure privacy, in contrast to the open fourth wall.

"The house was meant to feel like a shell: protective on the outside, with a soft interior," says Stephen Kanner. "It's comforting for the owners to know that they can enjoy the drama of a storm but also feel secure when they close their doors. Like a marine creature, its surfaces and openings are a rational response to the environment."

Donald and Lorraine Morton, who had been shaken out of their house in nearby Pacific Palisades by the 1994 Northridge earthquake, bought the previous owner's plan along with the plot in order to avert a long wait for new building permits. Even so, minor modifications to the design took two years to approve, and construction extended over eighteen months, because of the architects' exacting demands. "The tolerances were down to a sixteenth of an inch," notes Stephen Kanner. "In a house like this, every detail shows, and several things had to be redone." He had the owners on his side. Dr. Morton is surgeon-in-chief and medical director of the John Wayne Cancer Institute in Santa Monica. Precision is an essential part of his life. "I'm glad the architects were perfectionists," he says. "If I had been in charge, I would have been just as exacting." Even the underside of the house as seen from the beach at low tide is impeccable, in contrast to the debris and ducts that cling to some neighbors, and the stack of three cantilevered decks makes a wonderful sculptural composition.

The house has a warmer and richer personality inside than outside. The kitchen on the main floor is a glowing enclave of cherry wood and polished black granite that is set three feet down to command an eye-level view of the ocean. The same wood is used throughout the house for floors and built-in cabinets, its color and grain complementing the white walls, the expanses of glass, and the glittering water. Rooms are stepped so that each is on a different level and you slowly become aware of the complex geometry that knits them together.

As an expert on melanoma, Dr. Morton avoids sitting out in the sun, but he loves the ocean. "We took a Mediterranean cruise, and this house feels like the ship we were on," he says. "Living here, we see whales, dolphins, seals, and cormorants. I find the soft murmur through the double glazing to be very stimulating. In a storm it's like having a front-row seat at a production of Verdi's *Otello*."

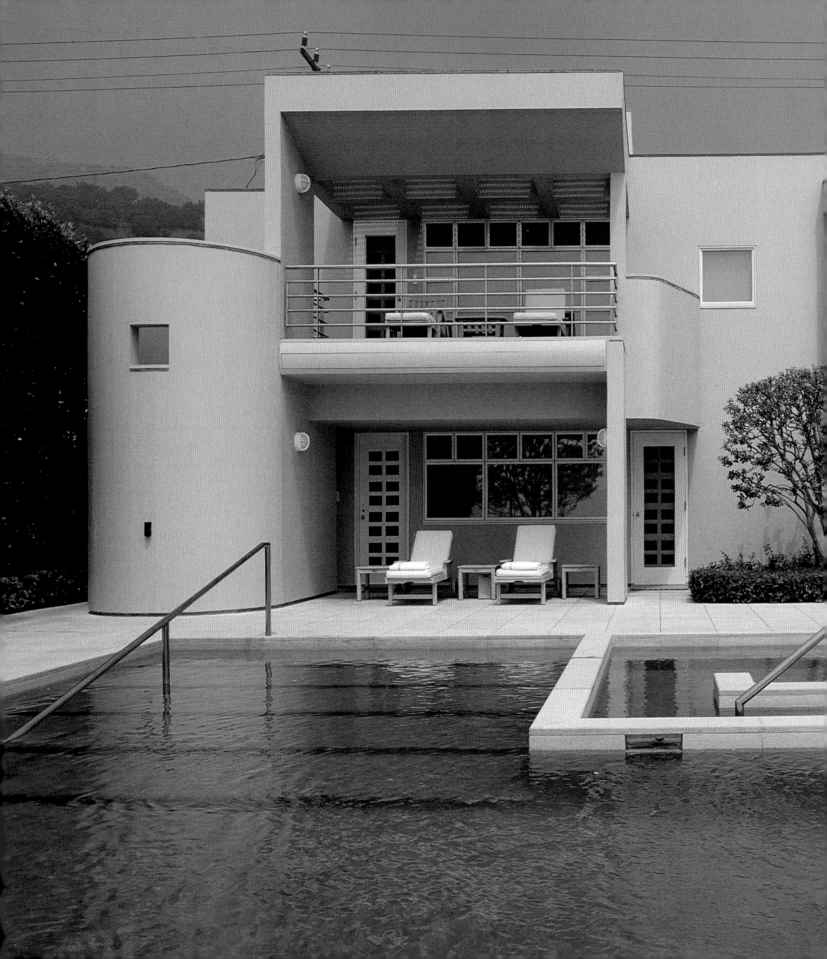

Malibu
Oceanfront residence
Gwathmey Siegel &
Associates,
1988–93

The great luxury along the narrow coastal strip is elbow room, and this house has it in abundance: a double lot that is 150 feet wide and 120 feet deep. Architect Charles Gwathmey had the room to create an eleven-thousand-square-foot residence of timeless simplicity, set off by an expansive pool court and terrace. He achieved a feeling of serenity through his choice of a few complementary materials, soft tones, and an organizing grid that appears in the paving, windows, and porticoes. And he exploited the drama of the transition from land to water, layering solid and open space to create a dramatic progression from the noisy six-lane highway to the tranquillity of the open and enclosed areas beyond.

The house is concealed behind an expressive two-story wall of vertical cedar boards stained a translucent gray, which runs the full width of the site. Projections hint at the hidden spaces, as does the surface geometry of glazed doors and high windows. But though it nods politely to the street and neighbors, it is clearly intended as a buffer to ensure privacy and hold the traffic at bay. Beyond the hard carapace is a soft void: a landscaped courtyard lined with pear trees that partially conceal the extent of the

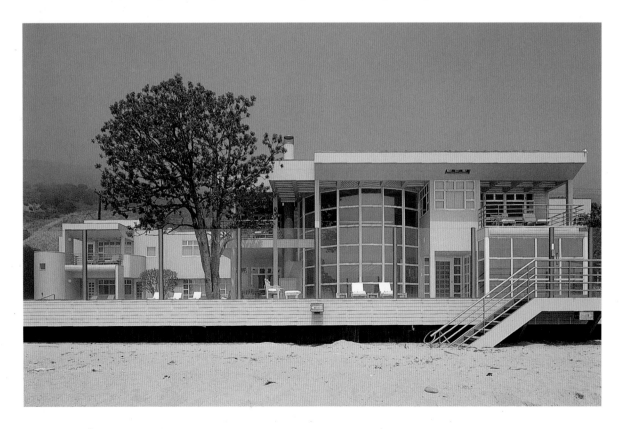

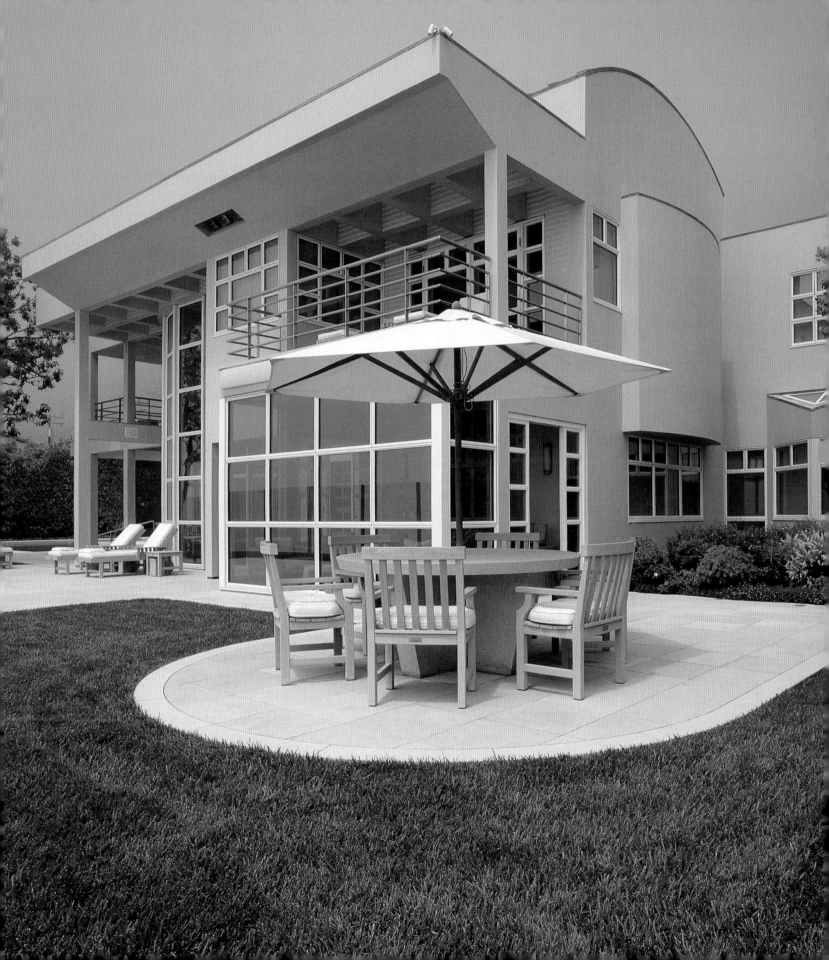

surrounding buildings. Only when you step from this decompression chamber into the soaring rotunda of the great room do you finally appreciate the scale of the house and the uninterrupted sweep of the ocean view.

Everything is spare, perfectly balanced, and precisely calibrated to achieve a feeling of calm and understated luxury. So tightly fitted are the gray cedar boards cladding the walls, decks, columns, beams, and brises-soleils, that the house appears to have been carved from a solid block of wood, hollowed out and set down on a uniform grid of limestone pavers. This stone remains cool on the hottest day, and it complements the tonality of the wood, throwing its cubes, planes, and curves into sharp relief against the cerulean backdrop of sky and sea but absorbing the glare of the sun. The play of forms in light is enhanced by the pools of shadow cast by projecting roofs, grids, and a single tree at the edge of the terrace. Pool and Jacuzzi carry your eye to the ocean, and the surf is reflected in the expansive windows and the protective glass screen at the edge of the terrace, dissolving the structure into liquid movement. Tall hedges screen the sides of the property.

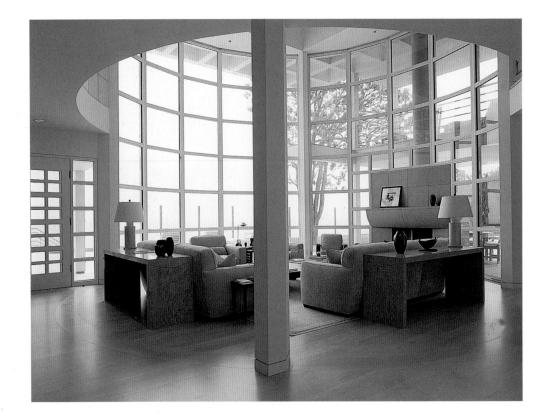

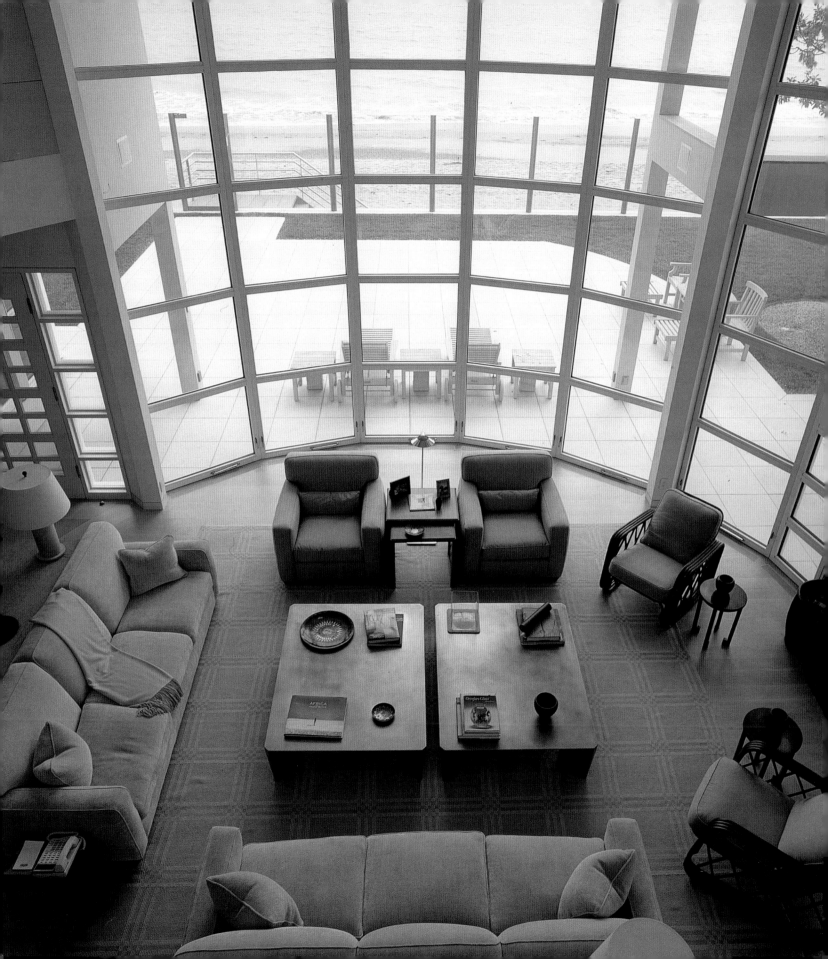

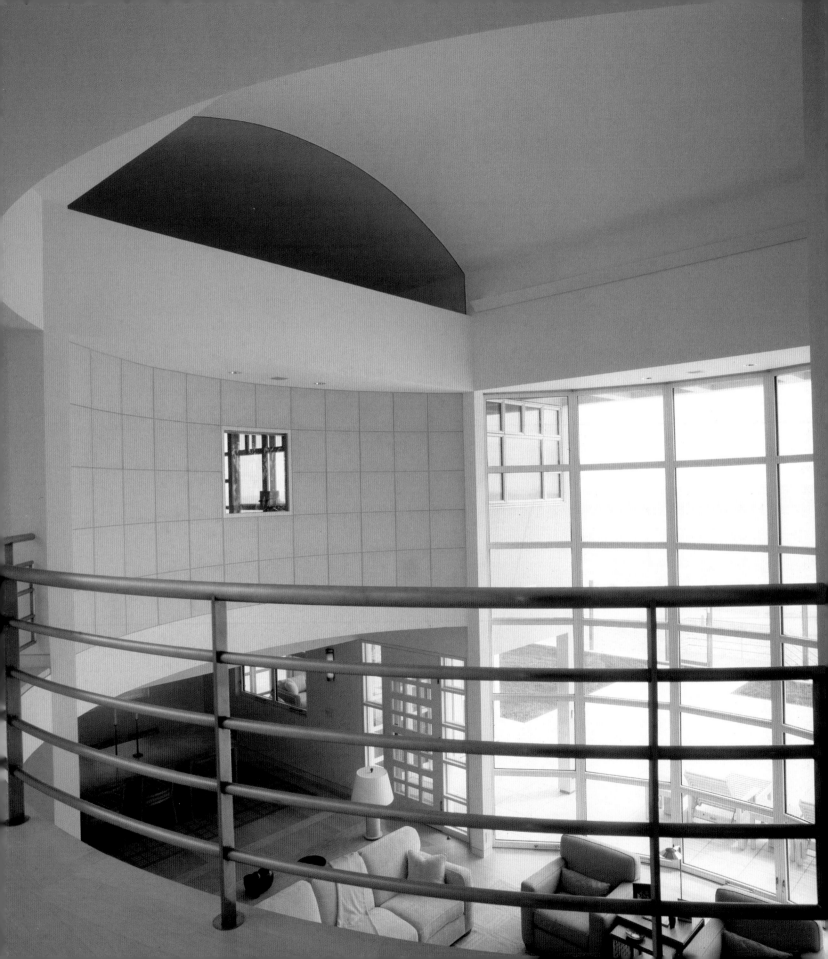

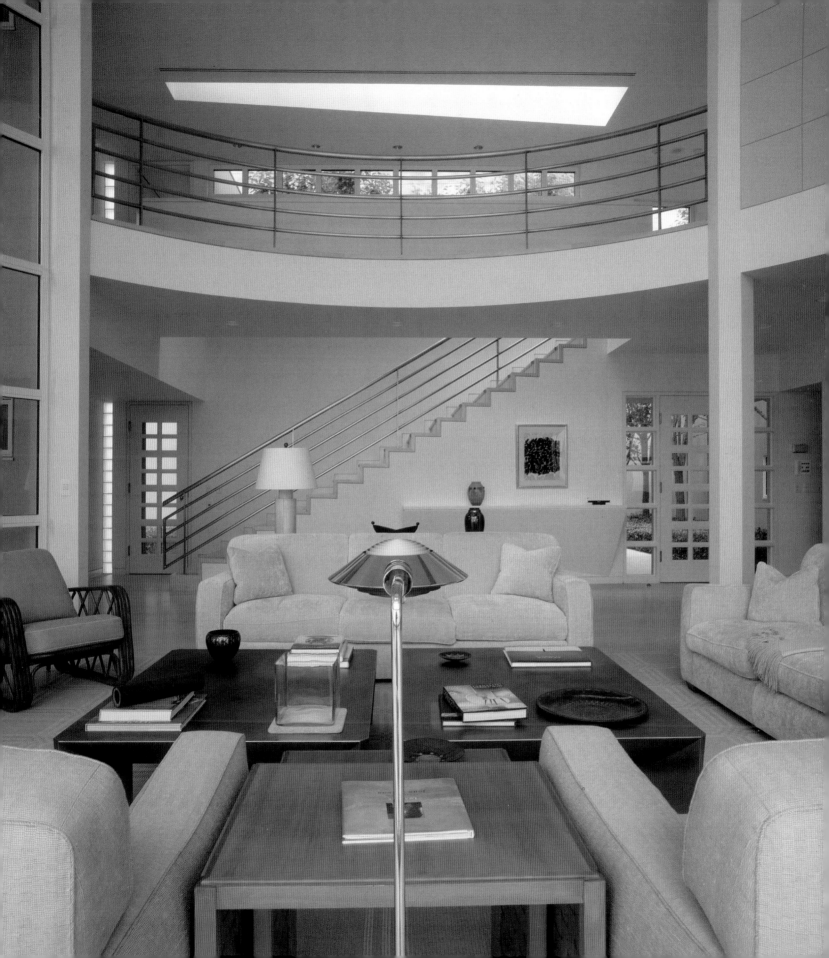

The serenity of the open areas is intensified within, for, as in all of Gwathmey's houses, there's a sense of formality, a separation between patio and interior even though the two are visually linked. The rotunda emerges from a cutaway cube of subsidiary rooms and porticoes. A bowed ceiling plays off the curved wall, and a wedge of stairs at the back of the room is echoed in the tapered skylight. Maple floors and treads and cream upholstery add warmth to the white surfaces; fabric panels dampen the acoustics and conceal speakers. The double glazing shuts out every sound but the muted thunder of surf; even the sunlight seems to tiptoe in respectfully. To one side is a formal dining room with the kitchen in back and a solarium with sliding doors that projects forward onto the terrace. Above is the master suite, with a view down into the rotunda.

A bridge links this complex to the two-story wing that extends along the highway. On the ground floor, opening onto the pool court, is a guest suite, alongside a twenty-seat screening room with heavily insulated walls. Each of its two levels has a symmetrical arrangement of sofa, low tables, plus armchairs and ottomans that swivel around to face the screen. Ten speakers are concealed within the canted cornice, and projection ports are masked by deep maple and glass shelves. Comfort and clockwork efficiency are fused, here as throughout the house, but one can leave this sybaritic idyll behind, pass through the glass fence, and descend a flight of steps to the same sandy beach mere mortals enjoy.

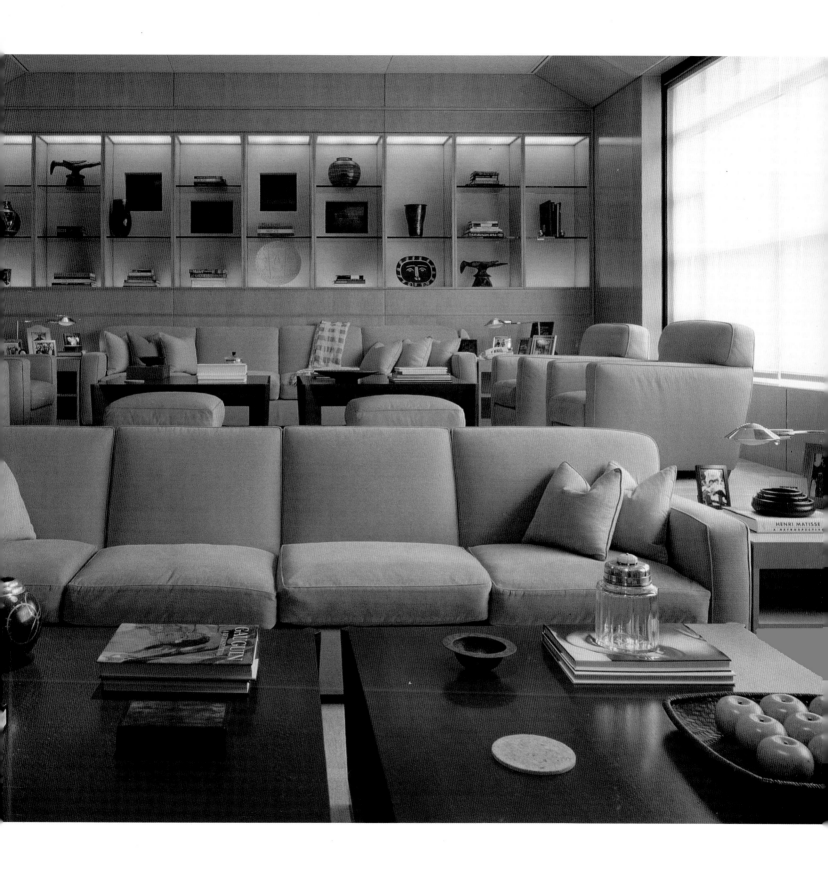